IS IT ME?

"I was told the gaping hole of emptiness and pain I felt in my marriage was my burden to carry forever. Natalie's penetrating, grace-filled words reshaped my perspective. I moved from shame-laden fear to owning my role in creating a future free from abuse and filled with joyful potential. I'm crazy excited to give this book to my friends who need it too."

—Alaine Edmondson

"After reading this book it was clear to me that what I went through in my former marriage was truly abusive. I am now in the healing stage, and this book has given me hope to know that I can truly live free in Jesus' love and care. Wonderful, life changing book for the confused Christian woman like I was."

—Lynn Searl

"Natalie's book empowered me with specific tools to clear away the brain fog and give me strength to make necessary changes in my life. Now I'm using this book to help others find freedom from the dysfunction and chaos and help them grow into all that God has called them to be."

—Amy Jones

"For over 34 years I felt helpless and hopeless in my marriage. There were days I wanted to die to escape the craziness. Like many Christian women, I was taught it was my duty to submit to anything and everything. Through Natalie's book I have learned some truths that helped me escape and realize how much God truly loves me. Praise the Lord, Natalie is setting the record straight!"

—Kelley Denver

"Finally, someone knows my life and the hell that I've gone through. Prepare to cry and be set on a new journey of finding yourself in Christ as a beautiful and wonderfully made creation. Thank you, Natalie, for finding your voice and putting it into words for those who have no voice."

—Kasey Eastman

"I was confused and hopeless about why nothing I ever did made a difference in my marriage. This book flipped that paradigm, completely changing the way I viewed myself, God, my husband, and my church community. Now I get to live in the truth, and the love and grace of Jesus is sweeter than ever."

—Abigail Harden

"I wish I'd had this book ten years ago. It summarizes very well what took me several months with a life coach to see. This book validated my experiences and led me to a new life of freedom I didn't think was possible."

—Ann Schell

Is it Me?

FLYING FREE
M · E · D · I · A

Flying Free Media
13090 Crolly Path
Rosemount, MN 55068

FlyingFreeNow.com

ISBN: 978-1-7328943-0-3 (print), 978-1-7328943-1-0 (epub)

Ordering Information:
Special discounts are available on quantity purchases by corporations, associations, and others. For details, contact the publisher at the address above.

Publishing and Design Services: MartinPublishingServices.com
Editor: HEDUA, LLC
Author Photo: Raquel Martinson

Making Sense of
Your Confusing Marriage

A Christian Woman's Guide to
Hidden Emotional and Spiritual Abuse

Natalie Hoffman

FLYING FREE
M·E·D·I·A

TO THE WOMAN OF FAITH BEGGING GOD
FOR HELP ON HER BATHROOM FLOOR.

HE SEES YOU.

"THEN YOU SHALL TAKE DELIGHT IN THE LORD,
AND I WILL MAKE YOU RIDE ON THE HEIGHTS OF THE EARTH."
—ISAIAH 58:14

CONTENTS

INTRODUCTION

This book is written specifically for **women of faith in confusing and painful marriages**. I wish that meant it was only for a handful of people, but sadly, this is a decent-sized segment of society. If you can relate to the first chapter of this book, then you are the woman this book was written for, and my hope and prayer is that God will use this book to start you on your own journey out of Egypt, through the wilderness, and into the Promised Land of freedom and hope.

If you are a woman in a confusing, painful marriage, but you don't have a faith in God, you may still find some answers to the questions that plague you, but please know in advance that I will be addressing specific concerns women of faith deal with in reconciling who God is with what they have experienced in their marriages and in their faith communities. If you are a woman of faith, but you're in a normal marriage with garden variety issues, you won't be able to relate to the message of this book. However, if you want to become familiar with what some of your friends may be experiencing behind closed doors so you can better support them in their unique struggles, then this book may be helpful.

If you are a man experiencing a painful, confusing marriage, and you want to read this book to find some hope and help, you'll need to apply the gender distinctions appropriately to your situation be-

cause the target reader here is female. If you are a pastor or religious leader who wants to learn more about some of the women in your congregation and what they are going through, then this book will help with that. But if you are a pastor or religious leader who is only interested in protecting the egos of men while reigning down shame and condemnation on women, this book will be gasoline for your fire. It's probably best that you put this one back on the shelf.

I spend a good portion of this book exposing religious propaganda used to maintain power over the female half of the human race. Please know that I do not believe every conservative Christian church in the world pushes this misogynistic agenda. There are many safe churches who preach and live out the gospel of Jesus Christ without shaming and hating on those who do not adhere to their specific set of rules. They are the true global Church of Jesus Christ, and all God's imperfect and very human children are welcome and loved in these places of worship. If you belong to one of these churches, you are blessed with a safe haven, and they will surely help you on your own personal journey to healing.

During my own experience living in a destructive marriage, others told me that what I was experiencing was either normal or exaggerated or wasn't even real. My most intimate companions during that dark time became books that put my experience into words. After being steeped in deception and confusion for so many years, these books became a lifeline of sanity to me, and through them, God began to heal me with His truth. For that reason, I will be recommending several of my favorite resources for further study throughout the book.

Natalie Hoffman

September, 2018

Is This Your Marriage?

DOES THIS SOUND LIKE YOU?

"Why do concerns I bring up never seem to be resolved? Why do I feel like Charlie Brown, flat on his back from having the football snatched away? Why, when I bring up a concern, do I always end up justifying my existence or being the one to apologize? How do things seem to get turned around on me?"

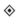

"I knew something was off for years but didn't know what it was exactly. I knew that we were different—I would hear of other husbands supporting their wives in pursuing their dreams and be absolutely blown away. I would hear of husbands encouraging their wives to go out with friends and not be able to relate at all. I would hear of decisions being made mutually and not understand how that even looked."

"I feel like I walk on eggshells, and I'm scared of his reactions to grievances I express, so I keep them to myself."

"Praying, bargaining with God, and submitting more hasn't ever improved our relationship. But I am stuck here, because if I don't hold up my end perfectly, I can't ask him to do anything."

"I would do searches on Google like, 'Why doesn't my husband love me?' and 'Why don't I love my husband?'"

"I remember as a young wife thinking, 'Is this normal? Does everyone feel this way? Maybe this is why old wives seem bitter?' It wasn't until year seven that I finally acknowledged something was wrong, and there wasn't anything I could change to make it better. It was years fifteen to twenty-four that I became unsure of reality and questioned my sanity."

"He always apologizes after looking at porn or after blowing up at me or the kids. But nothing ever changes. And he gets mad if we don't 'forgive and forget.'"

"He was a mechanic by trade, yet I was afraid to tell him whenever the car was acting up or making a noise. He would tell me he didn't want me putting miles on my car, so I would tell friends 'no' anytime they wanted me to come see them. I acted like a little kid afraid to ask permission to do stuff."

"We had tornado conversations that would spiral downward, suck up everything in their path, spin it around, and spit it out. When it was over, I'd be left stunned, having no clue what it was even about, but I'd be so glad it was over and just clean up the mess and wait for the next tornado conversation to come whipping back into town."

"Nobody yells 'Emergency! Call 911!' or 'Divorce!' with all those tiny little 'Hmmmm, that's-a-bit-off?' moments or maybe the 'Ouch! He hurt me!' scenes or the 'What the heck was THAT all about?' confusing moments that pile up over a period of years. All those tiny little pieces of the puzzle are things you just toss out with the trash because you're too forgiving, too patient, too loving, too empathetic, too kind, too giving, too enamored with him—until you start to secretly collect them and put the

real pieces of the puzzle (the truth) together and see a much clearer picture."

—Quotes From Women of Faith in Confusing Marriages

JULIE'S STORY

She wondered if she was going crazy. All she ever wanted was to be a good Christian wife and mom, and she gave her marriage and home all the love, energy, and support she had inside. But something was off in her marriage. No matter what she did or said, how many marriage books she read, how many conferences on Biblical womanhood she attended, or how hard she tried, she felt like a failure.

She worked hard to keep the house clean so her husband had a peaceful place to come home to after work, but she was always falling behind. He made little comments about the dirty bathroom or the clothes the kids were wearing. Keeping the children clean and well-behaved so they wouldn't bug her husband was a stressful, full-time job all by itself. She avoided asking him for help so he wouldn't get irritated with her. After all, he worked hard all day providing for them, and she needed to do her part. She felt alone and exhausted.

Oh, sometimes things seemed fine. They could be okay for days. Sometimes even weeks. But then things would begin to fall apart, usually after she had to ask for help, or if she gave him feedback about something she felt was important. This seemed to upset him and turn everything upside down again.

But didn't all marriages have their ups and downs?

They couldn't seem to resolve conflict unless she took full responsibility for everything, including what her husband did, and beg forgiveness for implying he might have done anything wrong. When she brought up a concern, it became about her, not the problem she wanted to solve. Her husband repeatedly complained that she was too picky, too whiny, too unforgiving, too angry, too nagging, too silly. She learned to pick her battles carefully, because once he was upset, she had to endure a tirade of accusations and condemnation. The silent treatment. No favors or help for a while. She felt bad if she wanted to go out with a friend. He would say little things that made her feel guilty for abandoning her family and forcing him to take care of the kids.

But wasn't she supposed to lay down her life and serve her husband and family?

Sex was horrible. She couldn't have an orgasm even though she read books about it and prayed for help. She couldn't relax. He made little comments about her body and her behavior in bed, and she felt ashamed and stupid. When they had sex, he did it and got it over with. She wanted him to. It felt impersonal and disgusting. He complained about her inability to get into it, but when she tried, he mocked her. There was no emotional connection.

What was wrong with her?

The burden of parenting alone most of the time was starting to break her down. She was getting short with the kids. Exhausted. Burnt out. When he would start in on her, she'd fight back now, saying sarcastic things she regretted later. He would point out what

an angry, bitter woman she was. Unforgiving. Disrespectful. He'd tell her "everyone" agreed with him. She had problems.

She began to hate herself.

At church, she made sure to dress up, smile, and keep her kids in order so the other ladies would know she was doing her best to be a Proverbs 31 woman. If they knew the kind of angry, negative things that went through her head, they would be shocked. Once she told a church friend about something painful her husband had said, but her friend told her she needed to talk about her husband in a more respectful way. She needed to be more forgiving and overlook his sin. She felt ashamed.

He was a good man. He was faithful to her. He took the family to church. He read his Bible every day. In fact, he knew the Bible so well, he could pull out Bible verses to support his various observations of how bad she was. She would weep in church when they sang songs about the grace of God. She wanted to feel that grace so badly, but most of the time all she felt was the condemnation of her husband—and God too—because didn't He speak through the authorities in her life, like her husband and church elders?

She was pretty sure God was disappointed in her failed efforts at creating a happy, peaceful home for her husband and children. She felt so much anger and resentment and hopelessness. How could God love her like this? She often locked herself in the bathroom, crying in hopeless desperation on the floor. Begging God to help her be a better woman. Begging God to forgive her. Begging God for *some reason to keep trying.*

Her mind looped over and over on the same things, mentally spinning in relentless circles. She was anxious and depressed. She had a

panic attack on the road the other day and had to pull over for fear she would black out while driving her young children to school. She was terrified there could be something seriously wrong with her.

When she looks in the mirror now, she hates what she sees: a scared, indecisive, insecure, stressed-out, unhappy woman who can't seem to do anything right. *What happened to the girl she once was?* She feels hopelessly stuck. There is no way out. She made her bed, and now she'll have to just lie in it until she dies. Sometimes she thinks dying would be better than living this way another day.

PATTERNS OF BEHAVIOR

"The Lord never skirted truth nor backed away from it. He always moved with great compassion and tenderness, but he never denied reality. If you want to untangle the difficult situation in which you may find yourself, it is important for you to be courageous enough to face the truth and seek the wisdom you will need to make the next move."

—Jan Silvious, *Foolproofing Your Life: How to Deal Effectively with the Impossible People in Your Life*

If what you've read so far is resonating with you, you're experiencing deep confusion and pain about your marriage. You may be feeling desperate to make sense of it in order to find resolution and peace within yourself. I'd like you to consider some of the most common patterns of behavior present in relationships where one person is in a power-over position. Let me be clear about something though: you

won't see *every single one* of these behaviors in *every single confusing relationship*, but you'll definitely see several of them. You'll notice I use the word *chronically* in every pattern. That's because we all exhibit similar behaviors at different times in our lives. These are all human behaviors that show up when we are at our worst. But in the kind of relationship dynamic we'll be looking at in this book, the person in the power-over position **chronically** behaves in these ways **throughout the course of the relationship**, and they don't take responsibility for those behaviors. They deny them, minimize them, blame others for them, and justify them, but they don't own them, and *they don't ever change them*. In fact, the behaviors get worse as the relationship progresses. Let's look at a few of them and see if any apply to your relationship.

- Is your partner chronically dishonest? Does he leave out information with the intent to mislead or hide something from you? Does he say things happened that didn't? Likewise, does he say things didn't happen that did?
- Does he chronically say he will do something, but he doesn't always follow through on those commitments?
- Does he chronically inflate his own good deeds while minimizing your efforts? Does he point out to you what he's done and expect praise for normal adult responsibilities?
- Does he chronically criticize your efforts and shame you for your preferences?
- Does he chronically turn a discussion into an argument and blame you for intentionally starting that argument?
- Does he chronically ignore your efforts to connect? Does he delay answering emails or texts or phone calls? Does he avoid eye contact when you are talking to him? Does he sigh or scoff and use facial and body language that indicate his disinterest and annoyance toward you?

- Does he chronically blame you for the things he himself needs to take responsibility for? Are you his scapegoat?
- Does he chronically put his own interests above yours?
- Does he chronically interpret the slightest disagreement with his decisions, opinions, or desires to be disrespectful on your part? Does he claim that, because you don't "respect" him by agreeing with him, that you are failing as a wife? Does he demand respect regardless of his behavior?
- Is he chronically critical of your interests, hobbies, choice of clothing, personal style, friendships, fears, hopes, and dreams?
- Is he chronically sullen when you are happy, and alternatively, is he happy-go-lucky when you are suffering in some way?
- Is he chronically unavailable when you need him most, such as during pregnancy or following the birth of a baby or the death of a family member or friend?
- Is he chronically uninvolved in the daily, emotional burden of raising the family and running the household? Does he show up only when he feels like it or when it suits his timetable or agenda or when someone from the outside is observing him, such as at church or an extended family gathering?
- Does he chronically project his own poor attitudes and behavior onto you, accusing you of feeling and doing the very things he himself feels and does?
- Does he chronically tell you what you are thinking? Does he presume to interpret your heart and motives? Does he maintain that his accusations of you are true regardless of what you've explained?

- Does he chronically use you in bed, meeting his own needs while disregarding yours? Has he ever raped you (making you have sex when you didn't want to)?
- Does he chronically lay the blame for the marriage problems on your shoulders? Is he unable to take responsibility for his behavior? Is he offended when you give him feedback about those behaviors?
- Does he chronically create an environment in which he does everything right while you do very little right? Does he withhold praise and encouragement and instead belittle you and make you feel small and insignificant?
- Does he chronically control the money and/or other assets?
- Does he chronically control what you do with your time? Does he demand your time and attention when you are giving it to others, even in serious times like family deaths? Does he attempt to isolate you?
- Does he chronically control other aspects of your lives together without regard to your input, needs, or desires? Some examples might be how you decorate the home, what food you eat, how many children you have, child rearing policies, etc.
- Does he chronically disrespect your boundaries? Are you allowed to say "stop" or "no" without suffering emotional and verbal consequences?
- Does he chronically sabotage your emotions before bed, an important commitment with others, or a special event? Does he shame you or try to upset you in public?
- Does he chronically withhold communication and affection in order to control your emotions and decisions? Does he withdraw for hours or days, punishing you with a silent treatment?

- Does he chronically refuse to take responsibility for his actions and attitudes in your relationship by blame-shifting, denying, justifying, and minimizing his behaviors?
- Does he chronically sweep conflict under the rug, never to be resolved?
- Does he chronically punish you later for something he's agreed about or praised you about earlier? Does he frequently change his positive judgements of you into negative ones later on?
- Has he made it clear to you that certain topics are off limits?
- Does he chronically accuse you of trying to control him? Does he accuse you of having the motives or behavior patterns that he does?
- Is trying to solve your partner's problems and manage his emotions all you can think about? Do these problems steal your attention from everything and everyone, including God, so that your focus is constantly on them? Is solving the confusion in your marriage the center of your painful world?

Did you answer "yes" to several of those behaviors? You don't have to have said "yes" to all of them for your relationship to be seriously problematic. Everyone's relationship is different, but these are the most prevalent patterns of behavior found in one partner of an emotionally abusive relationship. Have you tried at different times to speak to your partner about his behavior in the hope that he would care enough about you and your relationship together to make a change? If you stood up to your partner in any way, whether it was gently, submissively, with a slight tone, with a medium frustrated tone, or with a freaked-out shriek, did your partner use any of these verbal tactics to shut you down?

- Accuse you of something to get the focus off his behavior?
- Blame you for his behavior?
- Block the discussion?
- Withhold information to keep you in the dark?
- Correct the things you say in order to create confusion and doubt?
- Discount your credibility?
- Scoff at your concerns?
- Judge and criticize you?
- Threaten you?
- Call you names?
- Yell at you?
- Intimidate you?
- Minimize the impact of his behavior?
- Tell you that you're making a mountain out of a molehill?
- Accuse you of not trusting God?
- Deny his behavior?
- Justify his behavior?

When a woman is experiencing these kinds of behaviors over a period of many years, her emotional, physical, and spiritual well being will begin to break down. There are two reasons these behaviors are destructive. One reason is that they are connected to positive behaviors. The husband isn't always being disrespectful, neglectful, or unloving. Sometimes he is amazing. Sometimes he is attentive and kind. This creates extreme confusion, or what psychologists call cognitive dissonance. Cognitive dissonance occurs whenever there are two opposite realities side by side. In this instance, we have an intimate partner who is sometimes wonderful and sometimes cruel. Our brains can't figure that out, and if this crazy making occurs over a long period of time, it sets up a stress and trauma response that can cause symptoms of complex-PTSD. More on this in chapter five,

but for now the important thing to remember is that confusion is the key to control. If someone can keep you perpetually off kilter and confused, they can control you.

The other reason these behaviors are destructive is because they are hidden. Those outside of the relationship can't see what's happening, nor do they understand even when the target of these behaviors tries to explain them. This leaves the target feeling alone, trapped, crazy, terrified, despairing, helpless, worthless, incapable, out of control, shameful, guilty, unlovable, and empty.

The fact is, what's happening in your life and your marriage is a **thing**; it has a name, and *it is a problem that runs rampant in the conservative Christian church*.

HIDDEN EMOTIONAL ABUSE

All abuse is about *power and control.* The patterns of behavior we've just looked at describe an emotionally abusive relationship. This isn't just a difficult marriage relationship. It isn't just a challenging marriage relationship. It isn't just a confusing marriage relationship. *It's an abusive marriage relationship*. I believe emotional abuse is the most common, most destructive, and most dehumanizing type of intimate partner abuse. And because of the covert tactics employed in such a relationship, it is the most difficult type of abuse to identify.

My definition of hidden emotional domestic abuse **is the secret, regular and repeated, cruel mistreatment of the inner emotions and heart of another person living within the same home.**

SECRET

When something is a secret, it isn't known. It can't be seen. It can't be observed from an outside glance. It is covered up. Hidden. Concealed. Does this mean it isn't happening? Is reality only what a group majority observe and believe? Or is reality something a little more common sense than that? Because hidden abuse can't be observed from the outside, it has the opportunity to flourish, much like mold thrives in dark, damp, and hidden places. When mold is exposed to the sun and air, it dies. When we find mold, we get rid of it, but if we don't know it's there, it grows and does unseen, systemic damage to the foundations of homes as well as the immune systems of humans who inhale it. Likewise, hidden emotional abuse cannot be observed from the outside, and when we deny its existence, it also gets worse and does systemic emotional and physical damage to everyone living in that environment.

REGULAR AND REPEATED

There are hurt feelings in every marriage when partners have a bad day and become selfish and insensitive, but I'm not talking about normal, negative human behavior. Hidden emotional abuse is regular and repeated, always denied, and never resolved. An emotionally abusive man isn't remorseful or sad for the damage he has caused his wife. Instead he denies, minimizes, or justifies his behavior, or he blames his target for it. This cycle repeats itself over and over again—a never ending merry-go-round of crazy-making pain with no end in sight.

CRUEL MISTREATMENT

Abuse is behavior that is meant to hurt and do damage. The outcome of an emotionally abusive marriage is the slow, systematic destruction of a human life. *It's the improper use of the marriage relationship which was meant to be a safe haven of love and commitment.* When outsiders encourage an abuse target to stay in her cruel and unusual marriage, they are re-abusing her by enabling her abuser to continue his behaviors unchecked and even encouraged. Because of their own misguided beliefs rooted in historical, misogynistic traditions, they emotionally pressure her to remain a perpetual target with no way out. Often, these outsiders will use the Bible as a weapon of control, but we'll get to that in chapter three.

INNER EMOTIONS AND HEART

Physical abuse is more easily understood because the damage is done to the skin tissue found on the outside of the body. Bruises, broken bones, black eyes—these are all things others can see and acknowledge. But emotional abuse is damage done to the brain and spirit of a person. If you could peel back the layers and see inside, you'd see a shredded, bleeding human being who is unable to truly live a fulfilling life due to the fact that all her energy is put into surviving emotionally, spiritually, and yes, even physically as she deals with the breakdown of her entire body system. **It's a hidden double whammy.** The abuse is only done when nobody is looking, and the abuse is only done to the insides of another person, where nobody can see and validate the harm even if the victim goes forward to tell.

ANOTHER PERSON

We aren't talking about kicking a chair, ruining a car, or tearing down a house. We are talking about a human life. A person made in the image of God. A person with a heart and feelings and a history and a mind. A person who had hopes and dreams of loving and being loved. Knowing and being known. A person created with potential and purpose and meaning. That is what abuse destroys. A living soul.

LIVING IN THE SAME HOME

It's not just any human life. It's the person that someone promised to love and care for. Promised to cherish and honor. Promised to live in peace with. Promised to be safe for. It's a vulnerable human being who trusted the man she married to be who he claimed to be. It's taking advantage of that trust and vulnerability and betraying it.

Often, the victim is completely unaware that she is in an abusive relationship. She knows it is confusing, painful, and frightening at times. But abuse? That's a hard pill to swallow at first. Emotional abuse in a marriage can go on for years before anything is done to stop it, and even then, getting out of an emotionally abusive relationship is difficult and painful. But much like the slaves in Egypt who had to first walk through the wilderness before getting to the promised land, there is hope for a life of peace and rest for those who are able to take that journey out.

A WORD ABOUT COVERT ABUSE

The following section was written by Helena Knowlton. You can find more of her work on her website Confusion to Clarity (http://confusiontoclaritynow.com).

Throughout this book there are many examples of covert/hidden abuse. Most emotional abusers use covert tactics as well as overt tactics. But some abusers ONLY use covert tactics. Therefore it is important to talk about covert abuse as a separate type of abuse.

Covert abuse is emotional and psychological abuse that doesn't involve outwardly controlling behaviors such as raging, swearing, belittling, and threatening. The abuser instead uses subtle, hidden, covert tactics that are so off-the-radar that they are nearly impossible for the victim to detect and describe. She can be unaware that abuse is happening for years and even decades.

She has all the confusion, self-doubt, anxiety, guilt, loss of self, and torment that abuse causes, but she'll blame herself for how she feels and acts. Not only has the abuser convinced people outside the home that he is a great guy, but he has also convinced his wife that this is true. She is terrified that she could be the crazy and unstable one. Religious men often use covert abuse so they can keep up their false pretense of being a good Christian—the ultimate wolf in sheep's clothing.

Covert abuse is so tricky to identify because the behavior can appear either normal or abusive *depending on the perspective from which you're looking at it.* When you give someone the benefit of the doubt and try not to be critical, you attribute the same motive for his behavior that yours would be under the same circumstances. For example, if he's silent and withdrawn, you want to believe he's

just trying not to argue or is just taking a break from a hard conversation. A woman can spend years mislabeling and normalizing her abusive partner's behavior while she becomes smaller and more confused inside.

Many women who are being covertly abused read examples and definitions of the more obvious forms of emotional abuse and don't see their experience. They are thrown into the confusion of thinking, "*Something is wrong in my marriage, but it can't be emotional abuse, so it must be me.*" Yet they are living with profound pain, severe emotional distress, instability, and the paralyzing fear that they are slowly going crazy.

If this describes you, it is vitally important for you to be able to accurately label your experience.

Indicators of Covert Abuse

- You have tiny glimmers that something is wrong but they disappear so quickly that you doubt yourself. These can be subtle looks of contempt, a flash of rage on his face, or words that leave you wondering if they are a put-down.
- You experience beautiful times of closeness that leave you feeling empty. When he holds you, you feel awful and wonder what's wrong with you.
- Meaningful times like birthdays and family gatherings seem to get sabotaged by his moods or subtle comments that cause you to feel bad.
- You've experienced an insidious, gradual erosion of your sense of self-worth and abilities as well as a loss of trust in

yourself. You can't imagine surviving on your own. You feel like you're not enough and also too much.

- Maybe you feel manipulated. Maybe you feel dominated. Maybe you feel intimidated. Maybe you feel rejected. But when he treats you with kindness, you definitely feel crazy.
- Because he seems humble and sensitive, you can't figure out why you don't feel you're being treated kindly and sensitively.
- He subtly implies that you don't remember things as clearly as he does.
- He seems entitled and selfish, but you don't know why because he says all the right words.
- He professes to love and care about you but seems to somehow negatively affect your inner life and emotions and responses. You assume there must be something wrong with you to cause you to feel unstable, confused, anxious, and depressed.
- Your friends talk of how their husbands support them in overcoming their wounds and insecurities, and you wonder why your wounds and insecurities have been growing over the years. Your husband says he wants to help you overcome them, so you believe they are only there as a result of something lacking in yourself.
- The feeling in your home is heavy and oppressive. You're walking on eggshells and have no idea why, so you are obviously the problem.
- When you try to explain a troubling incident or define the problem, you feel you must sound needy, petty, or even paranoid. This reinforces your belief that you are the problem.

- You feel that you're falling short of a responsibility, not caring about something as much as he does, or somehow not living up to unspoken standards.
- He apologizes for something and explains so eloquently why he did what he did. You feel deep compassion for his woundedness that made him "accidentally" hurt you. You believe things will get better soon, yet the changes he promises never materialize.
- He's kind and caring and draws you in to trust him. You have heartfelt conversations and share your insecurities, but those conversations make you feel emptier than ever before, and over time he uses those insecurities against you in ways you can't define.
- If you question something, he presents his defense with plausible deniability: "I didn't mean that" or "You took it the wrong way." Then he turns it around on you: "Don't make this about me."
- For years you've been on a roller coaster of trusting your husband and then not trusting him—but not knowing why.
- Conversations with him are circular, and you lose your train of thought, but he never does. He subtly dominates conversations with his calm rationality, and he rarely raises his voice, yet the look on his face and his tone of voice evoke feelings of helplessness in you. You feel insignificant and often lose control. He expresses his loving concern at your instability.

Examples of How Covert Abuse Can Play Out in Real Life

He says he wants to work on the marriage, so you are hoping things will get better. For every issue you bring up, he has a perfectly good reason for why he does what he does. Then he sincerely explains that he feels he is being controlled by you, that you don't care enough about his feelings, that he has a hard time trusting you, and that he wants to take responsibility for his part. He calmly and rationally explains why the problem is your misguided perception. By the end of the conversation, the focus is on you and how the issues you're having are all your fault.

Even though he never shuts you down with obvious verbal tactics, you feel blamed and confused, but you think you must be too sensitive and are reading into things. You are mad at yourself for feeling intimidated and defensive about what appears to be nothing. You even wonder if you are the toxic person in the relationship. You vow to work harder on yourself. Why can't you trust this loving, kind husband who has your best interests at heart?

In public he's cheerful, helpful, and loving towards you. But at home you experience a Jekyll/Hyde dynamic. He will cook you a meal, tell you to get off your feet and rest, and put away the groceries. Yet he seethes with hidden rage when you are sick a few weeks later.

He writes you a beautiful card telling you what a wonderful mother and wife you are. Yet later he subtly implies you are ruining your child's life, and you assume you must have misunderstood what he said.

You want to pursue a dream or hobby, and he seems to support you. Yet he never gives you positive feedback, and he subtly undermines

what you have created. After you plant a beautiful garden he "accidentally" walks through it and crushes plants because he needed to fix the fence. Then he brags to friends in front of you about what a talented gardener you are and how lucky he is to have you as a wife.

WHAT HE IS DOING

He is systematically manipulating your emotional responses using ongoing secret mind games such as gaslighting, evasion, feigning ignorance, and word twisting because they are very hard to detect, describe, and confront. He knows your insecurities, joys, and desires, and he is using the *pretense of caring* to confuse and destroy the foundation of what makes you who you are. He is undermining your joy, causing you to doubt your strengths, and destroying your sense of self.

You experience inner cognitive dissonance between who you think you are and who you have come to believe you are due to your husband's response to you. When you look inside, you see one person. When you look at your husband's view of you, you can hardly recognize who you see. You're distraught at how self-deceived you are.

Often there's no obvious abuse cycle, just a roller coaster of ups and downs along with the constant wearing away of your identity, value, and personhood. His tactics are difficult to pin down. When you think you've identified a pattern, he changes tactics.

The most important thing to remember is this:

- if your husband doesn't treat you in obviously hurtful ways, yet you're confused and feel like you're on a merry-go-round of emotional pain, frustration, and self-doubt...

- if you feel like you're diminishing and dying inside, but you can't point to something specific that your husband has done or said because it could be taken another way in another circumstance…
- if you know that if you told another person what he said or did, they'd say you are being oversensitive…
- if you feel like you're living in the twilight zone…

…you are probably being covertly abused.

—Helena Knowlton

ONE COMMON DENOMINATOR

I've given you a list of typical behaviors, many of which you've maybe experienced in your marriage, but there is one common denominator of all emotionally abusive relationships, and it's this: **one person in the relationship doesn't take responsibility for his behaviors.** *Ever.* That's it. You can have an infinite number of variants as far as specific behaviors and abuse tactics, but boil it all down, and you get this at the bottom of the pan every. single. time.

This means you can't ever resolve anything. If you go to an emotionally abusive spouse with a bit of feedback about something, you will get nowhere. He doesn't want to hear what you have to say. Here are some examples of how this might play out:

Wife: "*When you did/said such and such, it hurt.*"

Husband: "*That's ridiculous. I didn't do that. You misunderstood. Why do you always have to jump to the worst*

conclusions? Can't you even trust your husband? What kind of wife are you? You're always on my case about everything."

The wife feels unloved, unheard, stupid, and she experiences tremendous self-doubt. Did she misinterpret his tone? Did she make it up in her head? Is she being unfair and mean? When this kind of thing goes on for years and years, she can start to question her reality and even her sanity.

Wife: *"While I'm gone, can you change the baby's diaper before he goes to bed? You forgot the last three times, and he woke up soaked."*

Husband: *"What? Are you crazy? I've never forgotten to do that. I think I know how to take care of a baby for crying out loud. Why do you always have to nag about everything? You treat me like a child. It's so disrespectful."*

The wife feels caught in a catch-22. She cares for and wants to help her baby, but she feels like she can't remind her husband of anything without being accused of being disrespectful herself. She doesn't want to treat him like a child. She wants to respect and honor him, like a good wife should. So she feels bad that no matter how hard she tries to show him respect, he only views her attempts to communicate her needs or the needs of her children as disrespectful. She also wonders if she is crazy. She could have sworn the baby was soaked the last few times her husband put him to bed. But he seems so sure…maybe she was wrong?

Wife: *"Can I go out with a friend next weekend?"*

Husband: "*I suppose. But I never get to go out with my friends.*"

Wife: "*But you can go out any time you want to!*"

Husband: "*Mmmmm. It's your day. Do whatever you want.*" (Deep sigh.)

The wife feels guilty. Uneasy. Like she is taking advantage of her husband's generosity and displeasing him. If she is in a sub-culture that says wives must please their husbands at all times and put their interests first, she may even choose to stay home knowing that would make her husband happy. She will feel insecure the next time she would like to take a break and spend some time with friends, and she may decide it is easier to just stay home and not to ask in the first place.

Wife: "*You committed to doing such and such over a year ago, but I've noticed that you haven't followed through. When will you keep that commitment?*"

Husband: "*Don't you have something better to do with your life other than get on my back all the time? What is your problem? Why do you have to make such a big deal out of everything? I've been busy. Can't you see that?*"

The wife feels guilty even though she hadn't mentioned the commitment for a year. She feels like she can't remind him, yet she will suffer the consequences of his lack of keeping the commitment.

Other typical responses to the wife's input or feedback:

"*You are goofy/silly/crazy/a @$#%&!*"

"Why are you always on my back? What a nag/ shrew/#$%$%"

"Everyone knows you think you're so great. What a judgmental Debbie Downer. Just back off, why don't you?"

A destructive person is critical, deceitful, and lacks empathy. They are not convicted of sin, and they don't repent. The only way to peace is for the wife to take full responsibility for her husband's moods and emotions. She has to sweep all issues under the rug and ignore them, because to bring anything up invites an attack on her personhood. All issues remain unresolved, and her feelings, interests, opinions, and desires are worth nothing.

She becomes a non-person in the marriage.

Let me repeat something I've said before that is very important for you to remember: the issue in the relationship isn't that one person behaves badly. Everyone behaves badly sometimes. That's normal. Here's the difference: in a normal relationship, the person who behaves badly realizes how their behavior has affected the one they love. They have authentic empathy for their partner's pain and genuine remorse for their own behavior which caused the pain. They own what they did, apologize, and work toward self-control and change for the good of the one they love and the health of their shared relationship. But in an emotionally abusive relationship, one person refuses to own his stuff, refuses to take responsibility, is unable to empathize with his partner, and scapegoats his partner by giving her all the responsibility for his behavior as well as the relationship.

I need to clarify one other thing about all abuse, whether it is emotional, financial, physical, sexual, or spiritual. Abusive relationships follow a predictable pattern. The pattern looks like this:

1. The husband pretends to love the wife, and the wife believes the love is real.

2. The husband gets annoyed by the wife, and the wife feels the emotional climate getting cooler.

3. There is an incident of conflict in which the husband dehumanizes the wife in some way.

4. The husband plays the victim role (*"You shouldn't have made me do that, it's all your fault."*)

5. The real victim apologizes or sweeps the whole thing under the rug in order to keep the peace.

And then it starts over again.

I realize some people don't like the word *victim* anymore than they like the word *abuse*. But the word *victim* is a word we use for anyone who is harmed by another person's actions or by a tragic situation such as a hurricane or car accident. The word *victim* accurately labels the one being harmed in an abusive relationship. So think of *abuse* as meaning *harm* and *victim* as meaning *the person who is harmed* and *abuser* as meaning *the person doing the harming*.

When you are no longer being harmed, you go from being a victim to being a survivor. And when your past no longer affects your present, you go from being a survivor to being a thriver. From crawling to flying. That's the ultimate goal.

YOU ARE NOT ALONE

Hidden emotional abuse is prevalent in conservative Christian environments. It is likely that one of every three women sitting in the pews of your church is in an emotionally abusive relationship. (http://www.thehotline.org/resources/statistics/) The reason for this epidemic in the church is that conservative Christian propaganda enables and supports this kind of abuse (more on that in chapter three). Emotional abuse in the church is systemic, and this means something important. **It means you aren't alone.**

Throughout the course of my own twenty-five-year-long emotionally abusive first marriage, I thought I was the only one experiencing the upside-down, inside-out, Alice in Wonderland feeling of confusion and pain. When I attempted to describe what I was going through, my friends couldn't relate. They assumed the things I was sharing were just descriptions of a difficult relationship, and they'd recommend the latest book on how to be a godly wife. I dutifully read every single one and redoubled my efforts again and again.

But nothing changed in my marriage. Why? **Because it takes two people to make a relationship strong and healthy, but it only takes one person to destroy a relationship.** It doesn't matter who you are. How good your communication skills are. How hard you're trying. What you've read. How many counselors you've seen. How many chances you've given him. *How many times* you've tried to explain it, or *how many different ways* you've tried to explain it. If you're the only one actively motivated to initiate and try, your marriage isn't going to work. And you need to know it's not a normal marriage, let alone a Christian marriage.

So if you picked up this book hoping for the key to a successful marriage, you're holding the wrong book in your hand. And I've got some more bad news for you. If your spouse isn't also actively looking for the key to a successful marriage, there isn't a single book out there that will end up changing your particular marriage. Because the key to a successful marriage requires two humble, active, motivated, hard-working partners coming together to make it successful. And if you're holding this book, I'm guessing you've only got one partner doing this in your marriage. You.

No, this book is not the key to a successful marriage. This book is the key to a successful **YOU**. It's the key to your future as a valuable and beloved daughter of God. You were not created to be dehumanized and cut off at the knees your entire life. This is not God's purpose for His daughters. This is the enemy's purpose for God's daughters, and he's gotten away with this blasphemous slander of God's character and the Gospel of Jesus Christ long enough.

To understand the tragic lie behind your emotionally abusive relationship, we need to first look at how a normal relationship functions. And that's the subject of chapter two.

FOR FURTHER STUDY

» *The Verbally Abusive Relationship* by Patricia Evans
» *The Emotionally Destructive Marriage* by Leslie Vernick

31

Check Point

You got through the first chapter, and I think that's brave. If you've experienced several of the things you've just read about, you may be feeling scared, alone, and even more confused than ever. I remember the first time I started reading about the things that were going on in my former marriage. I felt like someone punched me in the gut. I felt dizzy, sick, and in tremendous pain all over.

If this describes your experience, you might even be tempted to stop reading, but I want to encourage you to keep going. I wrote this book ***exactly for you***. I walked in your shoes, and I care about what happens to you.

You might need to read this book in small doses. That's okay! Some chapters will be easier than others, and that's okay too. You may not agree with everything you read. And guess what? ***That is also okay.*** Be gentle with yourself, and be patient with this process. You are like a burn victim in the ICU. You need intervention, tender care, and time.

Deep breath. Are you ready? Here we go.

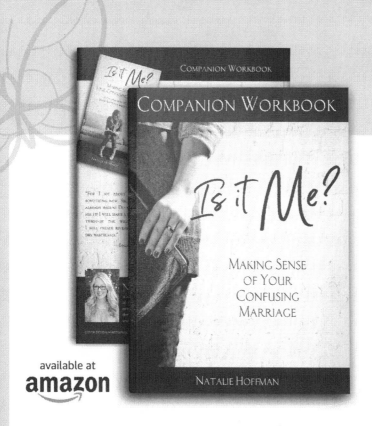

Take your healing to a new and deeper level by working through the *Is It Me? Companion Workbook*. This workbook takes the information you learn from each chapter of the book and, through the use of specially crafted writing and processing exercises, helps you pull all the material together in a way that challenges your core beliefs and addresses the trauma so you can get on with a full and meaningful life.

The *Is It Me? Companion Workbook* includes bonus adult coloring pages and small group questions at the end of each chapter.

Learn more about the *Is It Me? Companion Workbook* on our website: https://www.flyingfreenow.com/is-it-me.

CHAPTER TWO

What Does a Normal Marriage Look Like?

A NORMAL MARRIAGE IS NOT CONFUSING

"An intimate relationship is one in which neither party silences, sacrifices, or betrays the self, and each party expresses strength and vulnerability, weakness and competence in a balanced way."

—Harriet Lerner, *The Dance of Anger: A Woman's Guide to Changing the Patterns of Intimate Relationships*

If you grew up in a dysfunctional home, or if you've been in an emotionally destructive marriage, you might think what you've always experienced is normal. It's what you're familiar with, and you may have no reason to believe there could be another way for two married people to relate to one another. I've got news for you. A normal marriage never feels like you're living in the Twilight Zone. *A normal marriage is not confusing.* So what does a normal marriage look like?

I believe there are six characteristics of a healthy relationship: mutual love, mutual respect, mutual honesty, mutual vulnerability, mutual responsibility, and mutual submission. If you've been marinating in dysfunction for any length of time, you might be tempted to think that the things I'm sharing in this chapter are descriptive of a fairytale marriage that's almost non-existent in the real world. I want to assure you right here at the beginning that this is not the case. This chapter is really and truly a description of a simple and normal marriage relationship, and certainly a Christian one. I know it's possible and normal because I know couples like this. I also know because this chapter describes my second marriage, and my current husband and I are not extraordinary, fairytale people. We are your run-of-the-mill, ordinary folks with ordinary people problems. Yet our marriage is safe, enjoyable, happy, and normal.

Let's talk about what that looks like.

MUTUALITY

> "Mutuality is a way of being with another person which promotes the growth and well-being of one's self and the other person by means of clear communication and empathetic understanding."
>
> —Patricia Evans, *The Verbally Abusive Relationship*

When we say a relationship or an interest is mutual, that means it goes both ways. Mutuality is not a river running in one direction, taking everything with it. It's not a wave crashing on the shore, eating away at the surface. That's a picture of power-over. Mutuality

is different. It's more like what happens underground when water comes together from two different sources and meets, creating pressure that eventually bursts through the ground's surface in a powerful plume of water: a geyser. Mutuality is seed and earth embracing and enveloping one another in order to create something compelling and new that each one could not create without the help of the other one. When two become one, a synergistic force is created, and this force is more powerful than just taking two individual parts separately and putting them next to each other.

Although this concept of mutuality is not commonly taught in some culturally conservative Christian circles, it is not only Scriptural, but *it is actually the bedrock of a Christian marriage.* For a marriage to be truly *Christian*, it needs to be rooted in the whole Word of God—not just four or five verses about marriage. In other words, **just because someone is married doesn't mean the only verses that apply to them are verses on marriage.** For every verse specifically about marriage, there are hundreds that speak to relationships in general, and marriage relationships certainly count as relationships, too! In fact, the entire Word of God is simply the story of God's love for His creation and the unity we can have in Him and with one another because of this great love. It wasn't meant to be a Pharisee's rule book. Jesus made it clear over and over in the gospel of John that love trumps law.

All healthy relationships are governed by the law of love. This means if your marriage is not usually reflecting mutual love, joy, peace, patience, kindness, goodness, gentleness, and self-control, it's not a healthy marriage, let alone a Christian one. These characteristics of the evidence of the Holy Spirit at work in two people **go both ways**, not one way. Understanding the necessity of mutuality is critical to understanding why your marriage is destructive. It isn't

because you haven't tried hard enough. **It's because your relation-ship isn't mutual.** Mutuality is the key. In fact, the very spread of the Gospel of Jesus Christ is dependent on mutuality.

> *"I gave them the glory You gave to me, that they may be one as we are one. With Me in them and You in Me, **may they be so perfected in unity** that the world will recognize that it was You who sent Me and that You have loved them as You have loved Me."* (John 17:22-23)

When one person in a relationship makes all the decisions unilater-ally, they miss out on opportunities to truly know and love another human life. To give and take. To capitalize and draw on one an-other's strengths and knowledge and experience. To understand real intimacy and oneness.

A positive and more intimate outcome is almost always a possibility when you have mutuality. Will there be compromises sometimes? Absolutely. Maybe after talking out a decision, thinking about it over time, and coming together to talk again, there will be a meeting of minds. But if not, a couple can work together to make compro-mises and move things forward. Sometimes one partner will defer to the other. But which partner will that be? It won't be the same every time, nor should it be. Why? **Because of love. Because of mutuality. Because Christianity isn't about power-over.** When both partners are seeking to be like Christ, they will both look for ways to love, respect, and submit to one another. If one partner refuses to participate in the marriage in a Christ-like way because *they think marriage is about them and their power and control,* you've got trouble.

So to sum up, mutuality is oneness. It's unity. It's the movement of two separate parts coming together to create something powerful

and new. And mutuality within the framework of marriage is the movement of two people coming together in mutual love, respect, honesty, vulnerability, responsibility, and submission in order to reflect the cosmic reality of the unity and oneness of the Godhead as well as the unity and oneness of Jesus Christ and His people. The opposite of mutuality is the separateness that comes from *one person being in a power-over position and the other person being in a power-under position.* This is the world's pagan operating system, and it's abusive. You cannot have a dynamic, Christian marriage without mutuality.

Now that we've defined mutuality, let's dig into the six areas where we need to see this mutuality at work in order to call the marriage *normal.* (And *Christian!*)

MUTUAL LOVE

You may have heard the idea that women need love and men need respect. People who teach this do it based on a couple of isolated verses (Ephesians 5:25-33). But the Bible is full of verses that teach **both** men and women need **both** love and respect.

God created male **and** female in His image. There was perfect mutuality. Perfect unity. Perfect oneness. This was God's design. Then sin entered the world which ushered in consequences that included the power-over dynamic in relationships like hierarchy, patriarchy, and racism. But after Jesus came and redeemed creation with His sacrifice, God re-established the opportunity for true mutuality and oneness in relationships again—oneness with God through Christ, and oneness with one another through Christ. The world's hierarchy and patriarchy and racism were replaced with God's original plan for

the human race: "*There is no longer Jew or Gentile, slave or free, male and female. For you are all one in Christ Jesus.*" (Galatians 3:28)

God hard-wired certain needs in all human beings, regardless of gender, age, race, or socioeconomic status. Love and respect are two of those important needs. Men need love, and men need respect. Women need love, and women need respect. And a normal, healthy relationship of any kind, including and **especially** a marriage relationship, depends on the mutual giving and taking of love and respect. Let's start with love.

What is love? The dictionary says it is "an intense feeling of deep affection." Synonyms of love include: tenderness, warmth, intimacy, attachment, endearment, devotion, yearning, and desire. These things are all a regular part of a normal, healthy relationship.

In addition to the dictionary, here are a few things the Bible says about love. Let's look at each verse and how that verse plays out in a normal marriage.

> "*Owe no one anything, except to love each other, for the one who loves another has fulfilled the law.*" (Romans 13:8)

We owe our spouse love. When both partners love one another, they fulfill the law of God and create a normal Christian marriage. If a man is not loving his wife, he is not fulfilling the law of God, and he is not making a normal Christian marriage possible. He is creating a parasitical relationship where one person uses and sucks the life out of the other person who is playing the role of host. That might be common, but it isn't normal. (And by the way, saying the words, "*But I love you!*" doesn't cut it. Words need to match up with actions for them to have any meaning.)

> "*Be devoted to one another in love.*" (Romans 12:10)

Both partners are devoted to one another. Not just one partner. Both partners. To one another.

> "*If I have the gift of prophecy and can fathom all mysteries and all knowledge, and if I have a faith that can move mountains, but do not have love, I am nothing.*" (I Corinthians 13:2)

If a partner is a great preacher and has a strong faith and can build a big church, but he doesn't love his wife, he is nothing. In other words, big whoopee ding dong on everything but love.

> "*Love is patient, love is kind. It does not envy, it does not boast, it is not proud. It does not dishonor others, it is not self-seeking, it is not easily angered, it keeps no record of wrongs.*" (I Corinthians 13:4-5)

A normal marriage relationship is marked by patience, kindness, humility, honor toward one another (see? Everyone needs respect, not just men), selflessness, and forgiveness. If you are the only one seeking to work this character out in your life, you'll certainly grow, but your marriage will remain destructive. Unity of two requires, well, **two.**

> "*Do everything in love.*" (I Corinthians 16:14)

Are both partners making decisions, working together, planning together, and coming together for the benefit of the other one *in love*? Not just one person but both? If so, that is a normal Christian marriage.

> "*Let love and faithfulness never leave you; bind them around your neck, write them on the tablet of your heart. Then you*

will win favor and a good name in the sight of God and man." (Proverbs 3:3-4)

In a normal Christian marriage, both partners are lovingly faithful to one another emotionally, physically, and every other fathomable way. Because of this, they win favor in one another's eyes. An emotionally abusive spouse doesn't win favor in his partner's eyes because he's being a bully. People don't like bullies, generally speaking. And an emotional abuse target can't win favor in her husband's eyes no matter how faithful she is. Why? Because bullies don't love. Always remember, love has to be mutual to have a normal Christian marriage. No bullies allowed.

"And so we know and rely on the love God has for us. God is love. Whoever lives in love lives in God, and God in them." (I John 4:16)

In a normal Christian marriage, both partners know and rely on God's love for them. This love, in turn, spills out in grace and peace on the other partner. If that's not happening in a marriage, then while it might be common, it's not normal.

"With all humility and gentleness, with patience, bearing with one another in love, eager to maintain the unity of the Spirit in the bond of peace." (Ephesians 4:2-3)

When both partners are humble and gentle and patient toward one another, bearing with the weaknesses of one another, ***eagerly*** seeking unity (remember, that's mutuality!) and peace, then you've got a normal Christian marriage. Otherwise, you don't.

"Above all, love each other deeply, because love covers over a multitude of sins." (I Peter 4:8)

A normal marriage is not characterized by accusing, blame shifting, denying, and scapegoating. Both partners overlook minor offenses and talk through ones that aren't so minor. When issues come up, they both cooperatively work toward resolution because they are **both** mature, and they **both** want to.

> *"And let us consider how we may spur one another on toward love and good deeds."* (Hebrews 10:24-25)

In a normal Christian marriage, both partners are giving one another healthy, motivating feedback. And because they are humble and grateful and wise, both partners receive it willingly. No need to get nasty because they see and hear one another's hearts.

> *"My command is this: Love each other as I have loved you."* (John 15:12)

Are both partners loving one another the way Jesus loves them? If so, they've got a normal Christian marriage.

So this is what Christian love looks like. Jesus loved us this way, and He gives us life so we can love others this way. John 13:35 says *"Your love for one another will prove to the world that you are my disciples."* If we call ourselves Christians (his disciples), we will prove it to the degree that we love one another. This goes for all Christians. Even married ones.

Now we will look at five other characteristics of a normal marriage relationship, but please understand that love is what enables all of the following characteristics as well as many others to flourish in a relationship. In other words, love is honest. Love is respectful. Love is vulnerable. Love is responsible. And love is mutually submissive to one another. **So the next five characteristics really just flesh out what love is in a more comprehensive way.**

MUTUAL RESPECT

Encyclopedia.com says respect means "a feeling of deep admiration for someone or something elicited by their abilities, qualities, or achievements." Some synonyms for respect include: honor, deference, admiration, reverence, esteem, and regard. (encyclopedia.com/humanities/dictionaries-thesauruses-pictures-and-press-releases/respect-0)

Respect is being courteous, actively engaging with the other person's hopes and dreams, listening well, caring about the feedback of the other person, paying attention, compromising, asking their opinion, accepting their differences, working toward non-judgment, asking instead of demanding, and basically just treating the other person like they are special and worthy of your regard. You cannot demand respect. It must be freely given for it to be real, because respect is born of love, and love is given, not taken.

To disrespect someone is to ignore their voice, blame and shame them, take power over them, treat them rudely, look down on them, avoid them, give them the silent treatment when they don't do what you want them to do, call them names, demand obedience, threaten them, and refuse to tolerate their differences.

Let's go back to that belief that men need respect, and women need to give it to them. Is this really what the entire Word of God teaches? Is honor and respect only for men?

"*Honor one another above yourselves.*" (Romans 12:10)

"*In the same way, you husbands must give honor to your wives.*" (I Peter 3:7)

It's pretty clear here that respect, or honor, is not only for men. Honor is for the entire human race because we're all made in God's image. We honor our Creator when we honor one another, and likewise, we dishonor our Creator when we dishonor one another. In a healthy marriage relationship, the husband respects, honors, esteems, admires, and shows deference to his wife. Likewise, the wife respects, honors, esteems, admires, and shows deference to her husband. If one person is not inclined to do this, the relationship will not only be unhealthy, but it will be harmful to the person who is perpetually dishonored.

Now you may have also heard that if the wife shows her husband respect, she will create an environment in the home that will inspire him to truly love her. But that's not how love and respect actually work. We don't give respect to our intimate partner so he will give us love. And we don't expect love from our intimate partner before we can give respect. Well, we *can* do it that way, but it won't work. Because it's immature and manipulative. Also, because love and respect go together. See this?

"*Love does not dishonor others.*" (I Corinthians 13:4)

Love is respectful. Love is honoring. Where there is no honor, there is no love. Where there is no love, there is no honor. They cannot be separated, and **it takes both partners actively loving and respecting to create a healthy relationship.** This means you can be bending over backward to speak well of your husband to others, to cover up his bad behavior so as not to dishonor him in front of the children, to never argue, to always agree, to roll yourself up into a little ball of nothingness so he can take over and become Everything in the relationship. But that's not a relationship, because you're the

only one on the dance floor. It's a solo, and you'll burn out and die out before too long.

Maybe that's why you're still reading this book.

MUTUAL HONESTY

I recently asked my Facebook page readers to tell me what they believed both partners needed to bring to the table in order to create a healthy, normal marriage relationship. The number one answer, hands down, was honesty. Why? Because, **trust.**

Without trust, a relationship immediately sinks. There is absolutely no hope for a relationship built on lies, half truths, exaggerations, secrets, hidden messages, and omitted information. Hidden abuse is done under the radar, where nobody can see it. It's a white-washed tomb that looks pretty on the outside while hiding dead men's bones (Matthew 23:27-28).

I heard a story once that went something like this: Once upon a time there was a home full of different types of animals including a dog and a cat. The dog would threaten and torment the cat when the other animals weren't looking. The cat tried to get help and protection from the other animals, but the dog was super nice to them, and they never *saw* him hurting the cat, so they didn't believe the cat. The cat came to believe she wasn't worth as much as the dog and the other animals. She came to believe she deserved to be threatened by the dog and dismissed as 'that crazy cat' by the others. One day in desperation, the cat ran away. The animals said, "*That ungrateful cat. What was her problem? Why would she leave a perfectly good home? She really was as crazy as the dog said she was.*"

See all the lies in this abusive situation? The dog is lying to the cat by treating the cat as if she were a worthless animal, but the cat is not a worthless animal. She is precious. The animals believe the lie that the cat is crazy and even lying about how the dog is treating her. The animals believe the lie that the dog is nice simply because he looks and acts that way in front of them. The animals believe the lie that there is something wrong with the cat. But there wasn't anything wrong with her. She was a normal animal, and any animal would have reacted to the dog's hidden abuse in the same way. The animals also believed lies about the reasons why the cat ran away. She was ungrateful and silly and not as good as the rest of them. The animals also believed the lie that they were being fair and wise and right. They weren't. They were being arrogant and lazy and exclusive.

The layers of deception in abusive relationships are many and thick. They create a web that is nearly impossible to extract oneself from without Herculean effort and support. Do you see why so many women listed honesty as their top necessity in a healthy relationship? Without honesty, you have all kinds of dysfunction.

Another word I like to use alongside of honesty is integrity. The word means complete or whole. When a person has integrity, they are bringing the wholeness of themselves into their relationships. You can trust a man and woman of integrity. You know they will take personal responsibility for themselves and their behavior. They are alive and wholesome and 100% present. I don't like the idea of two humans representing two halves and coming together to make a complete whole. I think that's a recipe for disaster. I believe a healthy relationship is two whole human beings coming together to create a powerful, unified partnership. Both partners need to have integrity in order for there to be marriage wholeness and oneness that's rooted in total trust.

When one partner is dealing in deception, there is no trust. **The other partner, no matter what she does or how she wishes for things to be different, can't create an environment of trust on her own.** Trust requires a history of truthfulness and integrity.

To trust an untrustworthy human being is to deliberately choose something illogical and insane. Yet, that is what many religious groups demand of emotional abuse targets. They expect the victims to magically set aside their past experience with a person who chronically deceives them and trust that the other person meant well or that they will now never lie or try to deceive them again. They are required to forgive and forget all incidents of deception and abuse, and if they don't, they are actually accused of being the one without integrity.

The other maddening thing about this dynamic is that, generally speaking, those on the outside (the other animals) believe the nice doggie. Why? Because *it's what they want to believe.* They cling to their fantasy that naughty people aren't as bad as they seem and that they can change. ***Especially if they say they can.*** They believe formerly untrustworthy people can be trusted when they say, *"I'm a better person! I'm not as bad as my target says I am!"* That sounds awesome. It feels good emotionally, and because they've never seen or experienced that person behaving in cruel ways, they lazily buy the lie because, ***warm fuzzies***. So when the target says, *"No, that's not true!"* they attack the target with accusations of being mean and not forgiving. And of course, if conservative religion is involved, they will lob Bible verse bombs as well.

Welcome to the twisted Alice in Wonderland world of emotional abuse.

MUTUAL VULNERABILITY

"Give me the courage to show up and let myself be seen." This is researcher Brene Brown's vulnerability prayer found in her book, *Daring Greatly*. To be vulnerable is to open oneself up to potential attack. In battle, it's not a good idea. In a healthy marriage, it's a necessity in order to experience intimacy. But it definitely takes both partners willing to *"show up and let themselves be seen."*

If only one partner is showing up while the other one is exploiting that vulnerability, you've got a war zone, not a marriage. And that's exactly the problem in an emotionally abusive relationship. A Christian woman, strongly desiring to believe her relationship is normal, lays all her cards on the table. She shows up in the relationship in every way possible. She opens her heart and shares her hopes and dreams, sorrows and disappointments. She willingly takes responsibility for the relationship with the belief that she is investing in a quality intimate relationship that goes both ways.

But instead of reciprocity, she finds her partner twisting her words and painting a distorted image of who she actually is. (We'll talk more about this in chapter four.) Her partner isn't treasuring and carefully protecting her vulnerability. No, instead he is exploiting her emotional nakedness to fuel his own pleasure at her expense in every way possible. Before long, she starts seeing herself through his eyes, and the view isn't pretty. She is eventually humiliated and dehumanized. She thought she was naked before her **beloved partner**, but she found it was her **enemy disguised as a partner**. This is emotional, intimate partner abuse, and it utterly decimates the target. She has voluntarily and trustingly opened herself up to enemy fire, believing her wounds were the result of her own failures and actions, just as he brainwashed her to believe.

Another common problem in destructive marriages is that the abusive partner cannot or will not show up and let himself be seen. Ever. He protects himself at all costs while looking for ways to blow up the vulnerability of his partner. You might see this in your sexual relationship. Sex is less about connecting intimately and more about his gratification. You'll also see it in your communication patterns. When you ask him intimate questions, what kind of answers do you get? Does he share his fears with you and then let you comfort him? Or is he always on top of things while looking down at you? Has he ever kept secrets about his past from you?

A normal relationship isn't like this. Normal relationships are safe relationships. They are safe physically, emotionally, spiritually, and mentally. Both partners are able to trust that when they open up and share their intimate selves, the other one will safely care for them and never purposely expose them to shame. Neither partner would desire or even think of humiliating the other one. There is mutual sharing and comforting. There is deep connection on a heart level. A normal relationship is marked by empathy for one another. Each partner is able to put themselves in the shoes of the other one, entering into their world temporarily in order to more deeply understand that person.

Are you starting to see how all of these parts interplay with one another? If you don't have mutuality, you don't have love. If you don't have respect, you don't have safety. If you don't have honesty, you don't have vulnerability. None of this is to say that men and women in normal relationships never have to work through problems. Conflicts are a natural and normal part of human existence with other humans. But having mutual love, mutual respect, mutual honesty, mutual vulnerability, mutual responsibility, and mutual submission creates an environment in which conflicts can be re-

solved and deeper intimacy and connection can be achieved. That is a normal marriage.

MUTUAL RESPONSIBILITY

Mutual responsibility in a normal marriage looks like both partners owning their own behavior and taking wise stewardship of what belongs to them, including their own selves. It means I take ownership of myself, and my spouse takes ownership of himself. I am not responsible for his behavior, emotions, schedule, relationships, duties, and so on, and he is not responsible for mine. Mutual responsibility is having healthy boundaries (more on this in chapter six). It's personal accountability.

If your partner takes responsibility for his words and actions, you know you're safe. If your partner takes responsibility for his relationships, you know you're working as a team. If your partner takes responsibility for his schedule, job, volunteer work, and parenting, you know it's taken care of. You don't have to run interference for him. If your partner takes responsibility for his emotions, you know you can have open, fearless communication with him. And all of this goes both ways, of course, and this is normal. **This is what it is to be an adult.**

In a dysfunctional relationship, one or both partners are not taking personal responsibility. They are putting their responsibility on the other person. This looks like blame shifting, denying, minimizing, excusing, covering up, justifying, controlling, and accusing. When a man makes his wife responsible for his choices, his lack of initiative, his deceptions, his laziness, his anger, his failure to keep commitments, and his emotions, she will eventually collapse under the weight. A relationship cannot survive unless both partners are

owning their own stuff like adults. A marriage isn't a mommy/son relationship. Nor is it a slave owner/slave relationship.

You might see mutual responsibility practically playing out in a marriage like this: a husband knows he is going to be late for dinner, so he calls his wife to let her know. That's the best case scenario. But what if he forgets due to the craziness of his day? He is only human, after all. So he calls her as soon as he remembers and takes responsibility for the fallout. If that means his dinner is cold because his wife needed to feed the kids before he got home, he accepts that as a natural consequence for being late. It's a non-issue. The wife in this situation doesn't grovel in frustration or guilt for feeding her kids before her husband gets home. She doesn't feel bad. It's not her responsibility to read her partner's mind and keep dinner indefinitely hot. She is an adult. She can choose to go ahead and serve dinner without him and have no guilt. She knows he will take responsibility and won't get angry at her for not holding dinner for him.

This might seem like a simple example, but I know many women in conservative religious circles who would gasp at the idea of not keeping dinner warm or eating before the husband got home. And they would feel tremendous guilt for doing so. We'll get into the kind of religious propaganda that fosters this sort of thinking in chapter three. But for now, I think this is a good example of the kind of patterns many readers might find normal that really aren't.

Here's another example of how mutual responsibility of two adults in a marriage relationship might look: a husband is grieving over the death of a friend, and in his grief, he begins to grow distant from his wife for a couple of weeks. She lovingly gives him the space he needs and tries to be extra sensitive to what he is going through. She takes on some of his responsibilities around the house and gives

him time to heal. However, he begins to take out his grief on her in subtle, unkind ways. Because their relationship is normal and not pathological, she feels safe in gently letting him know that she hurts for him and wants to help in any way she can, but that she is not comfortable with being treated disrespectfully during the process. Because he is a mature adult man, he listens to her and recognizes the truth in what she's shared with him. He takes responsibility for his snippiness, and he seeks help from a grief therapist to get him through the stages of grief.

Personal responsibility is really just being an adult, and a healthy normal marriage requires two of those to work.

MUTUAL SUBMISSION

You may have been taught that the Bible teaches wives to submit to their husbands. If you're in a destructive marriage with someone who is threatened by your personhood, you may have had that verse drilled into your head every time you dared to use the voice God gave you. But did you know the Bible teaches submission in a beautiful, multi-layered way? Some folks like to pluck out just one verse about submission and ignore all the others. How like the enemy to take a holy mystery, twist it, and use it to oppress God's children.

What does the Bible say about submission?

> *Therefore do not be foolish, but understand what the will of the Lord is. And do not get drunk with wine, for that is debauchery, but be filled with the Spirit, addressing one another in psalms and hymns and spiritual songs, singing and making melody to the Lord with your heart, giving thanks always and for everything to God the Father in the name of*

> *our Lord Jesus Christ, **submitting to one another** out of reverence for Christ. Wives, **submit to your own husbands**, as to the Lord.* (Ephesians 5:16-22)

And this:

> *"What causes quarrels and what causes fights among you? Is it not this, that your passions are at war within you? You desire and do not have, so you murder. You covet and cannot obtain, so you fight and quarrel. You do not have, because you do not ask. You ask and do not receive, because you ask wrongly, to spend it on your passions. You adulterous people! Do you not know that friendship with the world is enmity with God? Therefore whoever wishes to be a friend of the world makes himself an enemy of God. Or do you suppose it is to no purpose that the Scripture says, "He yearns jealously over the spirit that he has made to dwell in us"? But he gives more grace. Therefore it says, "God opposes the proud, but gives grace to the humble." **Submit yourselves therefore to God.** Resist the devil, and he will flee from you. Draw near to God, and he will draw near to you. Cleanse your hands, you sinners, and purify your hearts, you double-minded. Be wretched and mourn and weep. Let your laughter be turned to mourning and your joy to gloom. Humble yourselves before the Lord, and he will exalt you."* (James 4:1-10)

And this:

> *"**Be subject for the Lord's sake to every human institution**, whether it be to the emperor as supreme, or to governors as sent by him to punish those who do evil and to praise those who do good. For this is the will of God, that by doing good you should put to silence the ignorance of foolish*

people. Live as people who are free, not using your freedom as a cover-up for evil, but living as servants of God. Honor everyone. Love the brotherhood. Fear God. Honor the emperor." (1 Peter 2:13-17)

And this:

"***Children, obey your parents*** *in the Lord, for this is right. Honor your father and mother (which is the first commandment with a promise), that it may be well with you, and that you may live long on the earth. And, fathers, do not provoke your children to anger; but bring them up in the discipline and instruction of the Lord.* ***Slaves, be obedient to those who are your masters*** *according to the flesh, with fear and trembling, in the sincerity of your heart, as to Christ; not by way of eye service, as men-pleasers, but as slaves of Christ, doing the will of God from the heart. With good will render service, as to the Lord, and not to men, knowing that whatever good thing each one does, this he will receive back from the Lord, whether slave or free. And, masters, do the same things to them, and give up threatening, knowing that both their Master and yours is in heaven, and there is no partiality with Him.*" (Ephesians 6:1-9)

We see in these passages that submission is for all human beings regardless of gender or position, and here is the list of who we all submit to, according to the Bible:

1. God
2. Husband
3. Parents
4. Masters
5. Human institutions

6. One another

Is submission just for Christian wives as so many believe? I'm not seeing that. Is submission something everyone, both male and female, is called to do? We just read a few verses that tell us YES. It is. Submission is a **voluntary** attitude of respect and cooperation, and it's critical when it comes to quality relationships. Without it we have anarchy and chaos inside, outside, and upside down. Wherever you see peace and harmony, you'll see submission in action somewhere.

Submission is about relationships, love, and what makes the world-go-round with the least amount of chaos as possible. Power-hungry people such as narcissists and some political and religious leaders seek to establish power-over systems in order to control others. That's the wisdom of men, but it isn't the wisdom of God. And by the way, when one human being forces submission upon another, it is no longer submission. Catch that? **It's not submission.** It's control, manipulation, despotism, coercion, and a number of other bad things that don't make for peace, harmony, or quality relationships.

Look at that list again. Who is the most important one on it? Anyone in "authority?" You need to have the answer to that super clear in your head, because we're in a real conundrum if our parent tells us to kill our unborn child. Or if our employer tells us to change up the numbers. Or if our husband tells us to make porn with him. Or if our youth pastor tells us not to tell anyone what we saw him do to our friend the other night. Why, no matter which way we turn, we'll have to disobey God's word, right? Wrong. **Because the only authority that trumps every other authority is God.** There is a hierarchy to these things, and it's not God, then men, and then women and children. Because of the sacrifice of Jesus Christ, all of humanity is now under one authority. The authority of Jesus Christ.

And never, ever forget the bottom line. The bottom line is love. It's always love (Matthew 22:36-40).

> "*Love does no wrong to a neighbor; therefore* **love is the fulfilling of the law**." (Romans 13:10)

> "*And Jesus called them to him and said to them, 'You know that those who are considered rulers of the Gentiles lord it over them, and their great ones exercise authority over them.* **But it shall not be so among you**. *But whoever would be great among you must be your servant, and whoever would be first among you must be slave of all. For even the Son of Man came not to be served but to serve, and to give his life as a ransom for many.'*" (Mark 10:42-45)

> "*Do nothing from rivalry or conceit,* **but in humility count others more significant than yourselves**. *Let each of you look not only to his own interests, but also to the interests of others. Have this mind among yourselves, which is yours in Christ Jesus.*" (Philippians 2:3-5)

Submission, whether you are a wife, a husband, a child, a friend, or an employee, is an attitude of love, respect, and cooperation. God will never tell you to do something hateful or destructive or unloving (although humans may manipulate you to believe you should so *they can get what they want*). You are safe to love, respect, and cooperate *with God* under any and every circumstance.

But humans are a whole 'nother story. And thankfully, the Bible gives us some examples of people who didn't submit to their parents, husbands, masters, government, and fellow human beings because to do so would have meant not submitting to God. And God (along with REAL love) trumps everyone else. Let's look at a few examples:

A wife doesn't submit to her husband and is rewarded by God.

1 Samuel 25—Abigail didn't submit to Nabal. I'm pretty sure he didn't want her to interfere in his refusal to help David, and I'm pretty sure she knew that too, and God rewarded her willingness to do what was right by killing her husband a few days later. (Seems almost scandalous, doesn't it? But do you see the love there?)

A wife submits to her husband and is killed instantly by God.

Acts 5—Ananias wanted to get the credit for giving all his worldly goods to the Church without actually doing it (notice the lack of authentic love). God didn't like all the lying and killed him for it. Sapphira submitted to her husband's plan, and God killed her too. If only she hadn't submitted to her husband, the story would have ended differently.

Some guys don't submit to human institutions, and God approves!

Acts 5— *"And the high priest questioned them, saying, 'We strictly charged you not to teach in this name, yet here you have filled Jerusalem with your teaching, and you intend to bring this man's blood upon us.' But Peter and the apostles answered, 'We must obey God rather than men.'"* (Do you see the love there?)

A daughter doesn't submit to her mother, and God rewards her with a place in the lineage of Jesus Christ.

Book of Ruth—Naomi told her daughter-in-law, Ruth, to go back home. Ruth refused, and she ended up in the lineage of Jesus Christ. (Do you see the love there?)

A woman doesn't submit to the "women keep your mouths shut" rule and blesses the apostles and their ministry.

Acts 16—Lydia (a business owner), after being converted, asked Paul and Co. if they would come and stay with her. The Bible says she "*urged*" them. Then it says "*she prevailed upon us.*" It sounds like she had to ask more than once. She wouldn't take "no" for an answer. If she had been more submissive, she would have backed off, already. (But, do you see the love there?)

By the way, when power-over teachers gloss over Ephesians 5:21 "… *submitting to one another out of reverence to Christ*" and focus on what comes next in Ephesians 5:22 "*Wives, submit to your own husbands as unto the Lord,*" they are completely missing the glorious point Paul just made. In that culture **it was a given** that wives would submit to their husbands. It was a "duh." No-brainer. Paul isn't telling the wives to do what they already do. He's breaking brand new ground by telling *both* the husbands and wives to *submit to one another as brothers and sisters in Christ out of reverence to Christ* while the wives are NOW to do their accepted, cultural submission *as unto the Lord*. In other words, **"Wives, don't submit because of the pagan, misogynistic culture you live in. Your submission NOW is as unto your Savior. Totally different reason. And everyone, including men and women, are to submit to one another. Why? Because you are now brothers and sisters in Christ, and this is one of the ways you show reverence to Jesus Christ who modeled this kind of submission for you."**

So let's sum it up. You know, according to the Bible and not according to a misogynistic bias.

1. Submission is for everyone.
2. Submission is voluntary.

3. Submission is rooted in love.
4. Submission to God trumps submission to humans, which means that...
5. There are times when it is wrong to submit to humans, but...
6. It is always safe and right and to our benefit to submit to God.

I hope you see how mutual submission is essential to all healthy interpersonal relationships, but certainly and especially to a Christian marriage relationship. Manipulated submission of one person to another is based on ***power-over structures that are rooted in paganism***, not authentic love. If that is your reality, then you may be marinating in propaganda designed to dehumanize you and break down your boundaries in order to control you. That propaganda is what we'll look at next.

FOR FURTHER STUDY

» *The Seven Principles for Making Marriage Work* by John Gottman

» *Mutual by Design: A Better Model for Christian Marriage* by Elizabeth Beyer

Check Point

I'm guessing all these things sound lovely to you, but if you're anything like me, you're wondering how all this fits into what you've always believed about marriage. What you've always been taught about male/female relationships and how they best operate.

In chapter three, I want to expose some of the most common beliefs we may have grown up assuming were true just because those over us said they were right and true. If I would have read this chapter myself fifteen years ago, I would have called it heresy. I had to overcome my fear of learning something that might rock my world and shake up my faith in order to find the clarity and peace I desperately needed. I had to study this out for myself, and that's exactly what I did. This so-called *heresy* led me to deeper worship of Jesus Christ for which I'm eternally grateful. (By the way, if it doesn't do that for you, you can always throw this book and these ideas in the trash! My desire for you is that you are rooted and grounded in the love of Christ. That's it. So if this in any way detracts you from Jesus, it's fine to chuck it out. I just ask that you might read it first so you know for sure what you're tossing out, because there is a chance it could transform your life and your relationship with Jesus!)

I now believe I was brainwashed for most of my life by a humanistic way of thinking that has an underlying agenda to power-over other people—**female** people. I

knew God's heart for the human race was not one of establishing a structure in which humanity grasps for more control and power of any kind. I knew Jesus came to show His followers a different way. Yet, I was seeing this power-over ideal being taught in the context of marriage in every church I became part of as an adult. And the fruit I observed was either non-existent, anemic, or rotten to the core. Something was wrong, and I wanted to figure out what it was.

This next chapter uncovers some of what I discovered. Hang in there, because the rollercoaster is at the top of the hill, and we are about to go over the edge. It will be scary, but it's worth the ride.

The Propaganda Machine

WHAT DO YOU BELIEVE?

"I believed I was making him unhappy, and if I could just fix things, he would go back to being the kind man I met."

"I believed if I tried harder, if I sacrificed more, gave more, loved more, I would measure up, and we would have peace and harmony."

"I believed I had made a vow before God, and I had to make it work even if he wasn't keeping his vow."

"I believed if I suffered enough, it might finally be enough to change him."

"I believed it was God's will for me to suffer."

"I believed that I had no right to express hurt over my husband's abuse because I wasn't perfect and also sinned."

"I believed I was not worthy of honor."

"I believed suffering was godly, and God approved when I pretended it wasn't happening. Overlooking sin was my Christian duty."

"I believed to obey my husband was to obey God. They were equivalent."

"I believed that God could change him if I just prayed hard enough and gave it enough time."

"I believed I would be a failure if I gave up on the marriage."

"I believed if my husband was unhappy with me and my performance, God was unhappy with me too."

"I believed he had potential, and I was going to be the person who made the difference in his life."

"I believed I needed to keep his cruelty toward me under wraps or I'd be disrespecting my husband."

"I believed if I was more fun, sexier, prettier, and skinnier, he would love me."

"I believed my faith was responsible for his heart and behavior. If he was being abusive, I must not have enough faith."

"I believed I needed to be prepared to die at the hands of my spouse if need be. This was my Christian duty."

"I believed I needed to forgive even though he was never sorry, and I must never bring up how much it hurt."

"I believed all our marriage problems were my fault in one way or another."

"I believed nobody would believe me."

"I believed I would lose my church, my family, my friends, and my emotional and spiritual support if I told the truth about what was happening to me."

"I believed if I left, God wouldn't love me anymore."

"I believed every desire should be fulfilled in Christ alone, and it was wrong for me to expect love and kindness from my partner."

"I believed I made my bed, and now I had to lie in it. No way out."

"I believed the millions of painful incidents were not enough to warrant leaving. I could only leave if he

did something huge, like beat me up. I used to pray he would."

—Quotes from Emotional Abuse Survivors

WHAT IS PROPAGANDA?

"The Bible, from its opening chapters, pictures woman as allied with God, in the eventual salvation of the world; paganism represents her as allied with the devil, for the ruin of man; this is one great mark of distinction between the true and false religions."

—Katherine C. Bushnell, *God's Word to Women*

Propaganda is biased information spread within a closed group in order to influence the group to believe or behave in specific ways. For example, in World War II, Hitler spread propaganda over the course of several years that influenced the German people to buy into his idea that some people were more deserving of life and liberty than others. His propaganda plan was so effective that he was able to murder millions of Jews while his countrymen either helped or looked the other way.

During the Civil War, some Bible-believing white people believed black people were created to be enslaved by whites. It was God's order of things, so they said, and they believed they had Bible verses

like Ephesians 6:5 and Titus 2:9 to back them up. (I can almost hear their battle cry: "It's BIBLICAL!")

Just like any tool, propaganda can be used for good or evil. It's obvious to us now, many years later, that Hitler and the southern slave-owning Christians were pushing their own prejudiced agenda, but what about today? Where do we still see injustice toward a segment of the human race? And who is spreading propaganda related to the subjugation of that segment?

I believe we see propaganda in the conservative, evangelical Christian church. And the target? Women. Misogyny, the prejudice against women, is alive and well in the conservative Christian church. It's hate disguised as spirituality and godliness.

Propaganda is a way of slipping bad thoughts and ideas into the collective consciousness of a group of people by presenting those thoughts and ideas as appealing and good and right. It takes an unpalatable belief system (hate Jews, hate blacks, hate women) and hides it behind Bible verses and nice sounding patriotic or religious language until enough people believe the hate is actually justified and even loving. Plus, religious propaganda will claim *God is the author of their agenda*, so it must be right. Right?

Always remember that good words can hide evil intentions. Satan is notorious for taking God's words and using them to destroy human lives. He did it in the garden, and he tried to do it to Jesus in the wilderness, and he'll do it to you and me. *Just because someone is using God's words doesn't mean they speak for God.* Question the intent behind the words. Is the intent to control people's choices and push a power-over agenda? Or is the intent to apply the love and safety and freedom of the gospel of Jesus Christ to a situation?

"Woe to those who call evil good and good evil, who put darkness for light and light for darkness, who put bitter for sweet and sweet for bitter!" (Isaiah 5:20)

Closed groups form their own set of beliefs and often discourage members of the group from reading and learning outside of their group's own set of books, classes, schools, and favored news stations. Why do groups do this? How does this serve their community well? I believe they do it out of pride, shame, fear, and greed. They believe they are superior. They don't want to lose control of the people within their group. Humans from the very beginning of time have tried to be more than human (god-like) by grasping for power, control, and superiority as a way of covering their shame and fear. Whenever you see control happening at any level, whether it is controlling a woman's life within the four walls of her home or controlling the information that is allowed to be accessed by a group of people, the goal is always about gaining power over others.

This is the world's way. But is it God's way? Why do Christians need to cover up their humanity by trying to be like God? Why do they continue to be afraid of losing control of other people? In their grasping for power and control, the conservative Christian church demonstrates their ignorance of the Gospel of Jesus Christ and the New Covenant way of living that Jesus came to make possible. Jesus came in human flesh to show us that we don't have to be ashamed of our humanity. We don't need to be like God. We can be united with God through Jesus Christ, but He didn't force people to come to Him. He loved them and extended His warm invitation. That's it. He respected the autonomy He put within each one of His created human lives. He lets us choose to worship ourselves as gods (pursue power-over) or to worship Him (acknowledge that we are not God).

And when we embrace our humanity and worship Him, there is no need for power-over anymore. Jesus shattered hierarchy.

In light of this, should the church be controlling the beliefs of the people? Should they be discouraging their people to remain ignorant of the ideas and experiences and beliefs of those outside their group? Was Jesus ignorant of these things? Did He set up a system, like that of the world, in which some humans control others? Is the church just another disseminator of its own propaganda in order to control people and access their loyalty and their wallets?

In this chapter, we will do a basic survey of some of the most prevalent theories in conservative thinking (and in the history of the world as well) about men, women, and marriage that contribute to the subjugation and abuse of women in the church.

TRADITIONAL BELIEFS ABOUT MEN, WOMEN, AND MARRIAGE

There are traditional views about men, women, and marriage, and then there is God's view of men, women, and marriage. We're going to look at how the conservative church has adopted the traditional views rather than embracing the Gospel view. Then we'll venture some guesses about what motivates the church to promote the traditional views and how those views contribute to emotional and spiritual abuse in Christian homes and churches.

Stereotypes of men and women have existed throughout history, having a crushing impact on both sexes by pitting the sexes against one another. Cultures have traditionally placed men in the role of protector, provider, controller, leader, fighter, and conqueror. They are raised to be tough, logical, and stoic. Women, on the other

hand, are placed in the role of supporter, submitter, adapter, and nurturer. They are raised to be soft, quiet, and dependent. Our world views men as being insensitive, afraid to commit to a relationship, and more interested in their career than in parenting. The world sees women as being more emotional, interested in marriage and motherhood, more child-like, and irrational. These generalizations are so woven into the fabric of our culture we aren't aware of them or how they adversely impact individual human lives. It sets up an environment of competition and disdain for the opposite sex, and it's a petri dish for the rapid growth of abuse. This **isn't** God's design for the human race.

Let me be clear. I'm not proposing that stereotypes are the **cause** of abuse. There are perfectly healthy couple relationships that function within stereotypical ideas and roles, and each couple has the right to choose for themselves how they want their relationship to work for them. I'm saying deeply rooted stereotypes are the reason our culture and the conservative Christian church *refuse to address and correct abuse.* If a woman comes forward to get help for her destructive marriage, the accepted stereotypical belief of those around her may be that she should respect her husband, so to air his dirty laundry would be disrespectful. They may believe women tend to be overly sensitive, and therefore her pain over the way her husband chronically mistreats her is overstated and not rooted in reality. She just needs to get a thicker skin. Or they may believe men are incapable of being tender-hearted and vulnerable, and therefore her desire for kindness and tenderness is unrealistic, and she needs to shut up and accept her man just the way he is. And so she will continue to suffer in silence, having been shut down by traditional stereotypes found in her religious and social circles.

"I was led to believe by the men in my life, including my husband, that any disagreement, my opinions, my wanting change, or wanting anything for myself were all signs of female control. That I was being controlling if I didn't like what he was doing or saying. That it was typical female behavior to be unhappy with the man. I tried so hard not to be *that woman*—to never appear controlling or unhappy."

"Growing up, I learned in church and especially from my parents that: (1) the well-being of the marriage was the wife's responsibility, (2) her happiness and fulfillment depended on how well she could keep her husband happy and fulfilled, (3) his needs, wants, and opinions mattered more than hers, (4) if he wasn't loving or kind, then she could make him be by being a good enough wife, (5) her role was to support him, encourage him, be there for him, and not expect anything in return, and worst of all, (6) if she was unhappy, then it was because of her own failures as a wife. In other words, IT WAS ALL HER FAULT, which meant if she could just somehow do it right, then she could make him love and adore her (the carrot we all strived so hard to reach). But if he wasn't affectionate to her, it was because she was doing it all wrong (the stick that nearly beat us to death)."

"The goal is to fight you, but you get your hands tied behind your back. The playing field isn't equal because you are a woman."

—Quotes from Emotional Abuse Survivors

As studies and statistics provide us with information in this area, our current culture is slowly changing in regard to gender stereotypes. However, the conservative Christian church along with other religions is falling far behind. Here's how former president Jimmy Carter puts it in his speech to the Parliament of the World's Religions, given on December 2, 2009.

"It is ironic that women are now welcomed into all major professions and other positions of authority, but are branded as inferior and deprived of the equal right to serve God in positions of religious leadership. The plight of abused women is made more acceptable by the mandated subservience of women by religious leaders.

The truth is that male religious leaders have had – and still have – an option to interpret holy teachings either to exalt or subjugate women. They have, for their own selfish ends, overwhelmingly chosen the latter. Their continuing choice provides the foundation or justification for much of the pervasive persecution and abuse of women throughout the world. This is in clear violation not just of the Universal Declaration of Human Rights but also the teachings of Jesus Christ, the

Apostle Paul, Moses and the prophets, Muhammad, and founders of other great religions – all of whom have called for proper and equitable treatment of all the children of God. It is time we had the courage to challenge these views and set a new course that demands equal rights for women and men, girls and boys.

At their most repugnant, the belief that women are inferior human beings in the eyes of God gives excuses to the brutal husband who beats his wife, the soldier who rapes a woman, the employer who has a lower pay scale for women employees, or parents who decide to abort a female embryo. It also costs many millions of girls and women control over their own bodies and lives, and continues to deny them fair and equal access to education, health care, employment, and influence within their own communities."

For several years now I've been talking to people who were deeply involved in conservative Christian culture most of their lives, and I've asked them what they perceive are the most commonly held beliefs in the conservative Christian church about men and women. Here are their answers:

WOMEN

- Women are emotional and therefore tend to make rash decisions.
- Women don't want sex as much as men do.
- Women need love, but respect is for the men.
- Women are to submit to their husbands no matter what.

- Women belong to their fathers until marriage, and then they belong to their husbands.
- Women are created to be keepers of the home. If a woman pursues a career outside of the home, she is disobeying God.
- Women are one-down from men—second in command.
- Women must like female colors, wear skirts, and have long hair.
- Women stumble men with their bodies, therefore they must keep themselves covered up. How covered up depends on the church you go to.
- Women who have opinions that differ from the men in their lives are rebellious.
- Women who bring up a problem are like a dripping faucet.
- Women can work in the church nursery, but they cannot teach a man.
- Women are subordinate to men.
- Women should not be in leadership positions.
- Women aren't allowed to have boundaries.
- Good women cooperate, accept, smile, and submit sweetly and quietly. Bad women point out problems and make trouble.
- Good women please their husbands and obey them like children obey their mommies and daddies.
- Good women don't try to learn more than their husbands do about theology. Being educated and well-read will only make their husbands feel inferior. (And it's all about keeping the women in that place, right?)

Men

- Men are rational and logical and by their very nature make good leaders.
- Men are created to be heads of state, heads of the church, and heads of their homes.
- Men require respect.
- Men need sex—lots of it. It is their right to have it.
- Men aren't natural nurturers and shouldn't be expected to be nurturing. That's weak, and men should be strong in every way.
- Men should oversee and be responsible for what their wives do at home and how they parent the children.
- Men require obedience and submission in order to feel respected and motivated to do their manly things.
- Men are required by God to make sure their wives and children submit to God by submitting to him as their head.
- Men need to make sure their wives aren't getting too uppity and knowledgable. They might become rebellious.
- Men make better decisions, but when they feel it is appropriate, they can get help from their wives as long as she understands that his word is final.
- Men are qualified to teach anyone by virtue of their manhood.
- Men have more important things to do than babysit their kids and contribute to the housework. They have KINGDOM work, after all.
- Men must not show weakness. To acknowledge mistakes or sin is weakness and will bring down a man's ego and destroy him.

- When a husband and wife come to an impasse, the husband gets the final say because he is God's anointed head of the home.

I'd like to share some quotes by famous men who have influenced many conservative religious people today. It's tragic that the love and submission of all God's children, both male and female, to Him and to one another has been replaced with these ugly ideas which are still upheld (though in more palatable language for our modern culture) to this day.

> *"In pain shall you bring forth children, woman, and you shall turn to your husband and he shall rule over you. And do you not know that you are Eve? God's sentence hangs still over all your sex and His punishment weighs down upon you. You are the devil's gateway; you are she who first violated the forbidden tree and broke the law of God. It was you who coaxed your way around him whom the devil had not the force to attack. With what ease you shattered that image of God: Man! Because of the death you merited, even the Son of God had to die... Woman, you are the gate to hell."* —Tertullian, (c160-225)

> *"Woman does not possess the image of God in herself but only when taken together with the male who is her head, so that the whole substance is one image. But when she is assigned the role as helpmate, a function that pertains to her alone, then she is not the image of God. But as far as the man is concerned, he is by himself alone the image of God just as fully and completely as when he and the woman are joined together into one."* —Saint Augustine, Bishop of Hippo Regius (354-430)

I've been immersed in conservative Christian culture since I was seven years old, and this is just the tip of the iceberg. These ideas are often backed by single verses pulled out of Scripture for the express purpose of proving that God supports them. It's beyond the scope of this book to get into the theology behind their "male trumps female" theories, but I will list resources throughout this book that will expose you to the perspectives of other theologians who have studied the original languages used in these Scripture passages along with their historical context. Be prepared to have your mind blown in a glorious new way that will inspire, not fear and horror, but deep worship of Jesus Christ and renewed respect for the Word of God.

Please remember that just because someone is a theologian and has a PhD after their name doesn't make them infallible or give them the final say on a matter. There is so much more to learn than what we've been taught. I encourage you to do your own studying rather than just learning your denomination's perspective. As children we believe what our parents taught us, but as adults we are responsible to do our own research, and that means reading outside our established circles. If we choose to continue to believe the things we were raised in after we've actually studied different perspectives, then we will be more firmly grounded in our own choice of beliefs rather than just going along with the crowd around us. Don't be afraid to deconstruct your belief system. You can trust God! Give God a chance to teach you personally what He wants you to know. You have the same Holy Spirit within you that other Christians have within them. There is no place for fear. He's got you no matter where your journey takes you.

Knowledge is not the enemy. The truth sets us free.

THE BIBLE AND HIERARCHY

Since both men and women were created in the image of God, we can know God's view of the human race by simply looking at who God is, how He revealed Himself through Jesus Christ, what His agenda is in this world, and how men and women play a role in that agenda. Then, all we have to do is decide if this over-arching vision of God for His world fits in with the traditional views a few conservative men like to promote. Let me break this down so it's super clear.

1. A minority group of people promote the view that men belong in power-over positions related to women. They have plucked a handful of choice verses translated by misogynistic men that seem to verify their hierarchical belief system. And they have predictably claimed God's approval of their power-over system.

2. Their claim that God approves of their system makes it seem right. I mean, if God approves, who can argue with that? And why try? They are the ones that went to school and studied theology in their denomination's seminary. They know best.

3. If they are right, and God really does approve, the entire over-arching message of the Bible will back up their belief system. We will see Bible themes pointing to the blessed goodness of this power-over system of hierarchy (patriarchy). We will see examples of Jesus teaching it and modeling it and sending humans out in the world to do the same. We will see examples of how this power-over hierarchy structure sets the entire human race up for humble love of God and love of neighbor. We'll also see the power of this model in the world today. We'll see how the Gospel goes out in greater fullness and authentic-

ity **because** this beautiful system of hierarchy is in place and shouts the love of God to the lost world. If patriarchy is God's original plan for the human race, we would see the root begin at creation and the good fruit of it harvested wherever it exists today.

4. If we **don't** see these themes playing out in Scripture, and we **don't** see the Gospel of Jesus Christ going out in greater fullness because of the beauty and holiness of patriarchy, then we need to examine more closely the handful of verses this small group of conservative theologians have taken as their proof texts. We need to figure out what they are actually saying if they aren't saying what a few theologians say that they're saying. Do you know what I'm saying?

So let's do it. Let's look at the themes in Scripture that reveal who God is and what His agenda is for the human race. Please be looking for hierarchy themes where some humans are supposed to have power over others in order for the gospel to be effective in the world today.

CREATION

God created male and female in His image, gave them both dominion over the earth, and pronounced the whole thing *very good* (Genesis 1:27-31). In Genesis chapter two we see God bringing man and woman together to be one flesh. **So far, no hierarchy.** Just unity. Oneness. Mutuality. Love. We see man and woman as allies. (Some will argue that Genesis 2:18 says Eve is a *"suitable helper for him,"* but we'll talk about what this verse is really saying about Eve in chapter seven.)

SIN

The first man and woman sin. Guess what their sin was? ***Hierarchy.*** The grasping for rule. It was the sin of the devil himself. They wanted to be like God, knowing good and evil. And the consequences? Instead of both male and female worshipping God, the woman would worship her husband (*"your desire shall be toward him"*) and the husband would rule over his wife (*"he shall rule over you."*) This wasn't a prescription for healthy living. It wasn't what God intended. This was a pronouncement of ***the curse*** they would gravitate toward as fallen human beings living ***outside*** of God's ways. ***Patriarchy is a curse.*** It's in opposition to God's original design. But maybe humans can dress it up and make it look godly so they can feel good about themselves instead of submitting to their Creator's design for them. Let's keep going and find out.

MORE AND MORE SIN

All throughout the Old Testament we see power-over themes. Cain killing Abel. Abraham forcing his wife to sell her body to Pharaoh to purchase his life. Abraham forcing a servant to have sex with him to produce an heir. David raping a woman and then killing her husband just because he was in the mood for sex. Pharaoh enslaving God's people. Solomon taking hundreds of women as wives and letting them languish their lives away in harems. Kings taking what they want because they are kings. Husbands getting sick of their wives and divorcing them without cause, leaving them destitute without divorce certificates that would enable them to remarry and be financially and emotionally cared for. And we're just scratching the surface. Hierarchy, so far, is not set up as a model for worship of the Living God. Instead we see the Bible exposing it for the life-de-

stroying, soul-destroying force it really is. The Old Testament shows that hierarchy is from the devil. But maybe the New Testament tells a better story of hierarchy. Maybe God will do a miracle and set up hierarchy as the answer for the world's problems.

ENTER: JESUS CHRIST

So now we've got God Himself on earth. He revealed His plan to a teenage girl, not her parents. He entrusted the gospel to a Samaritan woman. He disobeyed religious leaders and called them out for who they really were. Concerning authority, He said this: "*The one who speaks on his own authority seeks his own glory; but the one who seeks the glory of him who sent him is true, and in him there is no falsehood.*" (John 7:18) Jesus tells the Pharisees they judge by the flesh (hierarchy—John 8:15). He called fishermen, prostitutes, drinkers, and tax collectors to Himself. He said whoever wants to be great must be a servant of all. He came to this world as a poor bastard child and left as a criminal. Yeah. I'm not seeing a whole lot of hierarchy in the life of Jesus. He's definitely not the poster child for the defenders of patriarchy. With the advent of Jesus Christ, God ushered in a New Covenant in which the old, sinful, worldly order of hierarchy and patriarchy were replaced with loving unity and oneness in Christ between all humans regardless of race, gender, or socioeconomic status. ***This is the good news of the gospel.***

> *"There is no longer Jew or Gentile, slave or free, male and female. For you are all one in Christ Jesus."* (Galatians 3:28)

> *But Jesus called them together and said, "You know that the rulers in this world lord it over their people, and officials flaunt their authority over those under them. But among you*

it will be different. Whoever wants to be a leader among you must be your servant, and whoever wants to be first among you must become your slave. For even the Son of Man came not to be served but to serve others and to give his life as a ransom for many." (Matthew 20:25-28)

NEW TESTAMENT

So Jesus flipped the world's sinful system of hierarchy upside down. But maybe Paul will be able to twist it back around? Nope. Instead, he further fleshes out Jesus' radical restoration of unity and servant-hood, dismantling the trappings of hierarchy.

Remember, patriarchy was assumed in the culture from which the New Testament writings come. When Paul taught Christians (all Christians, not just a certain gender) to love one another, submit to one another, and all the other *one anothers* we've discussed earlier, this was brand new and probably a bit of a shock at the time. The entire New Testament is the way in which Jesus re-establishes God's Kingdom in individual human lives. And as His people turned away from pride, greed, fear, hate, shame, and the hierarchy that spawns those things, they would change the world.

THE CHURCH TODAY

There is organized religion made up of church buildings owned and operated by church leaders. And then there is the organic, living, and breathing Church of Jesus Christ, made up of human beings of both genders and every race on planet earth. Organized religion is predictably steeped in hierarchy, but the Church of Jesus Christ is the exact opposite. The true followers of Jesus Christ embrace all

of humanity and seek mutual love, respect, honesty, vulnerability, responsibility, and submission. True Christianity is an invitation to the fearless, shameless, audacious, courageous love of Christ and neighbor. It's not a closed group of rule-keepers and gate-keepers. You can be rejected by organized religion if you don't comply with their agenda. But you will never, *ever* be rejected by Jesus Christ and His people. It's one of the ways you can easily tell the difference between the two!

Hierarchy defines the world's broken and dysfunctional system. But hierarchy is not part of God's Kingdom. If we are God's people, we will reject the world's system of hierarchy and walk in the ways of our Savior, Jesus Christ. **This includes rejecting hierarchy in the most intimate of human relationships: marriage.**

WHAT GOD SAYS ABOUT MEN, WOMEN, AND MARRIAGE

Marriage was designed by our Creator to be a life-giving force in the world. Paul describes it as a beautiful metaphor of the oneness and unity of Christ and the Church. **But this oneness and unity is dependent on mutuality, not power-over.** It's about two coming together in love, not one forcing himself on the other. The enemy hates God, and he wants to make sure humans do not know the truth about who God is. Since the beginning of time, people have been tempted to believe God does not love them. That He is an exacting god seeking tyrannical rule over them. That they need to somehow protect themselves from such a god by their own efforts at perfection and rule-keeping and god-pleasing. (Hey, wait a minute. Does this sound like your marriage?) Destroying the picture of

oneness and unity in relationships and exchanging it with the lie of power-over and hierarchy is the enemy's magnum opus.

If there is one thing I want you to take away from this chapter, it is this: *an abusive marriage tells a lie about God.*

And that, right there, is blasphemy. Blasphemy is lying about God. If God is good, it is blasphemy to say He is wicked. If God is holy, it is blasphemy to say He is impure. Likewise, when the enemy takes something beautiful that God created and twists it into an ugly picture of neglect, control, and abuse, and then says "this is what God wants," that's a blasphemy toward God. It's like spitting in God's face before the entire human race. No wonder unbelievers want nothing to do with this image of God. When Christians enable abuse and coddle abusive individuals, they blaspheme God and undermine the gospel in the world. That's how serious this is.

But how did we get to the place we are today, where it's actually accepted practice for men in Christian homes to rule over and control their intimate partners? **Propaganda.** Conservative Christianity has adopted the world's view that within marriage, men must play a power-over role. They have taken God's Word and pulled out a few proof texts in order to develop a theology of men, women, and marriage that fits into their desire to rule over the daughters of God. They use a dressed up word called *headship* for the role of men. Women, on the other hand, must play the power-under role. They call her a *helper* (which, as we'll discover in chapter seven, isn't quite what the original word meant).

In a few situations, a patriarchal marriage can work from a pragmatic standpoint. If the husband happens to be a kind, loving man who chooses to connect intimately with his wife, treating her as a true partner and companion, and if the wife is naturally more of a

follower and feels safe to be herself in the relationship, then this way of life may work for them as a couple, because **in actuality it is a marriage of mutual love and mutual respect**, and there is a lack of power-over dynamics, even though they may claim otherwise. I've seen many mutual marriages in which the partners will say, "*I am fulfilling my power-over headship role*" and "*I am fulfilling my power-under helper role.*" And neither one is doing any such thing. They are both involved participators in a mutually loving and respectful relationship. I say let's be honest and call it what it is. To claim otherwise is again, to tell a lie. And lies only hurt the human race and the Gospel.

The fact is that patriarchal marriages with power-over and power-under roles only work under very specific conditions. The reality is that not every man is kind and good, not every man is wired by God to be a leader, and not every woman is created by God to be a follower. God is bigger and more creative than that. People are more unique and nuanced than that.

This spiritually glamorized power-over system creates an uneven power dynamic where a sinful man can strip a woman of her dignity, her voice, her thoughts, and her personal boundaries **with the blessing of his church.** After all, he is her head. Her role as helper is to humbly bow beneath whatever he chooses for her. If he is a tyrannical despot, it is her Christian duty to suffer under his oppression as his wife. If she dares to speak against his behavior, her credibility as a Christian woman is called into question, and she is labeled a prideful, unforgiving, rebellious woman. Another problematic belief in conservative Christian thought is that females are a stumbling block to men. They are the perpetrators and therefore cannot possibly be the victims. **Do you see how this story of marriage tells a horrific lie about the character of God?**

As we've seen, the Bible tells a different story. My rule of thumb is that if a belief system isn't saturated with the gospel of Jesus Christ and doesn't accurately reflect what the Bible teaches us about God, then it isn't a Christian theology. Pharisaism isn't Christianity, nor is the patriarchal, power-over system of marriage it promotes. God revealed His better plan of mutuality in the New Testament, and **that** is the marriage model He designed and blesses.

FOR FURTHER STUDY

» *God's Word to Women* by Katherine C. Bushnell

» *The Equality Workbook: Freedom in Christ from the Oppression of Patriarchy* by Helga Edwards MSW and Bob Edwards MSW

» *The Black Swan Effect: A Response to Gender Hierarchy in the Church* by several contributing authors

» *Vindicating the Vixens: Revisiting Sexualized, Vilified, and Marginalized Women of the Bible* by Sandra Glahn

Check Point

That may have been a lot to take in, and you may have more questions than answers at this point. Hang in there, because this ride isn't over. I will explain things in greater detail when we get to chapter seven, but for now, we are going to shift gears a bit and talk more about what you've been experiencing in your own marriage.

The next three chapters may be extremely painful to read. You will likely see things in black and white that you've spent many years trying to pretend didn't exist because they just hurt so bad. One of the ways we protect ourselves is by living in denial about how bad things really are, and the next three chapters will dig up a lot of what we don't want to look at. When you read things that are particularly painful, make note of it. Those are likely areas where you're experiencing abuse.

If it's too much, read a small section at a time. Give yourself some space to process. I remember reading a book about verbal abuse that had me ugly crying through every chapter. It was horrible. But it was also a defining moment in my life. If you can walk through this pain, you may discover some answers on the other side.

Are you ready to begin? I'm with you here. And more importantly, Jesus Christ is right next to you in every page. Deep breath. Here we go.

His Role

CONFUSING? OR SOMETHING MORE?

The title of this book probably drew you in with the word *confusing*. You are reading this book because your marriage makes no sense, and you want to make sense of it. You also wonder if the problem is you, and if so, you'd like to know what you can do to fix yourself so the problem will go away. It's painful, and you'd do anything to get relief. To have resolution. To find some peace.

Now that you've made it through the first three chapters, you may be wondering if your marriage isn't just confusing, but actually destructive. Even abusive. It's hard to use that word, *abusive*, to describe your marriage. After all, your partner maybe doesn't hit you. He may not swear or call you names. He does nice things for you. He may play with your kids. He may be a good provider. He may be a deacon at your church and a leader in your community. He may take you on nice trips to pretty beaches. I hope you'll keep reading because we are going to look more closely at what abuse actually is. Many Christians have no idea, and that needs to change. For the sake of the Gospel and for the safety and well being of women and children, that absolutely needs to change.

In the next four chapters we'll be looking at the roles everyone plays in a destructive marriage: your partner's role, your role, your church's role, your counselor's role, your family of origin's role, your friends' roles, and your pastor's role. We need to understand how a destructive marriage grows, is nurtured, and is perpetuated by all of these different players. Then we'll look at God's role. What is His involvement in a toxic marriage? If we claim to be followers of Jesus Christ, we need to be in alignment with His perspective of destructive marriages, the people in destructive marriages, and the people who support and enable destructive marriages.

Let's begin by looking at the role your partner plays.

HIS BEHAVIOR

> "He undermined my intuition and perceptions to get me to doubt myself so he could get control."

> "He made excuses for his bad behavior, saying he had an anger problem, addiction, and mental health issues. I was supposed to understand and get over it."

> "He criticized my parenting to the point where I thought if only I was dead, my kids might end up with a better stepmom."

"He would turn and walk away when I caught him in one of his lies. He threatened cruel punishments for the kids to get me to say 'No way!' so he could accuse me of not submitting to his leadership."

"He had no empathy or care for me. He pretended things happened that didn't and would say things didn't happen that did. He lied all the time, but I couldn't prove most of them."

"He constantly accused me of the exact behaviors he himself was doing. I thought I was going crazy."

"I think he truly believed his own lies. He was so convincing."

"My husband would give me the silent treatment and ignore me. I didn't even realize how it was destroying my personhood and sense of self-worth."

"Behind my back he would tell church leaders and then my friends all kinds of craziness so that if and when I

asked for help, they were conditioned to believe I was the abusive one."

"He called me a delusional liar and alienated my children and grandchildren from me."

"He was very skilled at silently communicating his disapproval and condemnation with his facial expressions, body language, and tone."

"He would verbally abuse me and then expect me to carry on like everything was fine. If I told him things were not fine, he'd accuse me of making a big deal out of nothing."

"He wouldn't show concern when I was physically injured. He would say hateful things to me and then say it was for my own good."

"While I was pregnant or nursing a baby, he was crabby and distant, accusing me of loving the baby more than him."

"I never saw him show remorse about anything he did."

"He said such horrible things to me. I used to beg God to make him hit me so I would have a valid reason for getting help."

"He got everyone to believe his story. I had to figure things out by myself without any spiritual or emotional support. It was the darkest time of my life."

"The best apology I could get was, 'I'm sorry you thought that happened to you.'"

"All he loved about me was my ability to serve him. He constantly demanded more and more of me while I had to demand less and less of him."

"He acted nice in front of other people but was a completely different person at home."

—Quotes from Emotional Abuse Survivors

There are specific behavior patterns we see in men who are emotionally and spiritually abusive. Let's look at five categories of typical behavior.

1. Deception

An emotionally abusive man is a master deceiver. He will sometimes just outright lie about stuff, and he is capable of doing this with a straight and sincere face and with no remorse. But more often he will deceive you by omitting the information you need to fully understand a situation, twisting the truth slightly so it's misleading, or feeding you a half-truth/half-lie to confuse you and plant doubt in your mind. Many emotionally abusive men lead double lives. They teach Sunday school in the morning and view porn at night. They lead spiritual devotions at the breakfast table and push emotional buttons at the dinner table. They raise their hands in worship at church and raise their hands in anger at home. His entire existence is a facade that leaves you feeling confused, uneasy, and hypocritical yourself as you cover it all up to protect his private ego and public reputation.

Another common deception technique he will use is called gaslighting. This is one of the most devastating and traumatic ways he fools you and others, and it involves denying your reality or experience about something. So if you remember him committing to something, he will say he never committed to that. Or if you remember an incident going down a certain way, he will say your memory is false. Even if you have proof or witnesses to something, he will deny it and say it isn't so. His reality and his memory are all that count, and you can bet it will play to his favor and to your destruction every time.

Some men do this on purpose to toy with their intimate partners. Some are just so caught up in their own myopic, skewed view of reality that they literally believe it's true even in the face of evidence to the contrary. Regardless of why they do it or how much or how little they are aware of what they're doing, when this happens over and over throughout the course of a relationship, the target begins to feel that she is going crazy in her head. It creates brain fog and psychological stress that can be debilitating.

2. **Denial of Responsibility**

Abusive individuals will not take personal responsibility for their behaviors. When confronted, they will employ one of the following tactics:

- Deny it—"I didn't do that/say that/show that! That never happened! You are making stuff up in your head again—just looking to start an argument. You're such a nag!"
- Minimize it—"You're making a mountain out of a molehill. It wasn't a big deal. Why are you always so nit picky?"
- Justify it—"I didn't get the memo. It wasn't my fault. My phone ran out of batteries. It wasn't my fault. The other driver stopped too fast, and that's why I rear-ended her. It was her fault. Why do you have to be on my case all the time? I'm doing my best, and all you ever do is complain and whine."
- Blame-shift—"Well if you hadn't done such-and-such, that wouldn't have happened. It's actually your fault. Grow up and take responsibility for yourself. If you hadn't made me so mad, I wouldn't have lost it with you. It's your fault."

I hope you noticed something else about those examples because part of your healing will require you to pay attention to this dy-

namic in your own marriage so you can identify it and respond to it appropriately. ***Did you see how he applied the tactic and then got the focus off himself and his behavior and onto you?***

And how do you typically respond when he uses this strategy? Do you feel guilty and try to apologize? Do you feel defensive, take the bait, and defend yourself? This is exactly why these verbally abusive tactics work so well for him. Once he's got the focus on you and your response, he's off the hook, and you get the unspoken message to never, EVER confront him about his behavior. You won't see him come to a place of conviction or remorse over the pain he caused you. This is the pathology of abuse, and it destroys the very core of the target's identity and personhood.

3. **Inability to Empathize**

An emotionally abusive person is chronically unable to put himself in someone else's shoes in order to experience something from the other person's perspective. This is why, when you express pain or joy or fear about something, he will not respond in the way you'd expect. Normally, when we express these things to another person, they are drawn into our experience and have empathy for us and our reality. They can step outside of their own experience to join us in ours. This is how intimacy and trust is created between people, and it's healthy and normal.

But when you express pain or joy or fear with an abusive person, they don't join you there. In fact, they do the opposite. They ignore your experience. They criticize your experience. They deny your experience. They minimize your experience. They mock your experience. Why? Because it's all about them. Their reality is the only reality that counts. They believe your experiences simply do not matter. In their mind, you are not worth listening to. You are beneath them.

Inconsequential. Why should you have a voice that they ought to attend to? Your mind belongs to them; they expect their reality to be yours, and they are offended when you express anything differently.

This is not to say that they can't mimic empathy when it serves their purpose. For example, if a toxic person wants something from you, he will pretend to care, to understand, and to be interested. You crave this. It feels far more normal than his usual dehumanizing behavior. So you take the scraps he throws you in the hope that he really is the person you thought you married. But once he has what he wants, it's back to his disconnected treatment of you because **at a core level he doesn't believe your experience and your personhood are worth anything.** If he apologizes, which is rare, it is never about the impact his behavior had on you as a person. It is only a half-hearted "*I'm sorry if you got hurt*" non-apology. Bottom line: he will not be there for you when you need him, and he will throw you under the bus without blinking an eye if it helps him manage his image. You are nothing to him but a possession whose purpose is to give him what he wants, when he wants it.

4. Control

The definition of abuse is when one person has power and control over another person. Conservative Christian circles often deny that a woman is being abused unless she has visible marks on her body, and even then they tend to be skeptical. I've heard it over and over. "*My pastor says I'm not being abused. Emotional abuse isn't a thing.*" That's like a history teacher giving his opinion about a specific brain surgery operation. He doesn't know what he's talking about, but even worse, he pretends he does. Abuse is all about power and control. Not bruises. There are many kinds of abuse, but we are addressing emotional and spiritual abuse in this book, so you need

to know how emotional and spiritual abuse are exercising power and control over you.

A man's belief that he has the right to control you comes from many places including his own upbringing, experiences, attitudes toward women, and theology. The fact that his theology supports a power and control model of male/female relationships gives him even greater power because he claims to have the approval of God, and who can argue with God? (Using God and the Bible to control others is the definition of spiritual abuse, by the way.) Because he is firmly entrenched in a power-over model of human relationships, he will have a clear conscience when it comes to controlling you and your life. He and his religious supporters actually believe that promoting a power-over model is **_godly_** and **_biblical_**.

Your husband may not control all areas of your life. It really depends on what is most important to him. Some areas in which we typically see Christian men controlling women are finances, education, career, home responsibilities, involvement in church activities, who she visits and for how long, parenting strategies, reading material, the food she eats, the way the home is decorated, and so on. Here's an example from my own former marriage. My husband would not allow me to put gas in the van because he wanted to use points on his gas card to get a few cents off per gallon. The only problem was that he didn't always keep my gas tank full. His control over my freedom to put gas in the car became a dangerous situation for the kids and me when we ran out of gas in precarious places on the road three separate times. God took care of us all three times, but after the third time, I no longer submitted to his instructions, and I kept my van's gas tank full myself. This made me a "rebellious, sinful, and unsubmissive woman," but by that time I didn't care. I was a grown woman, and my priority and responsibility was keeping the kids and

me safe. We will talk more about taking back control like this and setting healthy boundaries in chapter eight.

5. **Mind-Worm**

This is perhaps the most devastating and long-term issue for a woman in an emotionally abusive relationship because even after she is out, she will still struggle with his voice in her head. An abusive man targets a woman for her kindness and ability to empathize and love and understand. He seeks a woman with a sensitive conscience, a propensity to easily be convicted and feel guilty, and an eagerness to make amends, forgive, and have peaceful relationships. A woman like this has a desire to be needed and to make a difference in someone's life. And if she has been taught by her religious group that her entire existence is about being some man's helper, she will view any weakness on his part to be exactly the area where she has skills to help him. In this way she spiritualizes the potentially pathological dynamic. To entice her into forming a relationship with him, he will mirror her qualities so she believes he is a person like her, and in this way he will win her over with a false depiction of who he really is.

But once they are married, his true colors will begin to show. His selfishness and refusal to take responsibility. His control and manipulation. This change in behavior is disorienting and even frightening for the woman, and she can't make sense of it in her mind. When she opens up to him and makes herself vulnerable in the relationship, he uses her hopes and fears and weaknesses against her to manipulate and control her thoughts. Over time, his reality, his thoughts, and his beliefs about himself and her will become hers. ***She will see herself through his eyes.*** She will hear his voice in her head. Even when she is not with him, she will be obsessed with wondering what he would think of something she said or did. Would he approve?

Would he be upset? What motives will he assign to her actions, and will they be accurate or confusingly misplaced?

He will accuse and attack her person and then mind-twist her to believe it was her fault. She will try harder, and he will occasionally show her affection and kindness to make her think he is the person she wants desperately to believe he is. She will not have bruises on her body, but she will have bruises on her soul, and she won't even be able to pinpoint where they came from. This is the nature of hidden emotional abuse.

So his behavior is marked by the five categories of emotional abuse: deception, denial of responsibility, inability to empathize, control, and mind invasion. But it's important to realize that these behaviors are not based on how he is feeling, but because of what he believes about himself, his partner, and how the world best operates. **It's his core beliefs that drive his attitudes and behaviors**. And that's what we'll look at next.

HIS BELIEF ABOUT HIMSELF

Depending on your partner's upbringing, personality, and other shaping influences in his life, he may view himself in several different ways. Very often he will view himself as a victim. He may believe the world has dealt him a hard hand, and the universe has conspired against him. He may believe someone needs to take care of him and feel bad for him. That you owe it to him to pick up the pieces of his life. That he can't help it he forgets things or can't keep his commitments. Nothing is his fault or responsibility. He may have little sex drive and no passion for much of anything. He floats down the river of life blaming everyone else for why his life doesn't work the way he thinks it should.

Or he may have a more openly narcissistic view of himself, loving his body and hair and position at church. He might have a high sex drive and believe it is your responsibility to meet his necessary needs. He views others as objects to use for his purposes, and he expects cooperation and admiration. He might see himself as smarter and more spiritual than you and others. If you disagree with him, he may hold you in disdain as an annoying and ignorant woman. He may talk about others as if they are stupid and silly, and he may talk about you this way as well.

Or he may see himself as humble and caring and kind, while passive aggressively undermining your words and actions in ways nobody else can see. He may think of himself as a good Christian and a rule-keeper, while judging you for getting emotional, feeling afraid, or having a different viewpoint than he does. He will present well in public, seeming like the quiet, faithful Christian man. In reality, he may not contribute much at home, but he will view his minimal contributions as a big deal and expect gratitude.

Regardless of his style of self-view, he believes he is above criticism and that any negative feedback about his behavior is exaggerated, unfounded, or ridiculous. He may see himself as having the right to make all the decisions because he is a man. He believes his decision-making skills are superior to yours, and he can make better decisions without your input. If you disagree with him, he will believe you are not paying attention to his wise insights, and he will be irritated and sometimes downright angry.

He also believes he is entitled to your body, your obedience, your respect, your subordination, and all the various aspects of your relationship. He may believe it is his right to control your money, your time, your gifts, your friends, and your decisions. He may want

to control all or a few of those things, depending on who he is. He believes he has freedom and autonomy because he is a man. He does not believe he should be held accountable for his behaviors. He may believe he has the right to tell you what to do with your time, what to believe, how to dress, how to wear your hair, and how to behave.

He believes he is a good man, and impression management is high on his priority list. He has no conscience when it comes to lying and manipulation as long as it serves his purpose to make sure others see his innate goodness and minimal efforts and give him a pass when necessary. If his spouse finally dares to tell someone about his poor behavior, he believes she is the abusive one, and he'll make sure to plant that idea in the minds of anyone that she might reach out to for help. The sad thing is that many folks will buy it. Why? **Because he confidently believes it himself.** He would never blame himself for the fallout of his actions, no matter how much evidence there was to support it. Besides, that's what you're for. Let's look next at what he believes about women in general and you more specifically.

HIS BELIEFS ABOUT WOMEN AND MARRIAGE

Most of the women reading this book come from Christian faith communities and are probably married to men who come from these same communities. I realize there will be exceptions to this, but if your husband is involved with you in church and other religious activities, he will likely hold to some of the following beliefs that serve him well in his abusive lifestyle.

- Men lead, women submit.
- Men rule over their households as heads.

- Women must forgive 70X7 to infinity.
- Women are dripping faucets with their incessant complaints and demands.
- Women are rebellious Jezebels.
- Men are more spiritual and can teach anyone. Women cannot teach men.
- Wives must please their husbands.
- First God, then men, then women, then children.
- Women are temptresses, and men simply trip up.
- Women are responsible for the evils in a man's world.
- If a woman accuses a man of rape or abuse, she must have at least two or three witnesses. If the rape or abuse was done without witnesses, it didn't happen. And of course, a man could never rape his wife because he acquired ownership rights the day they were married.
- Women are not allowed to give men feedback unless asked, and then it must be done in a meek and quiet way so as not to upset the men. Whether or not she was meek and quiet enough is determined by the men.
- Women have no rights and are godly for suffering abuse without saying a word.
- A wife is not allowed to exercise personal boundaries. If she does, she is a rebellious, self-centered, arrogant Jezebel.
- Grace is for men, not women.
- Women are responsible for the emotional climate of the home. If anyone is unhappy, it is her fault.
- Women must die to themselves and live only for the service of others, especially their husbands and children.
- A woman's love will cover a multitude of a man's sins.
- If a woman stands against her husband, she is not in God's will.

- A woman must keep her vows, but men are not accountable and must not suffer consequences for not keeping theirs.
- Women owe their husbands a clean house, good sex, and perfect children.
- Women owe their husbands respect, and that means her voice is not allowed unless she is meekly and quietly agreeing with his opinion.
- Women who tattle on their husbands are slandering gossips.
- The word abuse is not in the Bible, so therefore it isn't something a Christian woman can experience.
- Women who don't stay with their husbands are not true believers. They are going against God who has bound them together for all eternity.
- Women who say no to their husbands are angry, bitter, and unforgiving, especially when it comes to sex.
- When a husband says he is sorry, a wife owes him a fresh start. Actions are not required. Change is not required. Just the words "I'm sorry."
- A wife must trust her husband as God's representative on earth to her—even if he is a chronic liar.
- If a woman is doing God's will in being a loving, submissive wife, she will change her husband back into the man she believed he was before they got married. If he doesn't change, it's all her fault.

HIS BELIEF ABOUT YOU

You are a woman. According to his belief system, that automatically places you in the *power-under* position—the *less-than* place of subordination. He believes your role is to be available to meet his needs. Your needs, on the other hand, are not significant. He may see you

as belonging to him because you are his wife. He may believe you are beneath him and owe him loyalty and obedience no matter how he treats you. He may not believe you have the rights to freedom and autonomy—that when you made vows to him, you signed away your individuality and your personhood in exchange for his authority over you.

He may believe he needs you to manage his emotions and make him happy. To take care of him. To do his bidding. To accept his behavior and overlook his sin against you. When you ask him to take responsibility, he may accuse you of controlling and nagging him. He believes you are controlling him when you ask him to fulfill his obligations and meet his responsibilities. He believes you are mean when you hold him accountable, and you are selfish when you ask him to stop doing something hurtful. If you set a safe boundary for yourself, he will believe you have criticized and rejected him, and he will be offended. He may lash out by yelling or throwing things. Or he may just passive aggressively make little comments to tear you down, accuse you of what he himself does, or get you to doubt yourself and your experience and choices.

He may be skilled at pushing your buttons in hidden ways, hoping to get you to fall apart emotionally. He views you as ridiculously sensitive, selfish, overbearing, emotional, irrational, and silly. He knows what you value most because you've revealed that to him. He uses your values to ignite your passion and get a lively reaction from you. He then shifts his focus to your reaction and shames you in the very areas you feel weakest. He knows this will send you into a cycle of guilt which will make you more vulnerable and controllable. He knows if he keeps the focus on you, he can do what he does without fear of consequences.

He may believe he can give you orders, but you cannot ask him for favors without getting accused of nagging, dragging him down, and sucking his time away from more important things. He does not value your contributions or appreciate the great lengths you go to support and cover for him. You bend over backwards to bring hope and life and peace and honest communication into your relationship, but he doesn't see or appreciate that. He views you as his servant who is there to give him dinner and sex. There to raise his children. There to soothe his offended ego. And when you fail to do so, he makes sure you know how you've failed in your biblical duties.

When you are not propping up his ego enough, he will be annoyed with you. He'll show you how he feels by dismissing your personhood in covert ways. He won't make eye contact with you when you're talking. He will give you the silent treatment for hours or even days on end. You are a non-person to him except when he requires something from you. After verbally berating you for the ways you've let him down, he will expect you to move on immediately and forget it happened. If you dare to bring it up, he will be sure to bring you down in shame for your insubordination and lack of Christian forgiveness.

He may believe your role is to make him look good to others, especially in your religious circles. You are good for hosting small groups, making meals for people, covering for him when he fails to meet his commitments at church, and standing by his side in the church foyer looking godly. Your role is to keep the children clean and well behaved so others will believe he is a man who has good control over his household.

His beliefs about you drive his behavior toward you. It's very important that you understand this. You may think the ways you try to

protect yourself, your reactions to his treatment, and your efforts to inspire change and movement forward are causing him to feel rejected, and his feelings then drive his destructive behaviors toward you. *In this way he has you and others fooled into taking responsibility for his actions.* As long as you focus on his feelings and managing his emotions, you will not be able to see the real reason for his bad behavior. Always remember that the real reason he treats you the way he does is because of his beliefs and attitudes toward women in general, and you more specifically. And there is nothing you can do about that. In chapters five and six we'll look at the devastating consequences of domestic emotional abuse in your life and the lives of your children, the church, and the culture at large. But next, we'll see how his abusive treatment of you bears consequences in his own life.

THE CONSEQUENCES OF HIS BEHAVIORS AND BELIEFS

Bob Hamp of Think Differently Counseling says that at the core of abuse is *wrongly assigned responsibility.* The abuser gives the responsibility for the relationship and his behavior to the abuse target, and the abuse target accepts that responsibility in hopes of fixing the relationship. The consequences unjustly fall on the abuse target. In order to stop abuse, we need to turn this around and rightly assign responsibility where it belongs—squarely in the court of the abuser.

A man who chronically, over many years, treats his intimate partner in the ways we've described is not a good man. He has a hard, unrepentant heart, and there are natural consequences for his behaviors. If we love him the way God loves him, we will not enable him to continue to live a wicked lifestyle. While we cannot do anything

(nor should we) to control his personal choices, if we love him, we won't coddle him, protect him from natural consequences, or naively trust him when he lies to us about how he has suddenly changed when faced with natural consequences. We will urge him to examine himself and his destructive set of beliefs, misogynistic attitudes, and choice of behaviors, and repent.

Repentance means he fully and openly acknowledges to everyone how his behavior has devastated his wife, children, church, and community. He turns away from his behavior and gets help from a skilled therapist to build new habits of relating to others, especially his intimate partner. He has a change of belief and attitude about who she is and her precious value to God and to him. He humbly abandons a power-over position and adopts the heart of Jesus Christ toward her and others. This will only happen if **he himself chooses to change**, which is extremely rare since he fully sees himself as entitled to do what he does. He doesn't believe he has a problem, and *nobody can fix a problem they don't believe exists.*

The Bible says we reap what we sow—if not here on earth, certainly in eternity. So far, he may have been protected from reaping what he has sown in his private life. Perhaps you have protected him. Perhaps his church protects him, believing that as a man, he is entitled to immunity from this natural law of sowing and reaping. But this protection is also a lie. The lie is this: *"It's okay to dehumanize your wife. She isn't worth much, anyway. You are entitled to treat your wife as you please. You are a man. There will be no consequences for your behavior."* But there will be. Your church community may support this kind of behavior, but God does not. Here is what the Bible says about what happens when God's people choose to do nothing about wicked behavior.

"Because the sentence against an evil deed is not executed quickly, therefore the hearts of the sons of men among them are given fully to do evil." (Ecclesiastes 8:11)

"When I say to the wicked, 'You will surely die,' and you do not warn him or speak out to warn the wicked from his wicked way that he may live, that wicked man shall die in his iniquity, but his blood I will require at your hand." (Ezekiel 3:18)

Though people may stand aside and refuse to lay sanctions on abusive husbands, God does not ignore this evil. And in fact, the very wickedness they do to others will be what ends up destroying them. In other words, **they ultimately destroy themselves**. These are the natural consequences for oppressing others. The people of God should not be standing in the way of these natural consequences. When we prevent consequences, we promote lies. This wreaks havoc on the gospel, and that's why this issue is so critically important. We will talk more about this in chapter nine.

"They spread a net for my feet; my soul was despondent. They dug a pit before me, but they themselves have fallen into it." (Psalm 57:6)

"Evil shall slay the wicked, And those who hate the righteous will be condemned." (Psalm 34:21)

"His own iniquities will capture the wicked, And he will be held with the cords of his sin." (Proverbs 5:22)

An abusive man may have the support of his religious community simply because they have the same misogynistic beliefs and attitudes toward women that he has. They are in alignment with one another for a reason. I have seen this countless times, and it is a worse abuse

than the original because it adds betrayal, spiritual abuse, and the blaspheming of God's character into the mess. Thousands of women have suffered in deep, profound ways from this secondary evil at the hands of their religious communities. They have been placed in the role of a suffering scapegoat and told they must "suffer for the glory of God." This does not bring glory to God, and He is not fooled.

> "*Thus I will punish the world for its evil and the wicked for their iniquity; I will also put an end to the arrogance of the proud and abase the haughtiness of the ruthless.*" (Isaiah 13:11)

> "*Assuredly, the evil man will not go unpunished, but the descendants of the righteous will be delivered.*" (Proverbs 11:21)

> "*Woe to the wicked! It will go badly with him, for what he deserves will be done to him.*" (Isaiah 3:11)

Some of the most common natural consequences an abusive husband will suffer include, but are not limited to, the following:

- Loss of intimate fellowship with his wife
- Loss of deep connection with his children
- Loss of deep connection with Jesus Christ
- Loss of marriage
- Loss of relationships with others
- Loss of financial status
- Loss of the blessings of a warm home and family
- Loss of freedom
- Loss of respect
- Loss of moral compass
- Loss of Christian fellowship

- Loss of reputation
- Loss of protection
- Loss of hope, joy, and peace

You probably don't want your husband to experience these consequences. You love him, and all you really want is for him to change so you can have a healthy relationship. It's tempting to keep the truth under wraps for these reasons, but I hope you can see that sometimes natural consequences are the only thing that will lead a hardened human being to repentance so he can experience the love and forgiveness of Jesus Christ. You cannot change your husband no matter how hard you try. Nor should you change him. That's not your job. Only by fully surrendering his life to Jesus Christ can a man truly experience life-transforming change.

CAN HE CHANGE?

I know what you're wondering. I know because I wondered it myself when I was immersed in my own abusive marriage. And I've talked to hundreds of women online who have asked the same golden question, desperately searching for the answer to make it happen.

Can he change?

In order for anyone to change, they first need to see something in themselves that needs changing, and then they need to *want* to change. It's easy for you to see how this works, and you've experienced it many times in your own life as you've matured and grown as a human being. But you've projected your own desire and motivation to change onto your partner. *Just because you value growth and change doesn't mean he does.*

I've got a question for you. How can someone who is not able to even admit to his poor behavior in the first place ever change it? Why would he change something he doesn't believe needs changing? He likes himself just the way he is. What would be his motivation to change?

John 16 says the Holy Spirit convicts and comforts the believer. Has your spouse ever expressed conviction of the Holy Spirit in an area of his life? We all sin every day. Have you ever wondered why it is only you that is convicted of your daily sin? How often does the Holy Spirit convict him of sin? How often has your husband expressed that he has been comforted by the Holy Spirit through repentance and forgiveness? If you haven't seen evidence of the Holy Spirit in the life of your husband, don't blame the Holy Spirit. The Holy Spirit isn't there. And if the Holy Spirit isn't there, your husband can't be convicted of his sin; therefore, he cannot change. Just because someone says they are a Christian and uses spiritual language and knows some choice Bible verses to lob at others when it serves their purposes doesn't mean they have a relationship with Jesus Christ.

> *"Not everyone who says to me, 'Lord, Lord,' will enter the kingdom of heaven, but the one who does the will of my Father who is in heaven. On that day many will say to me, 'Lord, Lord, did we not prophesy in your name, and cast out demons in your name, and do many mighty works in your name?' And then will I declare to them, 'I never knew you; depart from me, you workers of lawlessness.'"* (Matthew 7:21-23)

Men like this don't regret their behavior. They don't have empathy for how their behavior devastates you or their children. Their con-

science is not only devoid of the Holy Spirit, it is dead. They don't experience guilt or shame for their misogynistic attitudes toward women, their dehumanizing treatment of their partner, and their habitual deceit. They are masters at denying or minimizing their behavior and making excuses or blaming others for their behavior. They will not only **not** feel any conviction whatsoever, they will actually attack anyone who points out the hurtful effects of their bad behavior.

Can this kind of person change? I suppose it is within the realm of possibility, but I don't believe he will. They say the past is the best predictor of the future. Here's what he will do, though. If you create some healthy boundaries for yourself in order to get safe, he will ***pretend to have changed.*** You are his property, after all. He will continue to operate in his deceptive way and fake it in order to get you back where he wants you. As soon as he has re-established control over your thoughts and emotions, he will go back to business as usual.

Lundy Bancroft, a counselor who works with abusive men and author of *Why Does He Do That?* says there may be hope when you see an abusive man:

- admitting fully to what he has done.
- stopping excuses and blaming.
- making amends.
- accepting responsibility and recognizing that abuse is a choice.
- identifying patterns of controlling behavior he uses.
- identifying the attitudes that drive his abuse.
- accepting that overcoming abusiveness is a decades-long process — not declaring himself "cured."

- not demanding credit for improvements he's made.
- not treating improvements as vouchers to be spent on occasional acts of abuse (ex. "I haven't done anything like this in a long time, so it's not a big deal.").
- developing respectful, kind, supportive behaviors.
- carrying his weight and sharing power.
- changing how he responds to his partner's (or former partner's) anger and grievances.
- changing how he acts in heated conflicts.
- accepting the consequences of his actions (including not feeling sorry for himself about the consequences, and not blaming his partner or children for them).

Here's how you know his change isn't real. His seeming change and repentance will be **on his terms.** He will admit to what he wants to admit to. In his time. In his way. And if you hold out just long enough and don't get fooled by his feigned and limited repentance, you will see his true colors emerge in more brilliancy than you ever dreamed possible. It's breathtaking, actually. We'll talk more about that in chapter nine.

You might be wondering how this can be predicted with accuracy. It's like diagnosing a disease. If a person presents with a certain set of symptoms, and the tests show indicators of a specific disease, that person has that disease. It's like math. One plus one equals two every time. In the same way, there are specific markers of abuse; if a man presents with those markers, he is abusive, and he will react with the same predictable patterns of behavior every single time. He will first fake repentance, and if that doesn't work, he'll attack by launching a smear campaign against you, even saying that you are the abuser in the relationship or claiming you are mentally ill. But true emotional

abusers won't change because they don't believe there is anything about themselves that needs to change.

Here's the thing. It's not your job to help him change. To make him change. To do everything perfectly in order to give him the best opportunity and environment in which to change. God didn't give his life to you to manage and control. God gave you YOUR life to manage and control. So while you can't change your partner, nor should you make that your goal, you can change what you do about this reality. We'll be looking at how you can do that in chapter eight; but first, let's look at the role you're currently playing.

FOR FURTHER STUDY

» *Why Does He Do That? Inside the Minds of Angry and Controlling Men* by Lundy Bancroft

» *The Mind of the Intimate Male Abuser: How He Gets Into Her Head* by Don Hennessy

Check Point

Dear Heavenly Father,

Be near this dear daughter of Yours right now. She is hurting and frightened. She has been asking You for help for so long—but this? This feels overwhelming to her. She's maybe not even sure it's true or real.

But You have collected her tears over the years, and You see her now. Thank You for being with her. For loving her. I pray she would experience Your presence in a special way right now. Reassure her of Your love and acceptance and support. Open up her eyes to see the face of Your Son, Jesus Christ. To feel His breath on her face. And give her the courage she needs to stay focused on You even though the storm is raging around her right now.

In Jesus Name and for His glory,

Amen

The book you're holding in your hands is just the beginning of your discovery and learning process. I don't want you to feel alone when you're done reading, so I've developed an entire website specifically with you in mind.

On the Flying Free public website, you'll be able to access hundreds of articles and podcast episodes to teach and equip you to become all you were created to be—even in the midst of emotional and spiritual abuse.

Come visit: www.flyingfreenow.com

"Your work in Flying Free is one of the most important lifelines in my healing and recovery process. The Flying Free website even helped my mother process all that was going on in my life by reading many of your articles. Thank you."

—Flying Free Reader

CHAPTER FIVE

Your Role

"I HAD TO BE PERFECT"

"I believed I had to get him to change somehow by something I did or didn't do. It was my responsibility."

"I continue to struggle with the belief that I should have been better or done better so that he would have treated me better and would still love me. The reality I'm processing is that he never loved me and that I never could have been perfect enough for him to treat me right."

"If I was not admiring him despite his moods or threats, then I was subjected to his lectures which made me feel like a child being punished. I felt stupid and confused."

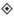

"I was a work horse. Four to five jobs at any given time while he sat at home having 'health problems,' watching

TV night and day, refusing to give me anything I needed to keep going. If a bill needed to be paid, and I couldn't pay it, he'd threaten me. All while ordering more subscriptions and buying more things without telling me."

"I kept getting hung up because I sin and do things wrong too, so I couldn't say 'stop.' I couldn't say 'no' or 'this is not okay' because I'm not perfect."

"I saw myself as unlovable and worthy of nothing good. I used to look at other women and think if I was like them this wouldn't be happening to me. I felt inadequate and thought he treated me this way because I didn't deserve any better."

"I had to be the perfect wife, which included perfect children, perfect meals, and a perfectly cleaned house. I had to have a fresh-from-scratch dessert each evening. I had to keep the kids from ever making a noise if he was home. I had to have perfect church attendance. I had to refrain from speaking my opinion."

"No matter how many hours I worked, I never made enough money for him. He took out credit cards and loans in my name to support his hidden sex, drug, and

alcohol addictions. And when I finally left, I got kicked out of the church."

"My role was to provide for his every need or desire without expecting anything in return. I was to serve him without complaint and make him look good to everyone as if his successes were his own accomplishments. I was to use my intellect, education, gifts, and talents to his advancement and glory while remaining invisible and subservient."

"Marriage was all about his life, and I was just there to encourage and support him as he sought to accomplish great things for God. Confusing, because I thought we had set out to follow God together, and I thought it was our life, not just his."

"I believed we both acted wrong, but I drove him to do it; therefore, I was responsible for both of our misbehaviors. He fully believed this too, making it really hard for me not to blame myself for his abusive actions. His voice was inside my head blaming me, so I blamed me too."

"In my marriage, Romans 7:18 became my mantra: 'In me dwells no good thing.'"

"I believed the deception and dehumanization I experienced was my cross to bear."

"If I do everything right and say everything JUST right, everything will turn out all right, right?"

—Quotes from Emotional Abuse Survivors

Can you relate? Are you mentally, emotionally, physically, and spiritually exhausted trying to be the perfect Christian wife? In this chapter, we're going to take a closer look at the kind of woman an emotionally abusive man targets and why. We've already talked about how he views you, but now we'll deep dive into how you view yourself and the consequences this has on your life. I hope this chapter will give you helpful insights into why you keep trying so hard to make things work with a man who not only doesn't appreciate and care for you as a person, but who keeps hurting you more the harder you try.

WHO IS THE DOMESTIC ABUSE TARGET?

The domestic abuse target can be anyone. She can be a business owner. An attorney. A professor. A doctor. A pastor's wife. An author. A homemaker. A company president. A picture-perfect homeschooling mother. A police officer. And contrary to the opinions of those who don't understand how abuse works, she isn't targeted because

she can't stand up for herself or has low self-esteem. In fact, most abuse targets are not co-dependent at all. Most of them have been wired from birth with some powerful personality traits that serve them well in their careers and in their relationships with healthy people. But these same traits, when under the influence of a toxic person, are exploited in profound ways in order to devastate them and render them powerless. That's right. ***Most victims are targeted for their strengths.***

Here are a few specific strengths that are sought out by an abusive man and how those strengths are used against her.

1. **She is considerate of others.** Because she puts the needs of others before her own needs, he can get her to dismiss her own human instinct to not only take care of others, but to also take care of herself. Add to this her religious community encouraging her to die to self, and you've got a perfect set up for his toxic mind control over her to thrive and grow.

2. **She is persevering.** When she makes a commitment, she sticks to it. Her commitment to her word is the super glue that keeps her tied to her partner, persevering through the confusion and pain her husband causes. Add to this a religious community that teaches divorce is the unforgivable sin and excommunicates those who initiate divorce, and you've got a very real prison from which there is no escape. Truly, the victim doesn't even consider divorce as an option until she feels so mind-twisted, traumatized, and fearful for her physical and/or emotional well being that she takes that drastic step, fighting for her life against all of her core beliefs. Many women will stay two to three decades before finally getting help and leaving—not because they are weak willed, but because their strength of perseverance and dedication to what they believe is so strong.

3. **She is trustworthy, open, honest, and forthright.** She vulnerably shares her inner world with him in the hope of building a deep, intimate connection, but he takes the things she has confided in him and uses them as ammunition to attack her when she isn't doing or being what he wants her to do or be. He forces her to violate her conscience by being dishonest when she keeps his mistreatment a secret. When she finally tells the truth about what's happening to her friends or church leaders, she is shot down and punished, adding to the cognitive dissonance that already plagues her.

4. **She takes responsibility for herself and those around her.** Because she is so committed to taking personal responsibility, when he blames her for her supposed role in his own bad behaviors, she accepts the blame and works hard to do better next time in order to avoid the guilty and shameful emotions that follow an abusive incident. This is perfect for him. As an abuser, he will almost always blame her for any wrong either of them do, and so he gets away with anything he wants to by shifting the responsibility for what he does over to her. **Once he controls how she defines his abuse of her then he can control her actions.** And when her religious community tells her to "forgive and keep no record of wrongs" and "as far is it is up to you, be at peace with all men" and "your role is to build your husband up" and "a good wife will a happy husband make," she re-doubles her efforts to take responsibility for fixing all the hurt and pain in the relationship. As she takes this on herself, she withers under the guilt and shame of this impossible task.

5. **She is generous—giving more than she takes and doing it with joy.** Because she is generous, she pours all her resources into the marriage, whatever they may be, believing she is investing in the most worthwhile relationship God has ordained for her. She will work hard at raising the children, taking care of their home, and

prudently spending. She will also work hard at her career to bring in monetary value. No gift is too great in her mind. It's all a pleasure to give. If she is a woman of faith, she does it for the glory of God as well. She believes that even if it goes unnoticed by her husband or others, God sees her efforts, and she will reap a good harvest one day. This works wonderfully for the man who views her as his servant, created to make his life comfortable and happy. After all, this is one of the main reasons he chose her. Her religious community colludes with the abuser by keeping the focus of her generosity disproportionately on her since she is the active and willing partner. This is exactly what the abuser needs to continue harming her with without experiencing any consequences.

6. **She is kind and empathetic, deeply caring about how others feel and her own effect on their feelings.** Her kindness and empathy work in his favor as well. Her default is to give others the benefit of the doubt, believing the best about their behaviors. When her abuser treats her poorly, she has already been trained to take on the responsibility for what he does. In addition, she feels it must be because of something sad and broken inside him, and she desires with all her heart to help him so he can be all he was created to be. She sees herself as equipped by God to accomplish this goal, and she applies all her compassionate energy toward the task. Her religious community teaches her that this is the right thing to do. Turn the other cheek. Love covers a multitude of sins. Love will win the day. Her partner grooms her to the place where he can offend and *actually get her to feel sorry for him because he hurt her.* See what's going on here? She not only blames herself for his mistreatment, she feels like she's failed him for not helping him enough and actually feels sorry for what she "made" him do!

7. **She is intuitive—sensitive to the emotional environment around her.** She picks up on tone and body language, and she adjusts her approach accordingly. The fact that she is intuitive actually makes it easier for an intimate partner to confuse and control her. Here's how that works: she skillfully picks up on all the non-verbal cues he gives her to covertly control what she does or how she interprets her experience. A certain look. An edge in his voice. The way he looks past her when she talks. These are the subtle, imperceptible things others can't see—but she can. This helps her navigate potential ugly situations or enables her to fall into them—whichever her partner wants at any given time. The fact that his words and his actions don't match make the experience all the more confusing, throwing the victim into the depths of self-doubt. Her religious community tells her she can't trust her heart. It is "deceitful above all things." They tell her she is making assumptions, and this plays into her abuser's narrative. These beliefs are implanted deep within her psyche now, making it hard for her to tell right from wrong when it comes to her own experiences.

8. **She is forgiving.** She will overlook wrongs and forgive without being asked. She is quick to feel bad for whatever she's done to hurt someone, and she assumes that's how her partner feels as well. As part of her commitment to the marriage and her own generous and forgiving nature, she forgives **even when her abuser isn't sorry and doesn't ask**. Her religious community not only encourages this blanket forgiveness, but defines her forgiveness to mean she must act as if he had never done any wrong. This level of forgiveness they demand from her includes allowing her abuser complete and total access to her, body and soul, at all times. It is her duty as a wife, and she takes it seriously. As a result, **there is never any sowing and reaping.** Her abuser sows destruction in their relationship and in her personhood without any accountability or consequences, and

she continues to forgive him for the ways he causes her pain, thereby enabling the abuse cycle to continue unabated.

9. **She is patient and long-suffering.** She will endure the attacks of her partner, believing in his potential as a human being. She will actively strive to endure the abuse to the point of falling apart emotionally and physically. She willingly sacrifices, believing that it is worth it if he will one day finally recognize what he is doing to her and stop and become the good man she believes he can be. Her religious community teaches her that suffering is God's will for her, and they do nothing to offer relief and practical help. That would mean circumventing God's plan of suffering for her life. This also plays into her partner's agenda to keep her doing what he wants her to do—all in the name of God. This is the ultimate spiritual abuse.

10. **She is courageous.** She survives the rejection of her love and the dehumanization of her spirit, and still she goes into each day with hope. Her courage in the face of daily abuse, both covert and overt, is incredible. This inner strength is exploited by her abuser who is both jealous of her strength and desires to use it against her. When necessary, he will praise her for it, getting her to believe that she must keep it up to win his admiration as well as to survive. Her religious community doesn't recognize her courage, strength, and depth of character forged in the furnace of constant affliction. To them, she is just another woman merely doing her duty before God and not doing it well enough to keep her husband happy.

11. **She is organized and resourceful.** She takes what she is given and multiplies it even though she is offered only criticism and rejection in return. The abuse target is often very good at coming up with creative ways to make money or make ends meet. Her contributions are minimized and taken over by her abuser, who will insist

the extra resources be placed in his capable hands. She willingly (at first) agrees to this, feeling that she must trust him as her intimate partner, and yet, this makes her feel like a slave or child rather than an equal adult partner. When she does insist on recognition for the resources she is generating, she will be attacked and blamed as a selfish, money-hungry female. She'll struggle with feelings of guilt and shame and confusion as she hears his voice in her head defining who she is and assigning wrong motives to her resourcefulness and hard work.

12. **She is loyal and doesn't want to betray her abuser.** It's difficult for her to recognize how his actions are wrong, much less abusive, even though she knows how much pain they cause her. This especially makes it difficult for her to reach out for help. First, he is in her head telling her it's all her fault. She believes this is true—that if she would have tried harder or been different or responded differently, she could have made things better. Her religious community will tell her the same thing. She knows if she tries to explain her experience, the tide of that belief is too powerful to go up against. But also, **she has no desire to betray or expose her partner.** Her heart is for him. Her motive is to help him so they can have an intimate relationship that is mutually satisfying. Against all the evidence to the contrary, she continues to believe this is possible, and her first attempts at getting help are for the sole and desperate purpose of achieving this end. However, most churches and Bible counselors will not be able to understand her or her problem. **The voice of her abuser is in their head, too.** In fact, they feed off of one another and abuse the woman together.

This kind of woman, when paired with an emotionally and spiritually healthy man, can co-create a beautiful and powerful marriage. But when a woman like this is paired with a toxic man who believes

he is entitled to power over women, especially his own woman, a distorted and sick version of marriage is birthed. An abusive marriage will have devastating consequences to her life, the lives of their children, and the health of their religious community and surrounding culture. The ripple effects are prolific and profound and will reverberate throughout eternity.

YOUR IDENTITY

How do you view yourself? We tend to see ourselves through the eyes of those we have relationships with. If our parents showed us unconditional love, honor, and kindness, we believed we were lovable, honorable, and deserving of kindness. But if our parents were chronically annoyed, angry, and critical toward us, we grew up believing we were a bad, ugly, and annoying child who deserved very little. We felt worthless, innately flawed, and unlovable.

As children, we had no choice about who raised us or how they viewed us, but as we grew up, we did have a choice to pursue people who would either value us for who we were—or who would use and discard us for their own purposes. Many women start out with the enormous disadvantage of being raised in homes where they were not valued, where their ideas and experiences were mocked or denied, where love had to be earned, and where the bar was always just out of reach. Because of this they grew up with the core belief that they did not have value in and of themselves. That they were just taking up space. That they were worth something only when they were useful to someone else. And sadly, this core belief often makes them vulnerable to being targeted by abusive people who thrive off of controlling and using others to fill in their own broken places.

An emotionally abusive man doesn't come up and introduce himself like this: "*Hello. I'd love to spend the rest of my life controlling you, using you, criticizing you when you don't come through for me, lying to you, and then discarding you when you no longer serve my purposes.*" No, it's more like, "*Hello. You are a beautiful woman. You have talents. You have skills. You have everything I want in a wife. You are my dream come true. You are everything I ever hoped for. I need you. I want you. I love you. Be my everything until you die.*" And that appeals to a woman. You look into his eyes and you think you see a beautiful, lovable woman standing in front of him, and you want to be that woman. You believe you could be that woman. The wind beneath his wings. The ministering angel he needs to take care of him. And it all feels so right—until it all goes so wrong after the honeymoon. Then everything eventually changes as his underlying attitude of entitlement and core beliefs about women begin to show.

Now that you belong to him, he no longer needs to convince you of anything. He doesn't have to prove his love. You are a Christian, and you've made it clear that Christians are married for life, so he believes you belong to him forever, and that was his goal. He wanted a wife to be his helper, servant, sex toy, housekeeper, cheerleader, and caretaker, and now—**check**. Here you are! He knows your commitment to your principles and your God and your religious community will keep you under his control for the rest of your life. He's the man, and you're his little helper, and life can be good as long as you cooperate with his plans. His opinions. His agenda. His desires. Pleasing him becomes your focus. Your obsession. You want to please him because you think if you do, he will view you as someone worthy of his love and respect, and that's all you want. Love and respect. And some peace.

But no matter what you do or how hard you try, you can't quite measure up for three reasons. One, because he already has a core belief that women are less than men. No amount of awesomeness on your part will change that. Two, because he didn't marry a Stepford Wife. He married a flesh and blood human being, and that means an imperfect woman. Also, because God made you a unique and separate person from him, you naturally have opinions of your own. Desires of your own. Ideas of your own. Plans of your own. And he is only concerned about his opinions, desires, ideas, and plans. You don't count. If you were hoping for mutuality, for a meeting of the minds, for honesty and open communication, you're in for a huge shock, because that's not what he was planning on.

You aren't the plastic Barbie doll he wanted, so now when he looks at you, he sees a nag. A messy woman. An ugly woman. A tired woman. A fat pregnant woman. A lazy woman. An unfair woman. A greedy woman. An angry woman. A jealous woman. A controlling woman. A mean woman. A selfish woman. A picky woman. A whiny woman. No matter what you do to prove the opposite is true, he communicates these messages to you with his words, his eyes, his body language, his tone of voice, and his silent treatment, and you feel it. *You begin to believe it.* The messages sink deeper and deeper into your psyche until you believe they are true. You see yourself through his eyes, and the view is far from pretty.

And the third and deepest reason you can't measure up is because in his mind, **you have to fail in order for him to succeed.** You have to be nothing for him to feel that he is worth something. He achieves this by a million little degrading comments and minor sabotaging incidents (each one too small to make a fuss over by itself) over the course of days, weeks, months, and years. Getting you to that place of utter shame and self-loathing is his goal because it's the only way

he feels relief from his own toxic inner world. You are quite literally his scapegoat.

You feel the shame of having failed in your dream of being a godly wife that brings her husband good all his days. He has made it clear you've failed in his eyes as well. But because of who you are, you believe, deep down, that you can make it up to him. You just haven't read the right book. You haven't gotten the right help. You just can't shake the feeling that you've got the skills and insights you need to help him be the man you know he could be so you could have an intimate relationship with him. But as the years go by and things get worse, you realize that doing the same things over and over again are getting you nowhere, and they always will. You feel like a mouse on a running wheel. It's exhausting, and now, not only do you feel your husband's contempt, but you also feel contempt for yourself as you see yourself through his eyes. You need to know that all this shame and hopelessness has been systematically programmed into your psyche over a long period of time through your husband's covert abusive treatment.

But how do you cope with this constant, heavy weight of shame?

HOW YOU COPE

Women in controlling, power-over relationships are dehumanized one seemingly insignificant incident at a time. There may never be a huge abusive experience. Instead it is a million small, every day, easily dismissible experiences that create an invisible, toxic atmosphere that eventually suffocates and erases her. How does she cope with the daily criticism and dismissal of her personhood? She actually has a toolbox full of defense mechanisms that help her survive and even put on a happy face when necessary so her children and those on the

outside will not suspect things are as bad as they are. Let's look at ten of these coping tools.

1. **She blames herself**—You might be wondering how this is a survival skill, but here's how it works: as long as she is to blame, she feels a sense of control over the situation and believes there is hope that she can change it. If it's his problem, it's no longer in her control, and there is little hope of change for the future. It is more cognitively comfortable to believe it's her fault (and this is supported by everything he says about her) than to believe the man she sleeps with is psychologically abusive.

2. **She denies her reality**—She married this man because she believed he was a good man and would treat her with love and respect. And sometimes he is very nice. Sometimes he behaves the way he did when they were dating, and that feels amazing. She wants to believe that is the *real him*. She doesn't want to believe in the existence of the man who treats her like a dog. How can he be both? He must be a good man who goes sideways sometimes. Surely he cannot be a bad man who acts nice only when he wants something from her? That's unthinkable. For her to admit such a horrible truth would blow her entire world apart, and she can't let that happen. She needs to hang on to hope in order to keep her sanity.

3. **She normalizes his behavior**—*"All men have an ego that needs protecting." "All couples have communication problems." "All men have a hard time listening to women prattle on." "Men aren't able to understand women." "Men have more important things to worry about." "No marriage is perfect."* She tells herself it's going to get better. Marriage is hard, but they'll work through it in time. Maybe if they go to a marriage conference...

4. She rationalizes his behavior—*"He had a bad day." "The children provoked him." "I shouldn't have brought up that problem." "I wasn't being sensitive to his needs." "He tried his best." "He just misunderstood." "He couldn't help it."*

5. She spiritualizes her pain—*"I'm suffering for Jesus." "I am turning the other cheek." "I'm keeping no record of wrongs." "I'm forgiving and moving on." "I'm submitting in all things." "I'm bringing glory to God." "I'm trusting God to change him." "I'm enduring all things."* Church friends reinforce these ideas as well, giving her support and encouragement as long as she leans on these religious rules and norms.

6. **She forgets**—After an abusive incident, she can't remember what the conversation was even about because her brain went into fight/flight/freeze mode, and she lost her ability to think clearly. Even if she wanted to write down what happened in order to keep track of the abusive patterns in her relationship, sometimes she can't even remember how the incident started or what direction it went. All she knows is that she feels sick in her head and in her heart, and she wants to crawl under a rock and hide. All she feels is blinding pain. She may remind herself that love keeps no record of wrongs anyway, and she spiritualizes her inability to process the abusive experience.

7. **She minimizes the impact of his behavior on her life**—*"I could have it much worse." "At least he isn't addicted to alcohol or drugs." "He is a good provider." "He plays with the kids." "It's only really bad when I'm pregnant or having a baby. It will get better when the kids get older."* She concentrates on all that is good about him and cultivates gratefulness.

8. **She distracts herself**—She joins a club, leads a Bible study, gets involved in women's ministries at church, throws herself heart and soul into parenting her kids, homeschools, starts a home business,

gardens and raises chickens, or gets into a hobby like quilting or knitting. She finds joy in these things, enabling her to believe her life is as good as she longs for it to be. Her activities take her mind off the pain of her broken relationship.

9. **She lowers her expectations**—Maybe other couples have date nights and long talks on the porch after the kids are in bed, but her husband isn't into that kind of thing. That's okay. She doesn't need that anyway. Maybe other couples discuss finances and make decisions together, but that's not how her husband likes to do it, and that's okay. Maybe other couples enjoy their sex life while hers is full of problems. Sex is overrated anyway. Maybe other couples can talk about anything while she has to be very careful about which subjects to avoid, but hey, everyone's different. Her husband is a little higher maintenance. What's wrong with that? If she expects nothing, she can't be disappointed. Right? She wants to be thankful for what she's got.

10. **She holds onto the hope**—Maybe one day he will see how destructive his behaviors are and will change. She prays for this daily. She hopes he will read a book that will help. She hopes the next marriage seminar at church will do the trick. She hopes their small group leader or pastor will take him under his wing and help him. She prays that God will help her be a better wife so he won't be stumbled by her failures. When he is nice, she makes sure to express her warm appreciation in order to reinforce his kindness. She remembers that love believes all things, hopes all things, and endures all things. And she will love him for the rest of her life, even if it kills her.

She can spend decades using these ways to cope while her soul is gradually annihilated.

THE CONSEQUENCES TO YOUR LIFE

Most of us have heard of post-traumatic stress disorder (PTSD). Veterans are at risk for coming home with PTSD after being involved in combat. But it can also occur when a person experiences a terrifying or traumatic event such as a car accident or a rape. PTSD has a cousin called C-PTSD. Here is Pete Walker's definition of C-PTSD in his book *Complex PTSD: From Surviving to Thriving*:

> *"C-PTSD is a more severe form of post-traumatic stress disorder. It is delineated from this better known trauma syndrome by five of its most common and troublesome features: emotional flashbacks, toxic shame, self-abandonment, a vicious inner critic, and social anxiety. Emotional flashbacks are perhaps the most noticeable and characteristic feature of C-PTSD."*

There are three key ingredients that make C-PTSD different from PTSD.

1. Repeated trauma over a long period of time.
2. The belief that there is no way of escape.
3. The lack of outside support, validation, and help.

Consider how emotional abuse by an intimate partner in a religious setting sets up the perfect environment for C-PTSD:

1. You have an intimate partner repeatedly bullying, demeaning, lying, and controlling a woman. Because they are married, he does it with full access to everything about her, including her body. Also, because they are married, he does it over a long

period of time, day in and day out, week after week, year after year.

2. Because she is religious, she believes she has to stay married to her abuser. There is no way to get out. She may fantasize about one of them dying because that is her only hope.

3. Nobody on the outside sees what's going on because emotional abuse is usually hidden. If she does try to get help from her religious community, they reject her because of his deception and their faulty core beliefs about men, women, marriage, God, and the gospel. She is not validated, supported, or helped. Instead, she is re-abused and sent back to her intimate partner for more abuse and trauma.

So when you have an uneven power dynamic in a marriage *plus* emotional abuse (and spiritual abuse if the husband or church are telling the woman that God is honored by her suffering) *plus* the teaching that divorce is wrong, and no matter what the authority/ husband does to her *she is stuck in the marriage until she dies…***you've got all the ingredients for an emotionally and physically crippling case of C-PTSD.***

Consider for a moment how similar this is to what a prisoner of war experiences. A POW is brainwashed with controlling propaganda, held against his/her will and told it's good for him/her, put in a place of subservience with all his/her actions controlled by others, told his/her opinions are meaningless and his/her experiences are rubbish, and dehumanized with no way of escape.

Similarly, the woman of faith in an emotionally abusive marriage has her freedom of thought, action, opinion, and choice stripped

away. She is disrespected as a human being. Viewed as less-than by virtue of her lack of a particular body part.

Most of the abuse targets I work with have full blown cases of C-PTSD, and they are largely unaware of it. Many of you reading this live with the debilitating symptoms of C-PTSD every day of your lives. See if you recognize any of these symptoms in your own life:

- Difficulty regulating emotions
- Persistent anxiety
- Difficulty in remembering events surrounding abusive incidents
- Reliving experiences (I call it looping) over and over in an effort to solve the problem
- Feelings of helplessness
- Inability to take initiative
- Shame
- Guilt
- Self-blame
- A sense of being different from the rest of the human race
- Believing the abuser is more powerful than he really is
- Preoccupation with the relationship to the abuser
- Desire for revenge alternating with feelings of gratitude toward the abuser
- A sense of alliance with the abuser and relief when buying into the abuser's belief system
- Rationalizing the abuse
- Repeated desperate search for a rescuer—someone who will listen and validate your experiences—the feeling that unless someone else believes you, it can't be true
- Repeated failure to protect yourself

- Loss of sustaining faith that borders on despair
- Disconnection that alternates with feelings of terror and confusion

Please note that some of these symptoms are also symptoms of co-dependency, borderline personality disorder, bipolar disorder, and dependent personality. The difference is that these personality disorders often develop from a combination of genetics and childhood trauma, and for the most part, they can't be changed or fixed. People who are diagnosed with these disorders will deal with them the rest of their lives. They are called personality disorders for a reason.

C-PTSD, on the other hand, is not a personality disorder. While it can show up because of childhood abuse, it also shows up in people who have experienced ongoing emotional abuse in a toxic, adult relationship. It can happen to anyone put in a toxic environment regardless of their original personality, their strength, their intelligence, their skill set, their will to survive or problem-solve, or their level of resiliency. *The good news is that it is treatable.* People can and do recover from symptoms of C-PTSD with the right treatment and some hard work with a skilled therapist.

Physical health problems will also surface as a result of C-PTSD symptoms. Here are a few common ones women in dysfunctional relationships report.

- Depression
- Anxiety
- Chronic fatigue syndrome, fibromyalgia
- Back and neck problems
- Chronic headaches
- Vision problems

- Insomnia
- Gastrointestinal issues
- Heart palpitations
- Panic attacks
- Asthma
- Stress
- Immune system breakdown, auto-immune disorders
- Endocrine system breakdown
- Unbalanced hormones
- Brain fog

Over a long period of time, a victim's health can break down permanently, and this is why I continue to insist that **emotional abuse is a covert kind of physical abuse rendered all the worse for the fact that it is hidden under the skin of a victim, invisible to others despite the very real physical effects decimating her body.**

C-PTSD is just one of the consequences she lives with. Here are some others:

- Because her husband and religious culture force her into a child-like, power-under role, she is unable to operate as the adult woman she is. Many adult women have a hard time making decisions or even knowing who they are and what they like after living in a toxic, controlling relationship for so long. They often express how much they still feel like they never really grew up.

- Because she is expected to cater to her partner's needs while denying her own, she is forced to play a mother role in the relationship rather than the role of an adult woman. It seems strange that she can play both the role of child and mother at the same time, but welcome to the crazy world of

emotional abuse. Many women have expressed a longing to only have to be responsible for themselves instead of feeling that their entire existence revolves around managing and maintaining someone else's emotional instability.

- She will suffer from cognitive dissonance—the confusion that exists when beliefs and behaviors don't match up. If she believes her partner is a good man who loves her, but he treats her badly, she will suffer cognitive dissonance. If she believes she is a likable person, but her partner communicates the message that she is boring and annoying, she will suffer cognitive dissonance. If she believes marriage is a good thing, but her marriage is horribly painful, she will suffer cognitive dissonance. If she believes something happened to her but her pastor says it didn't, she will suffer cognitive dissonance. Cognitive dissonance is painful and disorienting, causing extreme stress within her psyche that has destructive effects on her mind, body, and spirit.

- She is trauma bonded to her partner which makes it extremely difficult to leave the relationship. In a toxic marriage you have an intimate relationship in which the victim is sharing her body sexually with an abuser who is emotionally, spiritually, and in other ways hurting her but also intermittently providing good experiences to cover up the painful ones. This creates the trauma bond, and it actually changes the brain over time. Our bodies were not meant to be experiencing and recovering from psychological abuse over and over again.

FOR FURTHER STUDY

» *Trauma and Recovery* by Judith Herman

» *The Body Keeps the Score: Brain, Mind, and Body in the Healing of Trauma* by Bessel van Der Kolk, M.D.

» *Suffering and the Heart of God: How Trauma Destroys and Christ Restores* by Diane Langberg

Check Point

After reading this chapter, how are you feeling? Surprised? Shocked? Sad? Disgusted? Sick to your stomach? Angry? Numb? In disbelief? Any of those reactions would be normal. You might be feeling hopeless as well, but I don't plan to leave you without hope.

In chapter seven, I'll introduce you—not to a God who could care less—but to a God who sees and loves you dearly. And in Chapter eight I'll show you how you can harness all your strengths to change—not your circumstances—but YOU.

But before we get there, we need to look at the roles everyone else plays in your marriage, because *I believe it takes more than just two to tango.*

CHAPTER SIX

The Roles of Others

WHAT IS RE-ABUSE?

"When threatened, entire systems will deny the truth and alienate a victim or truth-teller rather than face the fact that there is a cancerous lump metastasizing and destroying the system from within."

—Diane Langberg

One of most important truths I hope to communicate in this book is that God created all humans regardless of gender, race, or socioeconomic status *equal, not just equally valuable*. Jesus set the pace when he rattled the cages of the religious elite by talking to Samaritan women, hanging out with lepers, and forgiving prostitutes. He didn't take into consideration anything other than their value to Him as human beings. He humanized the dehumanized by his radical love in actions and words.

But when people hurt other people behind closed doors by belittling them, devaluing them, treating them like slaves and sex objects, controlling them, lying to them, tricking them, pushing their but-

tons on purpose to make them scream and weep, criticizing them, ignoring them, dismissing them, and then act all loving and kind when they are in front of other people on the outside— this robs the victim of her humanity. Her God-given right to be treated with honor as a human being.

Toxic people pick on the vulnerable. The children. The wives who long to please and win the approval of their husband and their God. The ones who have deep empathy and don't want to embarrass their spouse by telling the truth of what they did. These vulnerable ones instinctively know that if they did try to explain to anyone on the outside, **they would not be heard or understood**. And, indeed, this is the experience of thousands of wives and children of emotionally abusive men. When they have dared to pull a card out from their house of cards, the house falls, and everyone points in shock and disapproval at the one who pulled the card instead of the one who built the card house in the first place.

The card-puller is shamed, blamed, scapegoated, attacked, told she is a liar, told she is disordered, told she is a hysterical female tearing her own house down, told she is a Jezebel, and on and on. Often, her husband gets everyone together: their counselor, her family, her church, and her friends, and they collectively heap upon her the shame her husband had piled on her the entire marriage. **It's a double dose of abuse often done in the name of God.**

I've talked to countless women who have hauled themselves out of abusive relationships only to be re-abused at the hands of their adult children, their churches, and others who have reasons for wanting them to stay married regardless of how their minds, spirits, and bodies were being shredded to pieces by their abusive partners. Is it any wonder that most women stay silent? These are women who

highly value their relationships. Why risk losing everything they've held dear? This is one of the worst ways hidden emotional abuse hurts women—through the re-abuse done by those on the outside looking in.

In this chapter we'll be looking at those who help spread emotional abuse in our culture. The abusive spouse does, obviously. But even more so, **I believe it is the collective, quiet agreement of the masses who refuse to stand against it.** In this way our culture conspires with covert abusers to give them free reign to dehumanize women and children without cultural consequences. Worse, there are many churches who actually encourage and endorse covert emotional domestic abuse in the name of God. Let's start there.

THE VOICES OF OTHERS IN YOUR HEAD

The following is a sampling of actual things women of faith in destructive marriages were told by others. Have you heard any of these?

"All couples fight."

"You are not in God's will."

"You need to give him more sex."

"You're not praying hard enough."

"Do what he wants you to do—whatever makes him happy."

"You made a vow. You have to keep it."

"All marriages are hard."

"If you leave, you don't love your children."

"Are you keeping the house clean enough? Do you cook him good dinners?"

"You had too many babies, so that's why he abuses you."

"Back away from your relationship with Jesus. It intimidates your husband. You must decrease so he can increase."

"IF these things are really going on in your house (and that is a big IF) then it's your responsibility to get him the help he needs."

"You are a slave to Christ and your husband. There is no greater love than to die for your husband. Treat him as if he were God. He stands in the place of God for you."

"Compliment him more. He is discouraged and just needs to be affirmed by someone who thinks he is good looking."

"Quit focusing on the bad stuff. Focus on the WINS!"

"Your personality is too strong. You need to be meek in order to let him shine." (This woman said she tried to be less intelligent, not have opinions, submit, and not use her sense of humor. Basically, become a non-person.)

"He's not complicated, but you are. You need counseling."

"You don't know how good you have it. Be thankful he isn't worse."

"The only right you have is to die to yourself."

"Your husband had an affair with your sister? You need to initiate sex, then. Because love covers a multitude of sins."

"Jesus is pleased with your suffering."

"If your husband is addicted to porn and sleeps with other men and women, it's because you are frigid and unimaginative. Work on that."

"Just because your husband recently cheated on you, and you are nine months pregnant, doesn't give you the right to refuse him sex."

"Remember the reasons you married him."

"Your quest for the truth is damaging your marriage. Stop making him feel bad."

"You're blowing things out of proportion."

"You obviously haven't obeyed him perfectly."

"Because of Eve, you owe him obedience and loyalty no matter what."

"Stop expecting a Hollywood romance."

"When he gets home from having an affair, smile at him."

"Christian marriage is hell. Accept it."

"It's just his sin nature. Give him grace."

"Stop complaining before something worse happens."

"He's not abusive enough for you to divorce him. We can tell."

"Grow a thicker skin."

"Forgive without limit. Respect him."

"You are having problems because you let him have your body before marriage."

"Study Hosea who married a prostitute and stayed no matter what."

"Buy a sexy nightie, and he'll stop sleeping around."

After attempted murder and a sexual assault, her pastor told her "your situation is a 3 out of 10. Let him move

back home or you'll be held accountable before God for putting a nail in the coffin of your marriage."

◈

"Repent of your bitterness."

◈

"Churches are exempt from protective orders, so your husband can be here."

◈

"Win him without a word."

◈

"You are obviously mentally ill."

◈

"He's not hitting you. What's the big deal?"

◈

"The word 'abuse' is not in the Bible."

◈

"A man would never treat his wife like this unless she were doing something wrong."

"If you don't stay, you have no faith."

"You aren't a Christian."

"God will kill your child if you leave."

"You don't know what your name is. You are _____'s wife. You have no name."

"It is your biblical duty before God to suffer within your marriage."

THE CHURCH

I work with women of faith in destructive marriages because I have a high view of women, a high view of Jesus, and a high view of marriage. Intimate partner abuse tells a lie about women, a lie about Jesus, and a lie about marriage. These lies need to be exposed. For the sake of the Gospel, these lies need to stop.

Where you find the true gospel, you find love, hope, and healing. You find compassion, truth, and humility. Where you find the anti-gospel, you find hate, hopelessness, and destruction. You find apathy, lies, and pride. With Jesus there is no condemnation (Romans

8:1). With Satan there is accusation (Revelation 12:10). Where you see Jesus working, you see good fruit. A bad tree, on the other hand, cannot bear good fruit (Matthew 7:18).

A large portion of the organized conservative Christian church has bought into Satan's lies about women (they are less than men), about the Gospel (it is only for the perfect or near-perfect), and about marriage (it is more important than human lives). They spiritualize these lies to make them appear righteous, but these dressed-up lies hide dead men's bones (Matthew 23:27) and bear nothing but rotten fruit. This rotten fruit is prolific across the years of history and across this planet. Only God knows the full devastation of these lies, but here are just a few over-arching examples of the horrific damage these lies have caused:

- Half the church (the female half) is maligned and disempowered in spreading the Gospel.
- Children grow up immersed in the lies and hypocrisy of their parents and the church and throw it off in disgust as they reach young adulthood.
- The culture views the church as "that crazy group that eats its own" (actual quote from an unbeliever who grew up in the church and now wants nothing to do with Jesus because he associates Jesus with hateful, judgmental human beings).
- Marriages are held in revered esteem regardless of whether they are toxic or healthy. The marriage itself is worshiped while the human lives and souls within the family are disposable.
- While the Bible teaches that marriage should tell a story of Christ and His bride, the Church—toxic marriages tell a story about Satan and the bride. The enemy accuses and condemns and defeats the child of God.

- Abusive marriages tell a lie about God, and the name of God is blasphemed in the world.
- The lives of women and children are covertly and systematically destroyed from the inside out.
- The church misses out on a beautiful opportunity to minister to the oppressed and bring glory to God by humbly learning and growing in the love of Jesus Christ.

Many women of faith in toxic marriages are afraid to tell people at church. They don't want to embarrass their husbands or be seen as a bad wife who is "tearing down her husband." However, when they get to a place of utter desolation and desperation, their church is often the first place they turn to for help. Within their churches they have invested their time in ministry, their financial resources, their emotional energy, and their love. They want to believe their church represents the loving body of Christ, and though they are usually fearful, they faithfully trust that if anyone might be able to help them, the church will. *If only the church could be trusted to do this.*

Instead, when the hurting woman finally puts herself in the vulnerable position of reaching out for help from her church, she often experiences one of the most egregious, shocking, and damaging phases of her journey: rejection and vilification from her church family. Why? Why does the very institution that claims to represent Jesus Christ in this world *not only walk past* a woman who has been emotionally and spiritually beaten over the course of decades, but *actually kicks her in the back* while she is down on her face in fearful supplication, begging for mercy and help? I've seen this over and over again. If it hadn't happened to me, and if I hadn't heard countless testimonies of the same from women all over the world, I would not have believed it was possible. Even now it is difficult to wrap

my brain around this. I used to have a naive view of the organized church, projecting my own passion for unity and peace on them. This is a perfect example of cognitive dissonance. We believe our church is good and loving, but when a revered idol like marriage is threatened, their behavior is shockingly hateful.

In talking with others about this ironic phenomenon, I've come up with some theories for why this is a common experience for emotional and spiritual abuse victims who are just waking up and trying to get to a place of safety.

One theory is that the leaders in the church have a savior complex. This happens when people have a deep need inside of themselves to find their identity in rescuing others. You would think this would be a prime reason for helping an abuse target who comes forward. And sometimes they will try to help—at first. *But here's the catch*: in many conservative Christian churches, the institution of marriage is treated as if it is a living, eternal soul that must be protected at all costs. **So it isn't actually the real living eternal soul they are interested in protecting as much as it is the marriage itself.** They are invested in being the savior of *the marriage.* This presents a serious problem when the victim is looking to get out of the marriage to a place of safety in order to build a new life of peace—free of abuse. As long as she agrees with the church that the ultimate goal is to salvage the abusive marriage, they will help her toward that goal. But *only* that goal. Because the marriage is what matters to them—not her or her children.

Often what happens is that the abuse target, being the agreeable and conscientious woman that she is, will go along with the church's agenda in the hope that perhaps the church can help her abusive husband change. **So the secondary goal of the self-appointed**

church savior is to change the abuser. They have a high view of their ability to convince the abuser of his wayward ways and a low view of the fact that his intimate partner has been praying and trying to do this for decades already. Right from the beginning they've put themselves in the position of the wise and all-knowing savior while putting the survivor in the position of failing in her duties to save and change her abuser.

She might try to send them articles or books or information she has learned in her quest for answers, but they won't be interested. They believe they already have the answers, and they don't need to learn anything more, at least not from a woman like her. She might try to offer them her own insights based on years of living with him and studying every nuanced thing about him to try to figure out how to make him happy and solve the puzzle of her painful relationship. But again, they aren't really interested in her input. In fact, she begins to annoy them after a while. Do you see how this is eerily starting to feel like life with her controlling husband? I point this out again because it is so important to remember what drives this kind of behavior: **a misogynistic view of women coupled with a fundamental belief that men should have a power-over position in relation to them.** This is the very root of abuse and re-abuse, and it bears repeating.

In trying to save the abuser from the error of his ways, the church takes on the role of God in his life. This is ignorance at best and arrogance at worst. **Always remember that their reason for wanting to change the abuser is to achieve their number one goal: *save the marriage.*** If he changes just enough to convince his emotionally unstable wife, maybe she'll settle down and get back to the business of servicing him the way good wives should. Of course, the abuser usually responds to the church's intervention by putting on a big

my brain around this. I used to have a naive view of the organized church, projecting my own passion for unity and peace on them. This is a perfect example of cognitive dissonance. We believe our church is good and loving, but when a revered idol like marriage is threatened, their behavior is shockingly hateful.

In talking with others about this ironic phenomenon, I've come up with some theories for why this is a common experience for emotional and spiritual abuse victims who are just waking up and trying to get to a place of safety.

One theory is that the leaders in the church have a savior complex. This happens when people have a deep need inside of themselves to find their identity in rescuing others. You would think this would be a prime reason for helping an abuse target who comes forward. And sometimes they will try to help—at first. *But here's the catch*: in many conservative Christian churches, the institution of marriage is treated as if it is a living, eternal soul that must be protected at all costs. **So it isn't actually the real living eternal soul they are interested in protecting as much as it is the marriage itself.** They are invested in being the savior of *the marriage.* This presents a serious problem when the victim is looking to get out of the marriage to a place of safety in order to build a new life of peace—free of abuse. As long as she agrees with the church that the ultimate goal is to salvage the abusive marriage, they will help her toward that goal. But *only* that goal. Because the marriage is what matters to them—not her or her children.

Often what happens is that the abuse target, being the agreeable and conscientious woman that she is, will go along with the church's agenda in the hope that perhaps the church can help her abusive husband change. **So the secondary goal of the self-appointed**

church savior is to change the abuser. They have a high view of their ability to convince the abuser of his wayward ways and a low view of the fact that his intimate partner has been praying and trying to do this for decades already. Right from the beginning they've put themselves in the position of the wise and all-knowing savior while putting the survivor in the position of failing in her duties to save and change her abuser.

She might try to send them articles or books or information she has learned in her quest for answers, but they won't be interested. They believe they already have the answers, and they don't need to learn anything more, at least not from a woman like her. She might try to offer them her own insights based on years of living with him and studying every nuanced thing about him to try to figure out how to make him happy and solve the puzzle of her painful relationship. But again, they aren't really interested in her input. In fact, she begins to annoy them after a while. Do you see how this is eerily starting to feel like life with her controlling husband? I point this out again because it is so important to remember what drives this kind of behavior: **a misogynistic view of women coupled with a fundamental belief that men should have a power-over position in relation to them.** This is the very root of abuse and re-abuse, and it bears repeating.

In trying to save the abuser from the error of his ways, the church takes on the role of God in his life. This is ignorance at best and arrogance at worst. **Always remember that their reason for wanting to change the abuser is to achieve their number one goal:** *save the marriage.* If he changes just enough to convince his emotionally unstable wife, maybe she'll settle down and get back to the business of servicing him the way good wives should. Of course, the abuser usually responds to the church's intervention by putting on a big

show of how he has started to have a change of heart and now wants to save the marriage. This plays right into the church's number one priority, so they jump on that (as the abuser knows they will) and then turn to the wife, expecting her to trust his sudden change and get back in bed with him (literally and figuratively speaking), which is exactly what the abuser wants.

So let's review the order of priority here. A victim comes forward for help. **She needs to be emotionally and spiritually and physically safe.** That ought to be the number one priority, but the number one priority of the church is to **save the marriage**, and the number two priority is to **change the abuser** in order to achieve the number one priority. So the abuser puts his energy into performing an act for the church, making it appear he has changed so he can regain his control over the woman, and while he is doing this, he is also covertly planting seeds of doubt in everyone's minds about her, paving the way for the future smear campaign he will need to launch in case his plan doesn't work, and she leaves him anyway.

The important point to remember here is that **the abuser is almost always the one who wants to save the marriage.** Think about it. Abusive men need to maintain control over their targets. It is a private and public affront to him to have his wife slip away, and he is all about image management and control. His agenda to hang onto his victim ("save the marriage") appeals to the church's number one priority, which automatically places him on the side of righteousness in their viewpoint. **His goal and their goal are the same.** Then, when they compare this seemingly noble goal of saving the marriage to the wife's goal, which is to stop pretending, stop covering up, walk in truth, set healthy boundaries, get away from the abuse, and pursue healing—they side with the abuser. *In order to justify their abandonment of the victim, they need to do exactly what*

her abuser has done for decades—control and shame her. So that's exactly what they do.

This scenario plays out over and over again in churches all over the world. You need to know this in advance so you won't be shocked and traumatized when it happens to you. Instead, you will be fore-warned and prepared to make the hard decisions that come from being forced to stand alone while your church joins forces with your abusive spouse in demonizing and rejecting you.

> *"Can you imagine being on fire and having no one to help put out the fire? Instead of helping to extinguish the flames, they throw gas on the fire by denying its existence and telling you, as you burn alive, that you are not really on fire, and it can't hurt that bad. Or if they acknowledge any fire, they say you did it to yourself, so you deal with the flames. That's what this feels like— begging for help and having someone who says they love God throw gasoline on you when you're already on fire."* —Emotional Abuse Survivor

Another theory for why the church rejects the victims while helping the abusers is that the church has invested a lot of time, emotional energy, money, prayer, and effort into creating what they believe to be a warm, inviting church atmosphere. When people within the church get messy and have out-of-control problems, the people who have worked hard may have a sense that they've failed others and even God. There is a tangled web of confusion and shame around abuse, and it takes time, humility, education, wisdom, skill, and ex-perience to gently untangle the threads and bring hope and healing to victims and their families. I believe the church of Jesus Christ should be the ones leading the way in this area, and I pray God

will turn this around one day. But for now, **the church is the most dangerous place for a victim to try to find hope and help.**

When a church's agenda for this process of helping a victim has to end with an intact marriage and a happily-ever-after testimony, the process is doomed right from the beginning. So if the underlying motivation is warm fuzzies and a success story, then taking the time, energy, and humility required to unravel abusive homes is not going to appeal to many churches. If emotional abuse is crazy when it stays hidden within the family, then it borders on totally insane when we bring an ignorant (though perhaps well-meaning) religious community into the mix. The web is larger and more impossible to figure out at that point because now the abuser has a growing number of actors in his drama, and the victim gets to play the role of scapegoat over and over again, experiencing re-abuse that spirals her further down into a pit of total despair and agony. She has two choices at that point: go back to living a lie and suffering under oppression, or divorce her husband and suffer excommunication and religious shunning. This is a dark time in a victim's life, and it causes some to even see death as the only way out. That's how vile and harmful the church's re-abuse is, and it can't be sugar-coated.

It is my personal opinion that underlying all of that mess lies a theology rooted in the original sin of trying to be god-like over accepting our human limitations and resting in our Father's love just as we are. Good works over grace. Control over trust. Pride over humility. People who believe they are flawed and unlovable and need to be perfect in order to win God's approval tend to lay that burden on others. They see others as flawed and unlovable and in need of being perfect in order to win God's approval as well. Groups like this are a breeding ground for dysfunction. *The gospel holds out a different option*—the option to receive the love and

acceptance of Jesus regardless of our weakness, sin, and mistakes. Then we can extend that same love to others, believing God is big enough to work in individual lives, and He doesn't need us to act as Holy Spirits in the lives of others. When a woman comes forward needing help in a healthy, Christ-centered church, she will be loved and accepted right where she is. She will be believed and supported, regardless of what her decision about her future may be. She will be honored as a precious human being with rights to her own life and her own safety. Her boundaries will be respected. She will be directed to skilled, experienced, and licensed therapists to help her recover from trauma so she can be whole again—able to make her own good choices for her life and the lives of her children as well as lovingly serve others in the way she has been lovingly served. She will not be condemned, suspected, silenced, blamed, or excommunicated should she make the painful, last-resort decision to divorce her chronically abusive spouse.

I've noticed that when survivors get divorced and then excommunicated, they often find another church similar to the one they were kicked out of. The new church will embrace and help her. Why is this? Why does a church excommunicate a faithful member while embracing a new woman who shows up already divorced for the exact same reasons? I believe it is, in part, because of the two dynamics I just suggested: the savior complex and the feeling of failure when they couldn't save a marriage. When a couple gets divorced, it means all of the church's teaching and effort didn't work. It wasn't effective. They interpret the divorce to mean the church failed, and that's embarrassing. They fear it is contagious. If this couple gets away with divorce, it will set precedence, and everyone will be wanting a divorce for frivolous reasons. Why, some women might even claim abuse just to get divorced and find a new man! But if a woman comes in already divorced, the savior complex kicks into

gear, and they can reach out and love on her because she doesn't represent failure to them. In fact, they can feel good about what an awesome church ***they*** are while the church that kicked her out is the one in the wrong. Yes, apart from the radical gospel of Jesus Christ at work in our lives, this is how human nature plays itself out, even in the church.

COUNSELORS

"A biblical counselor demanded I get down on my knees in front of him with his legs spread eagle and beg God for forgiveness for my sin, and the church elder that referred me to him said there was no way the counselor meant anything by it."

"My Bible counselor told me that I had traumatized my abuser and that I was bitter and vindictive. When I tried to explain how hard I worked to understand my husband and solve our marriage issues, he told me I was committing the sin of idol worship."

"A biblical counselor said that if I separated from my abusive husband, it would be like saying to God 'I don't believe you can fix this.' I was heartsick, but I stayed and tried for another 15 years."

"A biblical counselor told me that my husband's affair was due to my sin. I wasn't loving him the way he needed love."

"Bible counselors traumatized my children and me and gave my husband a pass in their church even though he was cheating on me. We were not allowed to talk about emotional abuse because they said there was no such thing in the Bible. They could not control my husband's temper in meetings, but they said it was because he was so hurt by my unfair boundaries. At the very end when I had finally decided to get a divorce, they tried to frighten me by saying I shouldn't expect to get much."

"One Bible counselor told me there wasn't a problem with my husband's anger but rather there was a problem with my filter. I was simply perceiving his behavior as cruel and angry when it wasn't." (This is a great example of gaslighting, by the way—telling the victim that what she is experiencing is in her head. It's one of the most insidious and brain damaging abuse tactics.)

"My Bible counselor was an engineer who told me I had committed the sins of not loving my husband enough and not being submissive enough. He asked me why I was

committing the sin of complaining when my husband had never hit me? I was committing the sin of ungratefulness as well. He told me my life would be better if I read the Bible and prayed more."

"A Bible counselor told me I might be schizophrenic because sometimes I seemed cheerful and other times I seemed depressed. I was so troubled by it (of course my husband agreed with the counselor) that I eventually went to a mental health professional who said that even in our brief session, she could clearly see that I had no psychosis. That Bible counselor was way out of line in diagnosing me that way."

"In my Bible counselor's office, I realized I would never be perfect enough to deserve any love. It was the most devastating moment in my life."

"A Christian counselor insisted that I focus on all my sins and failings, and everything would be fine if I would just forgive and have more faith. Also, she insisted that her own problems were worse than mine, so why should she empathize with me?"

—Quotes from Emotional Abuse Survivors

There are several different types of counselors to consider when looking for help to deal with and recover from a toxic relationship. You need to understand what your options are before deciding what's best for you. Here are a few of the main ones listed according to the credentials they require:

1. Requiring a masters level of education, practice hours, and licensure (ethical accountability):
 - Licensed clinical social worker (LCSW)
 - Licensed mental health counselor (LMHC)
 - Licensed professional counselor (LPC)
 - Licensed marriage and family therapist (LMFT)

2. Requiring a doctorate level of education, clinical practice, and licensure:
 - Clinical psychologist (Ph.D. Or PsyD) - can assess and diagnose mental illness
 - Psychiatrist (MD) - focuses on medical treatment of psychiatric disorders and can prescribe medication

3. Requiring no education, no experience, no accountability, no skills, no ongoing training:
 - Biblical counselor

Guess which of these choices most women of faith turn to for help most often? The biblical counselor. According to pastoralcounseling. org, these are the qualifications for a biblical counselor:

Quite simply, anyone who wants to be a biblical counselor can consider themselves one. Biblical counseling is based on the idea that all one needs is a deep understanding of the Scripture to offer counseling. While it's true that many who consider themselves biblical counselors are ministers or other

types of church leaders, this isn't a requirement. Any person who feels as though they have been called to offer biblical counseling to another may do so.

*Because all biblical counseling is to be based on the Bible and the Scriptures, there is no need for any courses on behavioral study, counseling, therapy, or psychology. Because of this, few biblical counselors hold degrees in counseling. In fact, the practice of biblical counseling is expressly against bringing these secular studies and treatments into the discussion. **All counseling should focus on identifying sin, changing behavior to overcome that sin, and making one's life more in line with what the Bible outlines.***

Doctors go to medical school because there is a wealth of knowledge and experience they need before they can understand and practice medicine on real people. So licensed counselors and therapists go to school because there is a wealth of knowledge and experience they need before they can help real human beings with the intricate complexities of dealing with and healing from chronic abuse, among other things—especially more nuanced and confusing *emotional abuse* (which is present in every other type of abuse as well).

I've read over 200 books on the subjects of emotional and spiritual abuse, narcissistic abuse, verbal abuse, healing from abuse, women's issues, shame, anxiety and depression, the problem of suffering, faith, neuroplasticity, divorce issues, grief, child development theory, emotional intelligence, and more. I've purchased and listened to seminars and taken online classes for licensed counselors (I am not a counselor) on this and related subjects. I have twenty-five years of experience living in an emotionally abusive marriage and fourteen years of experience in dealing with a large, spiritually abusive church

that ultimately excommunicated me. I've got almost two years of experience working directly with and learning from hundreds of emotional abuse survivors online. I've written twelve courses and have a private life-coaching practice with a full queue and a long waiting list. I can confidently say that I know **something** about this subject. *But I can just as confidently say that I am **not even close** to knowing what I could know.* And this is why I continue to eagerly learn more and hope to do so for the rest of my life.

The fact is, we don't know what we don't know, and if we think we do, we're just plain stupid. That's what I'm seeing here: utter stupidity on the part of ignorant people who call themselves counselors and who behave like elephants in a china shop—people who think they know but who clearly do not. After the conservative church, a biblical counselor will almost always be the next most dangerous resource for an emotional and spiritual abuse victim to turn to for help at this time in history.

Here again, just like in the church, you've got self-appointed saviors who arrogantly shun education and experience (because in their minds they already have all the answers and there's nothing more to learn) picking up where the toxic partner left off by ***rubbing the victim's nose in her sin*** and telling her to clean up her act, do her duty as a Christian woman, and be perfect. They call this biblical even though Jesus Christ never did this to anyone, ever. I used to think that maybe a biblical counselor could at least help others in their relationship with God, but I no longer believe that anymore, and here's why: ***if their goal is to keep you focused on your sin and make you perfect, they are not in alignment with Jesus Christ, so how in the world can they help you build an authentic relationship with Jesus?*** They will actually hinder your growth. Do you know what you need to build a relationship with Jesus? ***Jesus.***

Here's an idea. Get to know Jesus by reading the Gospel of John over and over again. The more you read it, the more you will discover His audacious love for you, and the more you experience this love, the more you will love Him in return. His love will set you free, and His people will always point you toward His love—not toward your sin. If their focus is on your sin, it isn't on Jesus, and that's why they can't help you. *Always remember that evil keeps you focused on sin and mired in shame while Jesus sets you free from both.* Oh, and by the way, the things I've learned in my studies, both Christian and secular, have all verified what God teaches us in His Word. They do, however, contradict religious Pharisaical propaganda. That's probably why Pharisee types don't like it.

I also hope you noticed something about every survivor quote I shared in this section. Those Bible counselors wreaked havoc on human lives with their hateful propaganda, but they could never be held accountable for their abuse because *there were no rules for them*. They have placed themselves above the law. They make a mockery of the Bible and a mockery of God Himself. And this is why I don't recommend Bible counseling for your toxic relationship. I do, however, recommend that you get personal therapy with an experienced and licensed professional who is especially skilled in helping victims of trauma.

FRIENDS AND FAMILY

Friends and family are often divided on how to deal with the information you might give them about what's going on in your life. People who have no experience with abuse will not be able to relate to what you're telling them. It's human nature to filter what we learn and see through the lens of our own experience, so if someone has

no framework with which to process your experience, they won't be able to understand or respond to it in an appropriate way. This can be painful because what you really need is validation, and you won't always get that.

If your friends and/or family are religiously conservative, you may get a lecture about what you can do to fix yourself and your situation. This is because human beings have a propensity to live from a shame-based foundation. Their answer to their shame is to put on a false self and work hard to be perfect, so that's their answer for you too. Here are some of the messages they will either outright say or covertly imply:

- "There must be something wrong with you that inspires your husband to treat you poorly. Figure it out before God and fix it. God will give you the strength and grace to do this."
- "Are you praying about this? Are you trusting God? He can fix your husband, but you might need to have a little more faith."
- "Focus on the good things and be grateful for what you have. Nobody's marriage is perfect."
- "If my husband did that to me, I'd never put up with it. Why do you?"
- "You always were too sensitive, even as a child. I think you expect too much of relationships. You expect them to be all romance. Accept real life, Honey."
- "Please don't talk about your marriage problems with us. God says not to gossip, and we're trying to honor God."

Not everyone will respond this way though. You may have some mature, emotionally and spiritually healthy people in your life who

can handle what you have to share. These are God's gifts to you and will be your life-line to healing. Here are some of the responses you will get from those who have either experienced deep suffering themselves or who are grounded in the love of Christ and have no need to feel more spiritual or holy than you.

- "I'm so sorry you are in such deep pain. Would you like to talk about it?"
- "When your husband does that, how does it make you feel?"
- "How can I pray more specifically for you?"
- "What can I do to help you right now?"
- "I don't know much about this kind of thing. Do you know where I could learn more so I can better understand what you're going through?"
- "I believe you. I can't imagine going through what you've been through. Tell me more."

Do you see the difference? The second group is secure in their identity. They don't need to one-up you. They have healthy boundaries and a realistic perspective of evil and how it works in this world. They aren't naive, nor are they interested in having power over others, so they aren't going to try to control your mind, will, and emotions. They have a solid faith in God and don't need to take His place in your life. When you are in the process of getting yourself to a safe place and beginning the long process toward recovery, you need a few of these safe people in your court with you. You need the opposite of what you've experienced in your abusive relationship. But do you know what you need most to be set free from emotional and spiritual abuse which are rooted in lies about men, women, marriage, and God? You need to know the truth—especially the truth about who God is and how He views you. That's what we'll be looking at next.

Check Point

Are you hanging in there? I've talked to so many women who have told me the worst thing they've ever been through is the rejection of those they loved. One of the biggest obstacles for me in getting out of my own destructive relationship was this exact fear. I didn't want to lose everyone. As it turned out, I did lose many people, but I didn't lose **everyone**. And most women who have survived this kind of traumatic experience have told me they are stronger, more resilient, and more free as a direct result.

It's okay to be afraid. Brene Brown says *"courage is fear walking."* Just reading this book is *fear walking.* Are you ready for the next chapter? It won't clear up everything for you, but I hope it clears up some of the most pressing puzzles you're wrestling with right now when it comes to God and your marriage experience.

Let's step into this together.

THE
FLYING
✼FREE
PODCAST

with Natalie Hoffman

The *Flying Free* podcast is a support resource for women of faith who need hope and healing from hidden emotional abuse, spiritual abuse, and narcissistic abuse. Tune in each week to hear conversations with Christian emotional abuse advocates and fellow survivors who will walk with you on your journey up and out. We hear you. You are not alone.

Learn more and access all episodes here: https://www.flyingfreenow.com/flying-free-podcast/

"Natalie succinctly nails it on topics related to abuse in Christian marriages. She is very knowledgeable and has a gift for cutting through the myriad facets of psychological abuse, how to recognize it, respond to it, and make healthy choices for yourself that may include leaving it. Natalie takes a complicated subject and makes it simple to understand, an important aspect for women who have been broken down to the point of despair. "

—Podcast Listener

CHAPTER SEVEN

God's Role

GOD'S VIEW OF WOMEN

Spiritual abuse puts people at odds with their best Friend.
It causes some people to question, doubt, and even run
the other direction from their Source. They see their
strongest Advocate as their biggest accuser, their Ally as
their enemy. For some people, spiritual abuse can have
eternal consequences.

—David Johnson, *The Subtle Power of Spiritual Abuse*

This chapter is a turning point for us. The first six chapters focused
on the lies that form the foundation of your confusing and painful
marriage. Because many of these lies are about how God views men,
women, and marriage, the abuse you've experienced is not only
emotional, but *it is also spiritual*. This is perhaps the most devastat-
ing consequence of abuse that takes place in Christian homes. The
last five chapters will focus on the truth you need to know in order
be free from those lies and the devastating bondage they have placed
you in.

I believe we find the truth in the person and character of Jesus Christ. It's really that simple, but it may not feel that way to you right now. Many women who have been spiritually abused have a love/hate relationship with the Bible. Some parts of the Bible may have been a soothing balm to your spirit in the aftermath of an abusive incident where your brain and emotions were twisted like a pretzel by irrational, circular conversations and shaming arguments. Maybe you turned to the Psalms after those times, drinking in the words that tell you God is powerful and sees you in your suffering. That He will one day rescue you from the enemies that pursue you. That you can hide in His strong tower until the storm has passed. Or maybe you read in the New Testament about the love Jesus showed to suffering and hurting people, including women, and it brought you comfort.

But other parts of the Bible were used to shame you and tear you apart, causing you to believe God loved your husband more than He loved you. Still other verses were taught from the pulpit of your church to mean that women are essentially inferior to men, and women can only please God if they are fulfilling certain roles that are historically associated with pagan, patriarchal cultures. There are hundreds of insightful, ground breaking, scholarly books written on these subjects, digging deep into the handful of controversial verses that have been used to promote a misogynistic agenda throughout history. We don't have space in this book to even begin to explore that vast landscape, which is why I am including several additional resource recommendations in case you'd like to explore this further. But for now, I'd like to make the point that while your husband's view of women and your church's view of women may be destructive, God's view of women is good. It's **very** good.

In Genesis we see that God made both male and female in His image (Genesis 1:26). If women are created in the image of God, this means He has bestowed the highest privilege of the universe upon them. It is evidence that when He looks upon us, He views us with honor and love. Genesis 3:8 teaches us that women, along with men, were given equal access to God, and according to Genesis 1:28, women have equal authority with men over God's creation (Genesis 1:28).

God not only gave women these honors and privileges along with men, but He also gave women an incredible responsibility in Genesis 2:18. The English words most often used in modern translations are "suitable helper," but this translation doesn't do the actual words justice. The original Hebrew words used in this verse are *ezer kenegdo*. "Ezer," a word used to describe God as a warrior numerous times in the Old Testament, is translated "to rescue, to save, to be strong," and "kenegdo" is translated "corresponding to." So when God said, "I will make a 'helper suitable' for him (Adam)," He was saying in essence "I will make a **warrior corresponding to him**." (http://temple.splendidsun.com/PDF/equalto.pdf) That's quite a difference in translation and meaning. Man didn't need someone to reign over; he needed an equal to reign **with**.

Here's how Carolyn Custis James expands on this rich and beautiful truth in her book, *Half the Church: Recapturing God's Global Vision for Women*:

> *"Like the man, she is also God's creative masterpiece — a work of genius and a marvel to behold — for she is fearfully and wonderful made. The ezer never sheds her image-bearer identity. Not here. Not ever. God defines who she is and how she is to live in His world. That never changes. The im-*

age-bearer responsibilities to reflect God to the world and to rule and subdue on His behalf still rest on her shoulders too.

God didn't create the woman to bring half of herself to His global commission or to minimize herself when the man is around. The fanfare over her is overblown if God was only planning for her to do for the man things he was perfectly capable of doing for himself or didn't even need. The man won't starve without her. In the garden, he really doesn't need someone to do laundry, pick up after him, or manage his home. If Adam must think, decide, protect, and provide for the woman, she actually becomes a burden on him — not much help when you think about it. The kind of help the man needs demands full deployment of her strength, her gifts, and the best she has to offer. His life will change for the better because of what she contributes to his life."

In the Old Testament we see examples of God's ezer kenegdos going into battle for the glory of God: Deborah, Esther, Ruth, Abigail, Rahab, and Hannah, to name a few. And God's view of women hasn't changed. When Jesus came to this earth, He lived in an unapologetically patriarchal culture that viewed women as less than men. He broke all the cultural rules when He talked to women without going through their husbands or fathers, when He gave a Samaritan woman the responsibility to evangelize her home town, when He invited women to follow Him and learn from Him (something only men were allowed to do with a Rabbi), and when He entrusted Mary Magdalene with the very first gospel message. He surrounded Himself with women and treated them with honor, **fully expecting both women and men to spread the gospel when He was gone.** You wouldn't have seen a religious leader doing that back

then, but He broke the social norms that divided men and women and established a new kingdom of oneness and unity in Himself.

After He was gone, you see women receiving the Holy Spirit (Acts 2:17) and being released into ministry of every kind. Junia was an apostle (Romans 16:7); Philip's four daughters were prophetesses (Acts 21:9); Euodia and Syntyche were evangelists (Philippians 4:2-3); Phoebe was a deaconess (Romans 16:1-2); and Priscilla was a pastor/teacher (Romans 16:3-5, Acts 18:24-26). Paul spread this revolutionary message of unity by speaking of men and women together as **brothers and sisters.** In fact, he refers to both men and women as **sons**, a position viewed as a place of honor in that patriarchal culture. This would have been as astounding to his audience back then as it is to many extremely conservative Christian churches today who have all but ignored His clear teachings:

> *"For all who are being led by the Spirit of God,* **these are sons of God.** *For you . . . have received a spirit of adoption as sons . . .* [and are] *heirs of God and fellow heirs with Christ . . ."* (Romans 8:14-7)

> **"For you are all sons of God** *through faith in Christ Jesus... there is neither male nor female; for you are all one in Christ Jesus."* (Galatians 3:26, 28)

> *"Therefore,* **my brothers and sisters**, *be eager to prophesy..."* (I Corinthians 14:39)

Think of every verse in the New Testament that talks about our new life as followers of Christ. Do they distinguish between male and female followers? **The vast majority of them do not.**

> *"'In the last days,' God says, 'I will pour out my Spirit on all people, and* **your sons and your daughters will prophesy,**

your youths will see visions, your seniors will dream dreams.
***Even on my male servants [ministers] and on my
female servants [ministers],*** *I will pour out my Spirit in
those days, and they will prophesy."* (Acts 2:17-18)

*"But you are a chosen race, a royal priesthood, a holy nation,
a people for his own possession, that you may proclaim the
excellencies of him who called you out of darkness into his
marvelous light."* (I Peter 2:9)

*"You are worthy to take the scroll and to open its seals
because you were slain, and with your blood you purchased
for God people from every tribe and language and people
group and nation. You have made **them to be a kingdom
and priests to serve our God,** and **they will reign** on the
earth."* (Revelation 5:9-10)

But what about the verses that do make a distinction between men
and women? First, we need to remember that there aren't very many
of them, and Bible scholars have wrestled and disagreed with their
meanings in light of the rest of Scripture throughout the history of
Christianity. So if the teachers in your denomination make it sound
like their way of translating and interpreting those verses is THE cut
and dried version of The Truth, I encourage you to do a little more
research so you can make your own decision based on information
from all sides of the historical debate, because the way modern
teachers and preachers spin those verses contradicts the message of
the Bible as a whole, and the fruit of their power-over theology is
horrific. It's worth studying. I promise!

I spent my early life heavily influenced by the teachings of Bill
Gothard, and later, as a homeschooling mother of nine, I immersed
myself in the similar teachings of Doug Phillips. Both of these men

were misogynists whose views they took to their logical conclusion by sexually abusing young women. I was also a member of John Piper's church in Minnesota for many years until they excommunicated me for divorcing my emotionally abusive husband. Piper was heavily influenced by the writings and theology of a Puritan preacher named Jonathan Edwards (18th century) and the writings and theology of Protestant reformer John Calvin (16th century), who was influenced by the philosophical work of Roman Catholic Bishop of Hippo, St. Augustine (4th century AD), who was influenced by the Ancient Greek philosopher, Plato, who predated Jesus Christ by 400 years. All of these men viewed women as inferior to men as is evidenced by the things they wrote about women. (See Bob Edward's book, *A God I'd Like to Meet* for more detailed information.) Is it any wonder that those who follow these teachers also encourage the oppression of women and ***call it good***?

I'm sharing a little bit about my own history so you can see how this works. I was content most of my life to just assume these men knew what they were talking about. I remember hearing leaders in my religious circles call other authors and teachers who had studied the same subjects and believed differently "heretics." It wasn't until I dared to read some of those "heretical" authors for myself that I discovered a new world of information that connected the dots, brought greater clarity to the Word of God, and strengthened my faith in a God who loved all of His creation—not just half of it. It transformed my life.

When we are confused about certain verses, we can consider how they fit into the entire message of *the whole of Scripture.* That message is that God loves both men and women and has a destiny for each one of us that is found in Christ. **The gospel is good news for**

everyone regardless of gender. As Sarah Bessey puts it in her book, *Jesus Feminist: An Invitation to Revisit the Bible's View of Women:*

> *"Life in Christ is not meant to mirror life in a Greco-Roman culture. An ancient Middle Eastern culture is not our standard. We are not meant to adopt the world of Luther's Reformation or the culture of the eighteenth-century Great Awakening or even 1950s America as our standard for righteousness. The culture, past or present, isn't the point: Jesus and his Kingdom come, his will done, right now— that is the point."*

Valerie Jacobsen, a domestic abuse advocate, expands on this further:

> "Wherever we are, in whatever condition, at whatever stage in our lives, we are called to God as his worshipers, and we have been put in community with men as our fathers, husbands, sons, and friends, to glorify, love, and serve the Living God together. Like two pillars that support a portico, we women are called to comparable service with men, to stand across from them as equal allies and as indispensable helpers (ezer kenegdo), and when this life is past, we will reign, in one kingdom together, as priests with them.

> "Our community life is not intended to have the features of a military hierarchy, neither in the family nor in the church. First Corinthians 11 beautifully summarizes our interdependent alliance—'*For man did not come from woman, but woman from man; neither was man created for woman, but woman for man. It is for this reason that a woman ought to have [a symbol of her] authority over her own head, because of the angels. Nevertheless, in the Lord*

woman is not independent of man, nor is man independent of woman. For as woman came from man, so also man is born of woman. But everything comes from God.'

"Modern patriarchalists and hierarchical complementarians have defied this biblical simplicity, insisting on the power to rule women according to their own desires and to place restrictions on us which are not found in Scripture. They fight tirelessly to return men to Adam's original 'not good' condition, when he was alone in the Garden sensing, deciding, and ruling alone (Genesis 2:18). But God has called us to take dominion together (Genesis 1:27-28) as equals, to share in community life, to exercise discernment and wisdom together, and to use our gifts and strengths to serve one another.

"Patriarchalists and hierarchical complementarians resist the commandments of Christ in I Corinthians 12, boldly telling us women that when it comes to hard decisions and important work in Christian community, 'I have no need of you.' But God himself has brought us into union with Christ as members of His Body, and the Holy Spirit is causing us to grow up in maturity, to bear good fruit, and to use the graces and gifts he has given us."

—Valerie Jacobsen

GOD'S VIEW OF YOU

"I thought I was bound to endure the psychological mind games forever because 'God hates divorce.' I thought I was destined to a life of trying to do as much as I could to be healthy while constantly being dragged back under by my husband. I thought confusion would be a fact of life for me and my children forever. Now I know that was never God's desire. I know that although my ex constantly puts barriers in front of me, he has no power. I know that God's plan for me is freedom and strength. I know that God has brought me a long way, and He will continue to free me. I know I am beloved by God and others."

"I used to think God was handing out judgment for my sin. I thought since I let my husband rape me when we were engaged, all the abuse that followed in our marriage was my punishment. Now I know God sees me as His precious daughter, that He is grieved by the sins committed against me, that He doesn't hesitate to forgive my mistakes, and His justice is forthcoming. I know He rejoices with me as I evade the traps that have been laid in my mind and in my life. I know He wants me to be free and experience peace. I don't think God is punishing me anymore. I know He has forgiven me and is making a way for me to live in freedom which includes not taking the guilt or responsibility for the sins committed against me."

"I used to think that I needed to subject myself to rules made by the church and my husband in order for God to tolerate me. My husband didn't love me. He spent a great deal of time and energy pointing out all of my faults. So how could God love me? But after leaving, I realized that there were two incredible gifts God gave to me. One was the fact that Christ died on the cross for my sins. The second gift was one I never really appreciated or thought about until I left my husband, and it was this: God created me. God gave me—*me*. He knit me in my mother's womb. He gave me the breath of life. He sustains me and my children every day. Creation and Redemption are both amazing, infinite gifts, and you can't have one without the other. All those years living with my husband, I had to completely deny God's creation of me and my intrinsic worth and value. Now I have gratefully realized my worth, stood up for myself, and found God to be greater than I ever imagined—far greater than the caricature that was presented to me by my husband."

"I knew God was faithful, but it was hard to get close to Him while living with my emotionally and spiritually abusive husband. Now that I'm out of that relationship, it is changing. It's as if there was background noise in my life keeping me from hearing God."

"I used to think that God loved me, but He was punishing me for making the bad choice to marry my husband. Now that I'm out of abuse, I've learned God loved me all along, and he wasn't punishing me. He has been there with me every step of the way and has provided in ways I could not have imagined. I know that God has me and loves me, and my only job is to love him back and share the love he gave me. I stopped trying to fix anyone or drag them unwillingly towards something they don't want. I am free in so many ways."

"I used to believe I deserved what I got because of my choices. I now believe God desires His best for my life despite my sinful choices. His best for me was escaping my abusive marriage."

"I thought God was punishing me because I got pregnant before I was married. I believed I had to stay with my abuser and endure as part of my life-long punishment, but now I know that God loves me unconditionally and wants what is best for me."

—Quotes from Emotional Abuse Survivors

Before we explore the beauty of how God sees us, let's consider what is underneath our passionate quest to please our parents, our husband, our friends, and our church community: *we deeply long to be loved and accepted.* We are hard wired for intimate connection, and when that need isn't being met, we experience shame and grief. As Christians, we know in our heads that God is the only One who can meet that deep need for the safety of unconditional love and acceptance, but when we experience rejection and constant criticism from our intimate partner over a period of many years, and when those messages are further amplified by misogynistic teaching in our churches, we begin to believe deep in our soul that we are worthless and even God couldn't love us.

The Bible says that Satan is the accuser of the brethren and the father of lies. Wherever you see accusation and lies, you see the enemy at work building strongholds in the lives of people. There is a Big Lie that has existed since the beginning of time, and it has two parts. The first part of the Big Lie says **God isn't good**, and the second part says **you have no value**. The first part tells a lie about God, and the second part tells a lie about you. It's the same old lie the devil used in the garden. "*God doesn't have your best interest in mind. Look what He's done! He has withheld something good from you! And you need to be God-like in order to truly find purpose and meaning in life. Have a bite.*"

This is what patriarchal, power-over theology promotes: the lie that God is good to men, approves of men, and caters to male needs while dismissing the needs of women (God isn't actually good, after all), and the lie that men have intrinsic value *while the worth of a woman must be earned through her efforts to be God-like as a perfect wife who makes everyone happy—especially her husband.* This is exactly what abusive relationships model for the culture around us.

So what's the truth, and how do we get to a place where we believe the truth?

Jesus Christ said that HE is the way, the truth, and the life. At one point when my own faith was wavering as a result of relentless emotional and spiritual abuse from my husband and church, I decided to immerse myself in the Gospel of John in an attempt to focus on what was essential: ***knowing Jesus***. So I spent a year just reading that book over and over and over again. I began to see things about God and myself that I had never seen before. I began to realize just how much I could rest in this Savior. That He wasn't a God who stood over me with a critical eye and a sledgehammer ready to come down upon me if I made a mistake and took a wrong turn in the road. Can I give you an example from the second chapter of John?

Remember when Jesus' mother told Him the guests were out of wine? She wanted Him to do something about it. She knew she couldn't, but Jesus could. He was God, and so far, only she and Joseph were aware of that (and Joseph was likely dead by this time as he isn't mentioned beyond Jesus' childhood). But what was Jesus' response? *"No, Mom. It's not my business."* Talk about boundaries! There was a need, but He felt no obligation to fix it just because His mom wanted to. So what does His mother do? She goes ahead anyway and tells the stewards to do whatever Jesus says! **She disregards Jesus' boundaries and plows ahead with her own desire to help out**. And Jesus? Does he reprimand her? Tell her to get out of everyone's business? Judge her motives? Tell her to stop being a busybody? Accuse her of rebellion? Insubordination? I mean, seriously! A woman goes over GOD'S head and gets a wee bit bossy! Can't you just hear the propaganda machine gearing up?

Look at the amazing response of our precious, gracious God. He doesn't argue. He doesn't rebuke. Instead, He graciously and lovingly honors her by quietly submitting to *her desires*. And do you know what's more incredible? *She knew He would.* She was fully resting in His character. She knew she was totally, 100% safe in His love for her. She knew **He knew** her heart. And of course, He did. Isn't that incredibly beautiful? And so began the miraculous earthly ministry of our God and Savior, Jesus Christ.

What about you? Do you live as a child reveling in His safe love for you? Just like Mary, *you can.* That's just one little hidden gem layered within the pages of the Gospel of John. And this message is for you. Jesus is SO not like your destructive spouse. He is SO not like any churchy person who shamed you or treated you as less than worthy because you were desperately seeking answers and help. He is our humble, sweet, kind, powerful creator and *friend*, Jesus. And He knows you, inside and out. He knows your heart. He created you fully human and embraces you exactly in your humanness—all the good and all the bad. You are totally safe and totally loved. Right now, no matter how badly you feel about yourself, no matter what choices you've made, no matter if you've failed yourself or others, He loves and accepts and likes you just as you are. ALL THE TIME, and NO MATTER WHAT. *Period and Amen.*

My deepest desire for you is that you will one day shake off the chains of the enemy and his lies and find your deep hope and joy and peace in resting in the unconditional love and acceptance of your very good God—your loving Heavenly Father, your precious Savior, Jesus Christ, and your ever-present Helper and Companion, the Holy Spirit.

Your God is nothing like your abuser and his allies. I promise.

GOD'S VIEW OF ABUSE

"I knew that God loved me, but I couldn't figure out why those I sought help from didn't treat me as He did. They told me God had called me to suffer, and it was my job to suffer well. It was confusing because the character of God isn't that of a cruel, heartless punisher."

"One hard question I really struggle with is how do I really believe God loves me? I grew up in an abusive home and ended up with an emotionally abusive marriage. I feel like I was set up to fail, like I never even had a chance. I have such a hard time reconciling God's love with putting so many of us women in these situations pretty much from day one. We are primed to be abused. It doesn't feel like love to me."

—Quotes from Emotional Abuse Survivors

Many Christians believe God condones some kinds of abuse. Everyone seems to have their own standards for what constitutes abuse, and they also have their own ideas about how the various types of abuse fit into their personal theology. And every single one firmly believes his particular opinion about abuse is the absolute truth, and anyone who disagrees, especially an abuse survivor, is wrong and deserves to be shunned. Of course, most of them haven't even studied the subject. They just buy into the propaganda fed to them by teachers who believe in a historically pagan, power-over

structure of human relationships. It's disgusting and tragic. An abuse victim's pastor and Christian friends not only minimize what she is going through (as if they know), but they also callously lecture her about how God wants her to glorify Him through her suffering. What kind of a god requires the suffering of women and children in order to be glorified? Moloch, maybe. Baal, maybe. But not Jehovah God. He is not a sadistic, pagan god, and I believe what will glorify Him most is to expose misogynistic lies and teach the truth about abuse.

Contrary to the propaganda you've been taught, God doesn't set women up to be abused as children and then adults. God doesn't perpetrate abuse on human beings. Human beings do that all on their own. God doesn't control people. He let Adam and Eve choose, and He has let every human ever since choose. People sin, and they do horrible things to other people. We see the effects of this on a global scale. God promises to love us, to be with us, to assist us in our efforts to overcome the effects of sin here on earth, and to one day set us free for all eternity. Every effort we make to tell the truth, pray the truth, live the truth, and put our hope and trust in our Creator, advances His Kingdom a little bit further on this earth. When we take a stand against abuse, whether it is abuse in our own life or in the lives of others, we are working on His behalf and for His glory.

Here's what God really thinks of abuse:

1. **He hates it.**

> *"There are six things that the Lord hates, seven that are an abomination to him: haughty eyes, **a lying tongue**, and hands that shed innocent blood, **a heart that devises wicked plans**, feet that make*

*haste to run to evil, **a false witness who breathes out lies,** and **one who sows discord among brothers.***" (Proverbs 6:16-19)

Interestingly enough, Christians love to say "God hates divorce" (we'll get to that in a bit), and they will prohibit an abuse victim from getting legal protection from her abuser and even excommunicate her if she doesn't obey them. ***But they won't do a thing about abuse.*** Here's an idea: as long as we are getting radical about the things God hates, why not get radical about dealing with abuse? If God hates abuse, why are they not supporting the victim in helping her acquire legal protection and excommunicating her abuser? Because it's easier for them to side with the abuser, it requires less of their time and effort, and it supports their underlying misogynistic assumptions that men matter more than women.

2. **He says an abuser is a fraud, and his religion is worthless. These are wolves in sheep's clothing, and they are dangerous.**

> "*If anyone thinks he is religious and does not bridle his tongue but deceives his heart, this person's religion is worthless.*" (James 1:26)

> "*I have been on frequent journeys, in dangers from rivers, dangers from robbers, dangers from my countrymen, dangers from the Gentiles, dangers in the city, dangers in the wilderness, dangers on the sea, **dangers among false brethren.***" (2 Corinthians 11:26)

> *"But it was because of the false brethren secretly brought in, who had sneaked in to spy out our liberty which we have in Christ Jesus, in order to bring us into bondage."* (Galatians 2:4)

3. **He says abusers are an abomination.**

> *"He who justifies the wicked and he who condemns the righteous, Both of them alike are an abomination to the LORD."* (Proverbs 17:15)

Abusive men and churches justify the wicked and condemn the righteous when they support abusers and condemn victims.

4. **He says verbal abuse harms people and carries the power of death.**

> *"...the companion of fools will suffer harm."* (Proverbs 13:20)

> *"Death and life are in the power of the tongue."* (Proverbs 18:21)

> *"Like a madman who throws firebrands, arrows, and death is the man who deceives his neighbor and says, 'I am only joking!'"* (Proverbs 26:18)

Religious people say it's no big deal. God says it's a matter of life and death.

5. **He says emotional abuse is a heavy burden to bear up under.**

> *"A stone is heavy, and sand is weighty, but a fool's provocation is heavier than both."* (Proverbs 27:3)

> *"A man's spirit will endure sickness, but a crushed spirit who can bear?"* (Proverbs 18:14)

You may get no compassion or understanding from religious people, but your Creator and Savior sees and validates the horror of it.

6. **He has hard words for abusers who damage their children in different ways.**

> *"But whoever causes one of these little ones who believe in me to sin, it would be better for him to have a great millstone fastened around his neck and to be drowned in the depth of the sea."* (Matthew 18:6)

How many emotionally abusive fathers create a chaotic, confusing, hypocritical environment for their children to grow up in, causing those children to want nothing to do with their father's God. This is perhaps the most devastating result of covert abuse. Especially when it is endorsed by the church. God will not be mocked.

7. **He says verbal abuse (emotional abuse) is the equivalent of being gutted with a knife.**

> *"There is one whose rash words are like sword thrusts, but the tongue of the wise brings healing."* (Proverbs 12:18)

> *"My companion stretched out his hand against his friends; he violated his covenant. His speech was smooth as butter, yet war was in his heart; his words were softer than oil, yet they were drawn swords."* (Psalm 55:20-21)

Many emotional abuse victims are told that emotional abuse isn't real abuse. People who haven't experienced emotional abuse will ignorantly claim that *real abuse* is being beaten, and you have to beaten a lot for it to be serious enough to justify legal protection through divorce. Even then, they encourage the victim to forgive and suffer. But emotional abuse? No biggie to them. And it's certainly not something to even **consider** leaving your husband over.

But you need to know that **God doesn't see it that way.** He knows what it's like, and He sees what you're going through. I don't believe God views this as "no big deal." Unlike those who refuse to believe you or understand what it is like to live in an abusive environment every day, Jesus understands perfectly and takes what is happening to you seriously. Here's just a taste of the kind of emotional abuse Jesus endured on our behalf, and I hope this helps you realize how much compassion Jesus has for what you're going through.

1. **Pious Jews and Pharisees accused Him of working for the devil.**

 > "*The Jews answered him, 'Are we not right in saying that you are a Samaritan and have a demon?'*" (John 8:48)

 > "*But some of them said, 'He casts out demons by Beelzebul, the prince of demons...'*" (Luke 11:15)

2. **They mocked Jesus when He told the Pharisees they couldn't serve two masters.**

 > "*The Pharisees, who were lovers of money...ridiculed him.*" (Luke 16:14)

3. **They tried to provoke Him and trip Him up.**

 > "*As he went away from there, the scribes and the Pharisees began to press him hard and to provoke him to speak about many things, lying in wait for him, to catch him in something he might say.*" (Luke 11:53-54)

4. **They denied their abuse and shifted the blame.**

 > Jesus said "*Has not Moses given you the law? Yet none of you keeps the law. Why do you seek to kill me?*"

 > *The crowd answered, 'You have a demon! Who is seeking to kill you?'*" (John 7:19-20)

Valerie Jacobsen writes:

> "Our lives here on earth depend on a mysterious union between our fallen souls and our fallen bodies. The old Gnostics did not see us as fallen, body and soul. They believed that we have souls, which are glorious and cannot be harmed, and bodies that are damaged, unworthy, and easily broken. Many teachers still reproduce those ideas when they teach that only physical abuse is real abuse and that only physical abuse should be escaped.

> "But God's heart is always for us whenever we are being harmed, whether spiritually, emotionally, psychologically, mentally, or physically. He sees us and knows that it is impossible for us to gauge the severity and the effects of abuse by looking over the surface of our bodies, by looking for bruises to count, or by using x-rays to check for broken bones. He sees that our souls ache from pain. He sees that emotional abuse and psychological torture do measurable harm to our brains and endocrine systems. He knows that PTSD is more painful and harder to treat than bruises or broken bones. He sees true suffering wherever it is, and when He sees it in us, He views it with compassion.

> "Whatever his weapons, an abuser attacks the image of God and wars against the creator. An abuser refuses to see what God sees—that we

were never created chiefly to please them, to bear children and keep houses for them, or to work for their provision. God has declared that our central purpose is to be His, to be faithful to Him, and to worship Him. When an abuser attacks the believing child of the living God, he seeks to divide us from our Savior, to cause us (as Job's wife said) to curse God, give up hope, and die. In this, an abuser is ignoring that we are beloved by God and that we have been redeemed at great cost. He openly wars against God, shaking his fist in God's face, demanding to have us, use us, consume us, and destroy us.

"As an abuser attacks, insults, and controls, God sees and knows that he is stealing our liberty and our peace. God sees that his sacred commitment to love, to honor, and protect us is being violated. God sees as the abuser willfully defies God as lawgiver, seeking to become a law unto himself.

"And God sees us, His precious ones, when we suffer. God sees our abuse as it is when our lives have become battlegrounds with real suffering and the risk of real casualties. He stands with us, and He walks with us while persecution takes its secret, underhanded forms in the most hidden places of our homes. Make no mistake. God sees His friends who love Him and trust in Him, repenting of our sins. And He also sees our abusers (especially our religious abusers)

as His enemies, as enemies of the truth, and as enemies of the gospel. He sees the heart of malevolence that craves an innocent victim and intends to cause injury.

"He knows that evil gives very little advance warning, but He taught us to identify the one who is deceitful, destructive, malicious, and malevolent, and He taught us to protect ourselves and others from harm and danger. It is He who is calling us to see our condition, *even when our hearts are aching with desire that what is true might not be true.* It is He who is opening our eyes and calling us to reflect His image by speaking and living in the truth. It is He who gives us the courage to say 'Thy will be done' in the unexpected and unwanted when we must flee from indignity and cruelty and when we must undertake an honest and biblical mission where we can find our liberty and safe place to stand firm before Him.

"As the ones who will live with the consequences for ourselves and our children, we are the ones who are given wisdom and strength and called to action. Our pain and distress in abuse also causes us to work with God as He cleanses families, churches, and communities from evil and creates places of real peace and safety for us. He taught us that no wolf in sheep's clothing must ever be tolerated or enabled, and each one must be removed from any place where he

is determined to cause harm. He taught us to report criminal wolves to the police, without hesitation or pity, and to speak the whole truth about them to investigators and in court. (Leviticus 5:1)

"As victims of abuse, it's easy to become entangled in a hopeless quest of trying to fix an abuser, help him, and cure him—but we could as easily raise the dead! There is only one Savior. We cannot save ourselves by our own good works, and we do not have the power to save anyone else, especially our abusers. We must submit to God who is Almighty—who is more than able both to protect us from evil and to do whatever He pleases with evildoers. We must come to Him as our good Father who always has another chapter for our stories and who gives us the courage and strength to close and bar the door against evil.

"While it may be true that abuse can be an opportunity to love an enemy, biblical love does not collude with an evildoer or keep him comfortable while he is on a quest to harm us, to harm others, or to destroy his own soul. Biblical love for an enemy provides what enemies require most, including accountability and justice. Biblical love avoids vengeance, seeks justice, and trusts God with every outcome, whether we are taking flight or appealing to courts for justice.

"As we stand firm against evil, we can pray that God will enable us to grow in grace, to see our weaknesses and errors, and to learn what it means to love others well and truly. With abuse, we often spend many years trying to support the dysfunction, hoping that we can make it better or at least make it tolerable. Our awakening is often very gradual as God teaches us to see clearly and weans us from our initial expectation when we made our wedding vows—that we vulnerably and trustingly believed we were at the beginning of healthy love and biblical marriage. In our awakening, we can continually remind ourselves that God is faithful to teach us that what we see is real, what we hear is being said, what we remember really happened, and what we know is true."

—Valerie Jacobsen

GOD'S VIEW OF MARRIAGE

For this section I'd like to contrast some lies you've maybe heard or believed about marriage with the truth about marriage.

Lie Number One: The ultimate goal for a woman is an intimate relationship with a man in marriage.

Truth: Marriage can be wonderful, and God can do some incredible work in our lives through a healthy marriage relationship, but not every woman will get married. The ultimate goal for every woman is an intimate relationship with her Creator—to find her identity and purpose in Him and His loving destiny for her.

Lie Number Two: Marriage is forever.

Truth: Marriage is not forever, nor does it always last on this earth. It is a temporary union.

> *"And Jesus said to them, 'The sons of this age marry and are given in marriage, but those who are considered worthy to attain to that age and to the resurrection from the dead neither marry nor are given in marriage, for they cannot die anymore, because they are equal to angels and are sons of God, being sons of the resurrection."* (Luke 20:34-36)

We see here that marriage is not eternal, and there is no marriage after this life on earth is over. Human beings created in God's image are eternal. When we apply the law of love, as Jesus always does, to our view of marriage and human lives, we clearly see our duty to care for human souls above our duty to care for a temporary earthly union, especially one that is causing harm to others and telling a lie about God. These are not unions we should be protecting at the cost of human souls.

Lie Number Three: A married woman belongs to her husband.

Truth: A married woman belongs to God, and both the woman and her husband have authority over one another's bodies. See that mutuality again? This was unheard of in Greek culture at that time.

> *"Know that the Lord, he is God! It is he who made us, and we are his; we are his people, and the sheep of his pasture."* (Psalm 100:3)

> *"For the wife does not have authority over her own body, but the husband does; likewise the husband does not have authority over his own body, but the wife does."* (I Corinthians 7:4)

Lie Number Four: A married woman is ruled by her husband.

Truth: Maybe this is true in a functionally pagan marriage where God's design for male and female are rejected in favor of the curse of Genesis 3:16. But a Christian marriage demonstrates the gospel restoration of humankind. No longer does one take power over another. Instead, by the power of the Holy Spirit, both husband and wife reign together as allies in mutual love and respect. I've seen both kinds of marriages. I've lived in both kinds of marriages. One was hell on earth. The other is heaven on earth.

Lie Number Five: A married woman's responsibility is to make her husband happy.

Truth: A married woman's responsibility is to walk in truth and obedience to Jesus Christ, not her husband or her church leaders. As both partners seek mutuality in all things, they will find real joy and peace in their relationship. This isn't possible with only one partner willing to relate mutually and keep her vows.

"Therefore a man shall leave his father and his mother and hold fast to his wife, and they shall become one flesh." (Genesis 2:24)

Lie Number Six: A woman can change her husband.

Truth: A woman can love her husband and do him good, but only God can change a husband, and a husband will only change if he sees a need to change and has a desire to change. This is not the wife's responsibility, nor can she or should she play the role of savior in his life. In fact, when she works to change her husband, she is violating his boundaries and his right to make his own choices about how to live his life. If he isn't interested in mutuality, there isn't anything she can do about that but accept it and make choices of how she will steward and safeguard her own life and resources. This is living in reality and taking personal responsibility as an adult. God calls us to love, not to change other people.

Lie Number Seven: All marriages are good and should be saved at all costs for the glory of God.

Truth: All marriages are not good or safe, and when there is abuse going on, the marriage covenant has been broken by one party. This does not bring glory to God. It tells a lie about God, and it is the responsibility of God's children to expose the lie and glorify God by walking in truth.

Valerie Jacobsen writes:

> "Many who present themselves as great defenders of 'biblical marriage' have not been defining marriage biblically. Marriage is a covenant of promises forming an intimate union between a man and woman. The wedding solemnizes those promises in a way that is legally recognizable

and enforceable in their society, and it is the beginning of the covenant-keeping that makes marriage.

"The covenant of marriage was designed as a boundary for sexual intimacy and for the flourishing of love and service—***not as a protected space for evil***. Thus, biblical marriage cannot be reduced to 'lies told in a church one day.' Those who would make marriage wide enough to include willful fraud, willful slavery, any deliberate campaign to cause suffering, adultery and incest, or violence are telling us they do not know the difference between concubines and wives—concubinage and marriage.

"We make these vows to one another to measure the marriage as they are kept and measure any potential fracture in the marriage as they are not kept. Some teachers have gotten unreasonable mileage and undue power and control from the statement 'Marriage is a covenant and not a contract,' but the word *covenant* has a known meaning. It refers to the simple fact that marriage is an agreement, based on meaningful vows made before the Lord, such that abandonment of those vows and that agreement will have serious consequences.

"Every legalistic, wooden definition of marriage tries to reduce this intimate and organic relationship to a set of rule-based algorithms: Do this, and then do that. But marriage is a particular kind of relationship, and it cannot be fully defined by paging through the Bible to look up every instance of the words *husband*, *wife*, and *marriage* and then trying to build a superstructure on those few verses. This paltry, weak method is how so many have

convinced themselves that it is appropriate to zealously enforce any fraud, overlook every danger, ignore every degree of hatred and harm, and embrace every degree of gross immorality *so that what is celebrated as 'marriage' is in some cases an open flourishing of noxious evil.*

"But an organic, biblical, and covenantal definition of marriage begins with recognizing that the Bible's words on marriage as a particular kind of relationship are set in a wonderful, rich, and deep context of teaching on healthy, viable human relationships. This approach does not get far without noticing and heeding the Bible's continual refrain that healthy relationships are an interchange of true love and joyful service, which look toward true benefit from hearts of true benevolence for the sake of mutual welfare. Such a biblical and covenantal approach is marked both by a ready will to keep the vows of the marriage covenant and by an understanding that covenant-breaking is the antithesis of biblical marriage, and it watches against all danger, all cruelty, and all treachery.

"A biblical and covenantal definition of marriage also realizes that marriage was never designed as a military hierarchy. Authoritarians have rushed to twist the beautiful head-body metaphor, which the Bible uses for intimate union in marriage, to teach that marriage is a constant and indefinite power struggle, where all that is precious utterly depends on a strong man winning every war with a grasping and conniving woman! (Is it any wonder that power and control abuses are endemic?)

"When the apostle uses the head-body metaphor, he is not commanding them to arrange themselves in a military hierarchy. He is not setting out a sanctified algorithm for making decisions as a couple. Rather, he is addressing that which every husband and a wife enjoy together in every biblical marriage—a true and intimate, lifelong union like the union Christ shares with the Church. This is a union in which Christ is distinct from the Church, He remaining himself and she remaining herself, and yet they are never again to be separated, unless it is by the willful and unrepentant apostasy that exposes a church as false and unrelated to Christ.

"Biblical marriage is marked by the love and mutual submission (Ephesians 5:21) which gives both individuals room to flourish. Biblical marriage is the opposite of oppression, treachery, and cruelty. Because it is established by vows which may be broken by either party, biblical marriage is a conditional covenant. Those who live in the marriage are charged by God to discern the difference between covenant-keeping and covenant-breaking. Others may advise and assist them when evil threatens their vows and their covenant, but no family, no friends, and no authorities can ever presume to know the heart of a covenant-breaker better than his own spouse.

"In a biblical marriage, a husband is called to love like Jesus did in His manhood as a human (John 15:3, Philippians 2) when He came as a suffering servant, took up His Cross, carried it to the place of His death, and gave up His precious human life for His bride. Those who say, against the first commandment, that husbands

are to be like Christ in His Deity, glorified in Heaven, and ruling as Almighty over all, have lost the distinction between God and mere men, and they approach blasphemy. The first commandment plainly teaches not to grasp for such power where it says, '*Thou shalt have no other Gods before me.*'

"A wife is called to submit to a true husband in a true covenant out of service to Christ, not as if her husband were Christ himself. Likewise, her husband is called to submit to her in the same way as unto the Lord. Biblical marriage tells the truth about the gospel. It cannot willfully lie about the character of Christ, and it ought to be marked always by a fear of teaching any lie about Christ to the children who grow up there.

"The home is a place of liberty, ruled by husband and wife together, combining their strengths and mitigating their individual weaknesses. The home is not the lowest administration of ecclesiastical order to be ruled by elders. While they may advise, and should advise if their advice is sound, their will for the family cannot trump the sanctified, obedient will of a faithful, covenant-keeping spouse and parent. Wherever men have liberty in Christ and women do not, the church is in error. We must call on our churches to preach and teach what it means to love one another and keep covenant with one another, for God's wrath is against covenant-breaking, not against the paperwork that solemnizes it in court."

—Valerie Jacobsen

GOD AND DIVORCE

The following section is written by Rebecca Davis, author of several books including *Untwisting Scriptures That Were Used to Tie You Up, Gag You, and Tangle Your Mind* and co-author of *Unholy Charade: Unmasking the Domestic Abuser in the Church.*

Would you want to enter into a lifetime covenant if you knew ahead of time that the other person could break the vows in the most egregious ways without any recourse for you? That the only person who had to keep the covenant was the one who was *not* breaking it?

This is essentially what Christians believe about marriage when they call it an "unbreakable covenant." But marriage is not like that. Just as Jesus said in Mark 2:27 that the Sabbath was made for man and not man for the Sabbath, so it is true that "people were not made for marriage, but rather, marriage was made for people." (Jeff Crippen with Rebecca Davis, *Unholy Charade: Unmasking the Domestic Abuser in the Church*)

BIBLICAL COVENANTS

Biblically, there are two types of covenants: one-way and two-way. In one-way covenants, one person bears all the responsibility for keeping all the terms of the covenant. Since God keeps His one-way covenants perfectly, they cannot be broken. (Because He meets all the terms, it can rightly be called a "covenant of promise.") For example, in the New Covenant, all the responsibilities for fulfilling all the requirements of God are taken by Jesus Christ—our only responsibility is to come to Him in faith.

But the marriage covenant is a two-way covenant. In the marriage covenant, *both* partners take vows to love, honor, cherish, forsake all others, and remain faithful until death. Maintaining the marriage covenant is dependent on *both* parties. In the marriage vows, the hard times described (for worse, for poorer, in sorrow, etc.) refer to life circumstances, which the faithful husband and wife pledge to face together. These hard times described in the vows don't refer to one party remaining faithful while the other party is being abusive and controlling, because *both* parties pledge faith, love, honor, duty, service, tenderness, cherishing, comforting, keeping, and forsaking others. The marriage covenant, which is clearly a two-way covenant, can be broken by either party egregiously violating the vows.

WHAT IS DIVORCE?

If the marriage covenant has been violated according to Biblical guidelines (adultery, abandonment, or abuse), then you, the one who has been sinned against, can rightfully declare the covenant to be null and void. This declaration is called divorce. ***Divorce is not the destruction of the marriage. Divorce is the declaration that the marriage has already been destroyed.*** If you're the one who was sinned against, and you're following biblical guidelines, then you have no need to fear that you're sinning in following through with the means God has provided to declare the covenant null and void after it has been broken.

Not all of God's covenants were one-way covenants. He entered a two-way covenant with Israel in which both parties solemnly agreed to the requirements (Exodus 24:7-8). After the marriage covenant had been broken, and after much forbearance on the part of the Sinless One, finally God divorced his people (Jeremiah 3:8). If di-

vorce in and of itself is sin, then God is a sinner. But the truth is that divorce according to biblical guidelines is not a sin. God recognizes it to be the declaration of the nullification of a covenant that has been egregiously broken.

IS THE "UNBELIEVER" A COVENANT BREAKER?

Paul said in 1 Corinthians 7:13-16 that a Christian with an unbelieving spouse who "consents to live" with her must not send away the unbeliever. But the "consents to live with" phrase indicates a loving and mutual relationship in keeping with the marriage vows, not an abusive relationship. This helps us better understand verse fifteen as applying to abusive situations in which the abuser wants to stay in the home:

> *Yet if the unbelieving one leaves, let him leave; the brother or the sister is not under bondage in such cases, but God has called us to peace.*

This Scripture indicates that abandonment is covenant-breaking grounds for divorce (keeping in mind that divorce is not the breaking of the covenant, but is simply the filing of the paperwork to declare that the covenant is already broken).

But what if an abuser will not leave the home (and thus, some might think, "consents to live with" the believer), but he makes it an unsafe and frightening prison-type environment? This in itself is understood to be a form of "leaving" as indicated by verse fifteen. When the abuser's evil conduct creates unbearable conditions, the one who escapes is not to blame for getting free from his evil which has already dissolved the marriage covenant. In fact, the creation of

conditions that are too harsh to live in is a hidden type of abandonment or desertion.

What about "God hates divorce"?

Actually, the Bible never says, "God hates divorce." This misquotation is based on Malachi 2:16, which in the 1984 NIV (which was immensely popular) reads,

> *"I hate divorce," says the Lord God of Israel, "and I hate a man's covering himself with violence as well as with his garment," says the Lord Almighty.*

But the King James, which was effectively the only translation used for hundreds of years, reads,

> *For the LORD, the God of Israel, saith that he hateth putting away: for one covereth violence with his garment, saith the LORD of hosts: therefore take heed to your spirit, that ye deal not treacherously.*

Even if God was the one saying this, "putting away" is very different from the way many people think of divorce today. "Putting away" was an action that shamed the spouse who was put away (almost always the wife in those days). The action of *fleeing abuse* has nothing to do with this concept of "putting away." But some have argued that God wasn't even the one saying this. Scholars have disagreed about how to translate this difficult verse.

The English Standard Version of this Scripture reads,

> *"For the man who does not love his wife but divorces her, says the LORD, the God of Israel, covers his garment with*

violence, says the LORD of hosts. So guard yourselves in your spirit, and do not be faithless."

The new version of the NIV (2011) has changed this verse to read,

"The man who hates and divorces his wife," says the Lord, the God of Israel, "does violence to the one he should protect," says the Lord Almighty."

Whether God was saying He hated "putting away," or He was referring to a man who hates his wife and puts her away, either way this Scripture is not making a reference to the legal acknowledgement, called "divorce," that the covenant has been broken.

CHRIST AND THE CHURCH ARE NOT REPRESENTED BY AN ABUSIVE MARRIAGE

Some Christians claim that just as Christ's covenant with His Church is unbreakable, so the marriage between husband and wife is unbreakable. (This shows a lack of understanding about the difference between a one-way and a two-way covenant.) They say that just as Christ loved the church steadfastly through the years in spite of sin, so we should love the sinning spouse steadfastly through the years in spite of sin. They say that just as Christ endured great suffering for His Church, the aggrieved spouse should endure great suffering from the abusive spouse. **But an abusive marriage does not represent Christ and the Church at all, and to say that it does is a travesty.**

For the twenty-five years of her marriage, a friend of mine lived in an increasingly oppressive concentration-camp type environment. In the early years she pleaded with her husband for deliverance from

the desperate conditions she and her children had to endure, but he would not relent, and over time the conditions worsened. Even though this man claimed to be a believer, this abusive marriage never represented Christ and the church because he violated his covenant in many ways.

In such a case, a believer should never need to struggle with despair, simply hoping her life or that of her husband will soon end.

*If the unbelieving one leaves (*including through the less obvious abandonment or desertion of a spouse via an emotionally, financially, physically, or spiritually abusive environment), *let him leave. The brother or the sister is not under bondage in such cases, but* **God has called us to peace.**

FOR FURTHER STUDY

» *Divorce and Remarriage in the Church: Biblical Solutions for Pastoral Realities* by David Instone-Brewer

» *God's Word to Women* by Katharine C. Bushnell

» *Good News for Women: A Biblical Picture of Gender Equality* by Rebecca Groothuis

» *What Paul REALLY Said About Women* by John Temple Bristow

» *Beyond Sex Roles: What the Bible Says About a Woman's Place in Church and Family* by Gilbert Bilezikian

» *Paul, Women, and Wives: Marriage and Women's Ministry in the Letters of Paul* by Craig S. Keener

Check Point

Did some of the things in this chapter blow you out of the water? I've been in your shoes. I had to go back to the drawing board on so many things in order to get all the puzzle pieces into place. I'm still working on it! There is so much to learn. I wish we could spend more time on this, but that would require another book. Or books. Thankfully, there are many excellent resources out there, and even the ones I've mentioned in this book are just the tip of the iceberg of what is available. If you like to study and learn new things, you'll feel like a kid in a candy store when you begin your own adventure of exploring these subjects.

But maybe you're just so burned out and exhausted that you can barely take in the little we've shared here. That is okay! It took me several years before I had figured out where I stood on issues. What I believed. And like I said, I'm still working on that and expect to be doing so for the rest of my earthly life.

The thing I want you to always remember is that it is okay to question and doubt. That's how we learn and grow. God knows this and isn't afraid of our questions or doubts. He sits with us in them. And He promises to give wisdom to those who ask. Are you wondering, "*Why didn't He tell me this stuff before? Why would He keep it from me?*" My short answer would be that He knows best what we can handle—and when. Also, He doesn't

see our lives as a destination. He sees them as a story. A journey. He is shaping us and growing us and training us in ways we may not understand, But He does. Will you trust Him?

Changing Your Role

ANOTHER OPTION

We've spent most of this book talking about the problems in your marriage—how they got there and why they persist in spite of your efforts to solve them. You've maybe read several marriage books and tried to implement the various tips and strategies you've learned, but nothing helped. The problem isn't their ideas and advice, because it's probably good advice for a marriage with two involved partners who are both working hard to make the relationship better. The reason those books haven't worked for *you* is because you're the only involved partner in your marriage. For you, I present another option. Instead of spinning your wheels trying to get another person to change, *what if you put all that same effort into changing your role*?

First, let me make it clear that by changing your role I am not implying your actions were in any way responsible for your husband's toxic behavior and choices. I am not suggesting that you can improve your relationship with him by changing how you relate to him. You can't control anything about him or his behavior. That's his house and yard (more on this in the next section), and he alone is responsible for himself. What I do want to communicate in this

chapter is the truth that you *can* improve your relationship with yourself by changing how you view and respond to what he does. Abuse is never the victim's fault. Ever. But once you awaken to the reality that you are in an abusive relationship, you need to have strategies for dealing with it so you can find freedom, hope, and healing. That's what this chapter is about.

BOUNDARIES

One of the books I recommend most in my work with survivors is *Boundaries* by Henry Cloud and John Townsend. ***Boundaries are THE KEY to an emotionally healthy and satisfying life.*** People who have healthy boundaries have healthy relationships. They have time to do the things they excel at because they know how to say *no* to everything that isn't right for them. They have the best chance at leading fulfilling, well-balanced lives of peace. The word *boundaries* may not be in the Bible, but the concept is modeled numerous times, especially by our Savior. Jesus was the most well-boundaried person who ever walked planet earth. He loved and served people, but *He did not let people manipulate Him from His mission.* He didn't chase after people to try to convince them of the truth or tell them what they had to do. He respected their right to choose for themselves. He took responsibility for Himself and His work, and He let others decide whether or not they wanted to follow Him. When dysfunctional folks gnashed their teeth at Jesus, He let them gnash. He didn't try to argue with them or change them. And He didn't let their negative opinions stop Him from doing what He needed to do.

Here's an analogy from *Boundaries* that I'd like to expand on. Imagine that every person has a house and yard with a fence around it. Your husband does. Your kids do. Your siblings do. Your parents

do. Your friends do. Your co-workers do. *And so do you.* It doesn't matter what color you are, what gender you are, how much money you have, how smart or popular you are, your marital status, or where you live. You've been assigned to your **own** home and yard. God gave you your house and yard, and He put a fence around it to show you where it ends and where your neighbor's yard begins. The fence is your boundary. God doesn't expect you to water and mow your husband's lawn; however, He **does** expect you to water and mow **yours**. In other words, just because you are married doesn't give either of you free reign to disrespectfully tromp all over the other person's house and yard. Sharing an intimate relationship absolutely requires respect of boundaries.

What happens when someone else leaves their own yard and comes over into yours and starts mowing it for you (and you didn't ask)? If you have poor boundaries, you might be afraid to say, "*Excuse me, but this is my lawn, and I'm taking care of it.*"

Or maybe you *would* say that, and the response would be, "*So what? I think you're doing a lousy job here, so I'm going to do it for you. You should be THANKFUL I'm here instead of bossing me around like a smarty pants. Who do you think you are, anyway?*" They've actually committed a **double boundary violation**. One for invading your space and one for attacking your person when you tried to protect your space. This is double bad, and it's what women who live with abusers deal with on a regular basis. Here are some more real life examples of how this dynamic works:

What if someone else leaves their home and walks into yours, uninvited, and begins to read through your private journals? When you point out this boundary violation in an abusive relationship, you get accused of being selfish, hiding things, not being unified,

not trusting the other person, and being mean. **Double boundary violation.** One for the original invasion of your privacy and one for attacking your character when you tried to protect your space.

What if someone grabs you, carries you over into their yard, forces you to get into their car, and drives dangerously through town? In an abusive relationship, when you point out this boundary violation, you get accused of not trusting God, being picky, and being a nag. **Double boundary violation.** One for the original invasion and one for attacking your character when you tried to protect your space.

What if you invite someone over for dinner, but they refuse to leave when you ask them? When you point out this boundary violation in an abusive relationship, you get accused of not sharing, being mean, being selfish, and being rude. **Double boundary violation.** One for the original invasion and one for attacking your character when you tried to protect your space.

What if someone comes into your house and says your housekeeping skills are crappy, and everything else about you is also crappy? In an abusive relationship, when you point out this boundary violation, you get accused of not taking advice, not being humble, being stuck up, unwilling to learn, and lazy. **Double boundary violation.** One for the original invasion and one for attacking who you are as a person when you tried to protect your space.

What if someone comes over and steals your personal information in order to open up a credit card in your name and rack up debt? When you point out this boundary violation in an abusive relationship, you get accused of being stingy, not sharing your life and finances, being controlling, and being selfish. **Double boundary violation.** One for the original invasion and one for attacking you when you tried to protect your space.

What if you close the door of your house and lock it so the Boundary Violator can't get in anymore to hurt you, and your *pastor* comes marching through your garden gate, bangs on your front door, and informs you that you aren't a Christian, and he never wants to see you in his church again unless you allow the Boundary Violator to do whatever he wants to do to your person, your garden, and your house? **Double boundary violation.** One for the original invasion and one for spiritually abusing you when you tried to protect your space.

I know what some of you are thinking. *"Well, it would be bad if it were a stranger on the block. But if it's my husband, I guess I'm supposed to be okay with it because we are married; and when you are one flesh, it's like your houses and yards are the same because...**married people don't have boundaries.**"*

I get it. I used to believe that too. And that juicy little morsel of propaganda has effectively kept countless women trapped in controlling, abusive relationships where their homes, yards, and persons are repeatedly violated over the course of decades. We'll get back to that ugly lie, but let's look at this from another angle first.

Have you ever gone over into someone else's yard and said, *"I don't think you should plant the roses there. They won't get enough sun, and they'll die. I know better than you do, and I'm not going to wait for you to ask for my advice because I need to take care of you and make sure nothing bad ever happens to you so you aren't unhappy."*

Or do you ever find yourself feeling like you are required to come over and mow your husband's lawn every week because if you don't, who will? And if it doesn't get mowed, he will be annoyed or upset—so get on it!

Or do you ever feel resentful of all the neighbors who feel free to walk inside your house with muddy feet? Yet you instinctively know that if you asked them to leave, they'd get mad, and you'd feel like a big old meanie?

Or do you ever feel angry that your gate always has to be open to everyone in order to keep them all happy, but when you try to go into someone else's yard, they get upset with you?

Do you see how bad boundaries go both ways? You might think doing good to someone and helping them or saving them when they haven't asked is actually a *good* crossing of boundaries. But it's not. It might feel good, but it is ultimately not good for you or for the other person. So many of us have done that for years, fully believing we were doing our partners a huge favor and confused about why they didn't appreciate it. If you can get this truth to click inside your heart, you will make a huge leap toward your healing. ***You are not responsible for your husband's life.*** For his growth. For his change. For his happiness. For his peace. For his ANYTHING. He is a big boy, and you are a big girl. You get to each be responsible for only one person's house and yard. ***Your own.***

To sum it up, your boundaries need some work if you let others take over your property management, and your boundaries need some work if you think it's okay to take over the property management of someone else's property. Healthy boundaries mean you stick to your house and yard, and *you* get to decide who comes over and when and why. And healthy boundaries also mean you don't cross over into someone else's house or yard unless you are invited (their initiative), and you only go if you decide that you can. In other words, you don't allow anyone to force you to come over into their territory.

I hope this is beginning to come together for you. The big hang-up for women of faith is that they believe the lie that boundaries are okay in all situations except ones that involve authority. In the case of someone who is in authority over you, **the authority** is actually in control of your house and yard. **They** have the final say. So let's talk about this concept of authority and find out who really has authority in your life.

WHO IS YOUR AUTHORITY?

"The Bible teaches that men and women should be servants of all, and nobody should seek or desire to have moral or spiritual authority over anyone. Evangelical men seem infatuated with obtaining this spiritual authority and preventing women from having it. The problem is their infatuation with spiritual authority. In New Testament Scriptures, Jesus Christ is the Head, the sole authority over every single believer regarding spiritual life and moral well-being. Each believer in Jesus Christ (both male and female) is a priest unto God (i.e. "the priesthood of the believer"), modeling for the world what it means to walk with God. Christians serve one another, encourage one another, and help one another, but the moment somebody tries to take a position of spiritual authority over another person he or she has crossed a line in terms of New Testament Christianity."

—Wade Burleson, *Fraudulent Authority*

One of the most destructive pieces of propaganda used to keep women in a power-under position related to men is the idea of authority, and more specifically that men have authority over women. So if you want to paint your walls yellow or get a different hair cut or purchase a new rug—better check with your male authority. If you aren't married, that would be your daddy. If you are married, that would be your husband. And if your daddy is dead and you are unmarried, that would be your male pastor or a male elder. But you are not allowed to make that decision without the permission of your male authority. This takes the responsibility and control of your life (your home and yard) away from you. See how this is a boundaries issue? But is that really God's design for the human race? Or is that the world's power-over way of doing things—all dressed up with a religious veneer that makes it sound reasonable and seem holy?

This issue of the authority of men over women negatively affects so many facets of life. R. Starke writes:

> "*The belief that authority is ontologically attached to personhood, particularly manhood, will shape the way you view any number of issues our country is focused on today— domestic abuse, clerical abuse, police brutality, and civil disobedience. It will shape the way you interpret America's troubling legacy of slavery and segregation, its lingering effects, and the Protestant church's passive complicity and active participation in it.*" (https://thethinkingsofthings. com/2018/08/27/our-evangelical-authority-crisis/)

There was no power-over system in the Garden of Eden. Power-over was the result of sin, and the New Testament teaches us that eliminating power-over in Christian relationships was one of the hallmarks of Jesus' sacrifice on the cross. But for some reason, a

few Christian teachers think the world's power-over system is good. Probably because they are men, and it works for them. (They sure wouldn't like it if women thought power-over was good—but only when **women** were the authority figures! In fact I've heard some complain that women just want equality so they can be in power over men, and that's not fair to the men! See how silly this gets?) But God's kingdom is not a power-over system *for anyone*. Mark 10:42-45 says:

> *"And Jesus called them to him and said to them, 'You know that those who are considered rulers of the Gentiles lord it over them, and their great ones exercise authority over them. But it shall not be so among you. But whoever would be great among you must be your servant, and whoever would be first among you must be slave of all. For even the Son of Man came not to be served but to serve, and to give his life as a ransom for many.'"*

Now, of course there is legal authority in our world. For example, even in a church there are officers listed in every 501C-3 non-profit entity. But is there any situation where human beings are given spiritual authority over other human beings in order to control their lives? No. And keep in mind that legal authority actually exists to **serve** those under their jurisdiction. Police officers **serve** their cities. A president **serves** his/her country. A teacher **serves** his/her students. That's how it should work when it's functioning in a healthy way. Here's how that might look related to boundaries:

Our job as parents in authority over our children is to help them grow up by learning how to care for and manage their own homes and yards. You've successfully done your job if your children become adults who take responsibility for themselves. If your children are

still expecting you or someone else to mow their grass and wash their dishes, then you've got some work to do. And it isn't mowing and washing. It's getting out of their home and yard (out of their business) so they can discover what happens when they don't mow. You might not want them to experience the pain of an ugly yard, but if they don't experience that pain, they'll never be motivated to mow for themselves. So get out of the way.

Likewise, the role of any authority is to help those around him/her take responsibility for their own homes and yards. If someone breaks the law, a police officer gives a fine or makes an arrest. This teaches the law breaker to tend to his/her own house and yard and leave the houses and yards of others alone.

God created Adam and Eve as equals. They are both under the authority of God who teaches us to take care of our own homes and yards. When they sinned against God, God held each one personally responsible for their own sin—not for the sins of the other one. He gave them their own, custom made consequence as a result. He didn't punish Adam for Eve's sin and vice versa.

In every description of a pastor or elder, and in every example the Bible gives of what a pastor or elder does, the emphasis is on **serving and helping where service and help is needed.** The emphasis is *not* on control and power-over. *Ever.* So whenever a male person claims to be in authority over you, check to see how they are exercising their office. If they are using it to serve you, build you up in Christ, and support you in your efforts to steward your own house and yard, then they may be operating in the spirit of Christ. If they are using their office to condemn, judge, control, and break you down, then they are definitely operating in the spirit of the world's power-over

system. Their stolen authority over you is fraudulent, and you are not under any obligation to surrender your home and yard to them.

The idea of church authority is cultural, not biblical. Men and women who follow Jesus Christ have one authority. Jesus Christ. They bow to Him alone and answer to Him alone. So when husbands or spiritual leaders tell you to do something or cover up something that you believe is wrong, you may need to decide who your real authority is.

> "And Jesus came and said to them, 'All authority in heaven and on earth has been given to me.'" (Matthew 28:18)

> "But Peter and the apostles answered, 'We must obey God rather than men.'" (Acts 5:29)

God's love for you is not dependent on whether or not you obey those that have placed themselves in authority over you. **Never forget that as a redeemed child of God, you are always directly under the authority of Jesus Christ.** This frees you up to make choices in your life without paralyzing fear, because the love of Jesus casts out all fear.

YOUR RESPONSIBILITY TO CHOOSE

> "Make a decision inside of yourself—a deep decision— that you are 100% responsible for your actions and he is 100% responsible for his actions. You have zero responsibility for what he does, and he has zero responsibility for

what you do....When men blame women for their own behavior, that's one of the benchmarks of abuse."

—Lundy Bancroft,
Daily Wisdom for Why Does He Do That?

How would our lives be different if, instead of being people pleasers (an impossible and stressful task), we made the decision to zero in on aligning ourselves with God's view of us and our lives? What would happen if we saw ourselves as adults with God-given power and responsibility to steward our own lives? I'm talking about asking yourself some important questions like: "Who is responsible for my life?" "How will I share power in my marriage relationship?" "If I begin to act like an autonomous adult in my relationship, what do I risk losing, and am I willing to risk that?"

The fact is, God gave each of us one life to be responsible for: our own. We make decisions for ourselves every single day. We may decide to maintain peace in our marriage by not rocking the boat, going along with whatever our spouse decides for us, and refusing to vulnerably engage on a deeper level out of fear of being attacked. We may decide not to push against emotional and spiritual abuse because we want the marriage to work out no matter what the cost to our spiritual, emotional, and physical health. We may choose to go with the flow out of fear our spouse will hurt us even more deeply than we've already been hurt. Maybe we're afraid if we make an effort to change, our religious community will reject and shame us. But the first step in creating change in our lives is to acknowledge that we do *have choices*, we do *make choices*, and they are *our own choices*.

There are many reasons we choose to keep things status quo, and sometimes these reasons are good ones. Sometimes we have very little choice, especially when children are involved. But often, we have more choices than we are willing to admit, and we may not be aware of our ability to change in small increments, slowing rewiring our brains, learning new skills in how to relate to abusive people and groups, and awakening to our own value as daughters of God. Change almost never occurs overnight. More often, it takes place quietly in the small, imperceptible things we alter slightly every single day. This is the kind of change I'd like to challenge you to pursue. In this way, over the period of one year, five years, and ten years, you will change the entire course of your life. In order to make these kinds of changes, you may need to think a little differently than you have in the past. Here are some important truths emotional abuse survivors have told me they had to learn in order to start making some pivotal changes in their lives.

1. **You don't need the agreement, approval, or permission of other human beings to steward your life before God**. God isn't going to hold any of those people accountable for your life. He's going to hold them accountable for *their lives*, and He's going to hold *you* accountable for yours. Remember the biblical parable of the talents? A man went away on a trip and entrusted his servants with varying amounts of talents. The faithful ones invested their money and doubled it, but one simply hid his to keep it safe because he was afraid of losing it. When the owner came home, he didn't penalize the ones who chose to invest their money just because one chose to do nothing with his. Nor did he let the one who chose to do nothing off the hook because the others invested well. He rewarded the ones who took the initiative to make choices and exercise their power, and he penalized the one who did nothing out of fear. We need to stop looking sideways at others to see if they are okay with us or not.

Their opinions don't matter. We live for an audience of One: Jesus Christ. And with Him, there is no fear. Go out and invest whatever He has entrusted you with in full freedom.

2. **It's okay to be human and make mistakes.** Survivors are often paralyzed with fear that they will make a wrong move and lose the love and acceptance of their spouse, their church, and even God. But God says love casts out fear (I John 4:18). When we know we are loved no matter what, we are free to choose a path without letting fear stop us. It's true that you may lose the love and acceptance of your spouse and church community, but could you really call that love in the first place? When people only love you because you do what they dictate, that's not love, and you haven't really lost anything but the fantasy that they actually cared. Hopefully, there will be a few people in your life who love you no matter what. People who will eagerly support you as you learn to take personal control and come into the fullness of your adult identity as God intended.

3. **When you come to a fork in the road, it's not always the path to heaven or the path to hell.** Sometimes it's two equally viable options. And guess what: if nothing can separate you from the love of God which is in Christ Jesus our Lord, then you can rest assured He will walk with you on either path. So many Christians stand at the crossroads over and over in their lives, wavering in doubt and fear. This isn't gospel freedom. If an abuse victim has the opportunity to make a choice to stay or get out, *she gets to decide which path to take for her own life.* Both of those paths will be dark and painful for a while. But it isn't the responsibility or personal business of others to decide what is best for her and her children. As Christians, our role in the lives of others is a supporting role. A loving role. A *"let me sit in the messy darkness with you so you're not alone"* role. We do not have a *"I'm going to take it upon myself to be the boss and*

judge of you" role. That's not the gospel, and that's not Christian love or community.

4. **You cannot know the future; therefore, you cannot make decisions based on predictions of that unknown future.** The past is the best predictor of the future anyway. So either way, you can only make choices based on your reality *right now*. If you've been living in an emotionally abusive relationship for ten years and nothing has changed, your best prediction of how life will be in ten more years is that it will be the same—except for what *you* choose to do about it today. It's tempting to believe a miracle could happen, and God could change your abuser. Could that happen? It isn't outside the realm of possibility, but it is statistically rare because, first of all, abuse is deeply rooted in ideology and entitled attitudes toward women, and secondly, abusers don't believe they have a problem that needs changing. Of course God can do anything. He can make pink unicorns fly across rainbows. But He doesn't choose to control people. He invites, but He never coerces. And neither should we. Your best bet when choosing what to do regarding your abusive relationship is to make decisions based on reality rather than wishful thinking.

Learning how to make decisions for your life is a messy and meandering journey, especially if you've been steeped in the toxic belief that you are like a child or just a dumb, easily misled female. One of the first steps to getting started on this journey toward confident adulthood is knowing who you really are. ***Because your abuser has it all wrong.***

DISCOVERING YOUR TRUE IDENTITY

I grew up in a conservative Christian home believing God loved me. In fact, I often felt that I was one of His favorites, if God could have favorites. The reason for this is that I was subjected to severe emotional, verbal, and even physical bullying in my neighborhood and at school for several of my formative years because I was openly Christian. As a child I would read the Psalms and relate to David's fleeing to the shadow of God's wings to hide from his enemies. I believed that, just as David was the apple of God's eye even though many humans hated him, so I could be the apple of God's eye if I remained faithful and put my hope in God. I shared my faith in Jesus with everyone I knew, and I counted it a privilege to suffer rejection for His sake. As an adult, I look back on that little girl and wonder at her unwavering faith. My identity was rooted in how I believed God saw me; but as I grew older and became more steeped in oppressive and legalistic religion, that began to change.

Somewhere along the way, probably due to the influence of Bill Gothard, a popular Bible teacher our family learned from in the '70s, I began to associate God with human authority. In other words, if those humans in authority over me were pleased with me, then God was pleased with me. But if those in authority over me were displeased with me, then God was displeased with me as well. This applied to other relationships too. If I was at peace with people, I was doing well. If someone was unhappy with me, I must have done something wrong, and it was my duty to apologize, ask forgiveness, and let them off the hook for anything they had done that offended me. Give my everything. Take nothing. It was the perfect set-up for what would come later in my life.

I was an extremely conscientious child with a strong desire to please, so I made my decisions based on what I thought my parents would most approve of. When there was a conflict between another person and myself, I assumed it was my fault, apologized for it, asked forgiveness, and hoped I hadn't ruined my chances of being loved by that person. Of course, I was a human being like everyone else, and as hard as I tried to be perfect and make everyone happy, I failed over and over again. I began to split my true self with all of my human weakness from my ideal self—the self I thought I needed to be in order to be loved and accepted. I was constantly saying I was sorry and begging for forgiveness. And because I couldn't maintain that perfection of my ideal self, I came to believe I could not be the apple of God's eye, after all. I was more like a thorn in His flesh.

I also came to believe that to be loved and accepted by God and others, I must always be *nice*. I think we should all strive to be empathic and kind, but being *nice* in the way I believed meant that I couldn't speak up, say no, or rock the boat by confronting bad behavior—especially when the bad behavior was perpetrated by someone in authority. Instead, I had to unconditionally forgive and love, which really meant that I had to accept being used by others. I had to accept being treated like a doormat.

Along with this was the belief that my opinions or observations meant nothing. My authority figure was always right *just by virtue of the fact that they were in authority*. That meant I was always wrong, even if I was right. The reality is that nobody is right all the time or wrong all the time, and everyone has a voice that deserves to be heard. But when you are immersed in this kind of teaching most of your life, it can eventually cause confusion along with troubling relationship issues down the road.

As an adult who has worked through a lot of this faulty thinking in therapy and studying, I have come to believe that God permits us to use our voices, to stay rooted in reality rather than magical thinking, and to stand against abusive behavior regardless of who is being abusive—including husbands and pastors. We may suffer for standing up for what is right, but contrary to what you may have heard, **it is not a mark of spiritual maturity to suffer needlessly.** Christianity is not a religion of asceticism. And as I've stated earlier, I believe our only authority as adults is Jesus Christ. My goal as a parent is to raise kids who understand that. They will answer to God alone one day, and in Christ, they are fully loved and completely safe to become exactly who they are and do what they are wired by Him to do with their lives. If others don't agree, that's their problem, and they can take it up with God. But I want my children to be *free* from spiritual abuse and the bondage of legalism. I want them to live by the law of love for God, themselves, and others. And that is how I am determined to live as well. This requires wisdom, not rules.

So what does this have to do with your identity? The point I want you to take away is that you are not defined by the opinions of those who have placed themselves in authority over you. You are defined by your Creator, and He says His creation of you is *good.* You are *good* just as you are—an important human because you have an important Creator. You are *good* even if you make mistakes. You are *good* even if you fail at times. You are *good* to accept your limitations and refuse to spend your life trying to be like a perfect little god. You know what real humility is? It's accepting all this about yourself and your humanity and taking pleasure in just being a child of God, knowing you are loved and safe no matter what. If you could *really just totally rest* in this truth, you would experience real inner peace.

Spiritually healthy people are okay with themselves before God. They come boldly before the throne of grace (Hebrews 4:16). They see who they are through **His eyes**, not the eyes of those around them. And likewise, they are respectful of others being themselves, trusting that God has each of us on a separate journey. People who can't do this are desperately attempting to cover up their own shame by trying to be perfect themselves and expecting perfection from others. This covering up ruins relationships and unity in the body of Christ today just as it has all throughout history. It's pride. It's believing we can actually somehow get ourselves to a place where we are good with God by our efforts at being as perfect and godlike as possible.

I'd like to describe for you what I believe an authentic, healthy believer in Christ is like by looking at what they do and what they don't do. First, here's what they don't do:

- They don't idolize or put on a pedestal their families, husbands, or church communities. They have a good grasp on the fact that all these people are human beings who make mistakes and have problems.
- They don't honor men more than they honor God.
- They don't obey the letter of the law when it means hurting other human beings.
- They don't try to be perfect, and they are okay with their imperfections.
- They don't expect perfection of others.
- They don't live in paralyzing fear with every decision that needs to be made.
- They aren't afraid to speak out against injustice and deception even when it means standing alone and being ridiculed, slandered, shamed, and rejected.

- They don't live under debilitating, toxic shame.
- They don't chase after love and acceptance at the expense of their well-being because they already know they have all the love they will ever need in Christ.
- They don't try to attract the popular crowd or the spiritual people or any other group to make themselves feel good enough.
- They don't hate on themselves.
- They're not people-pleasers.

Here's what they do:

- They serve Jesus Christ alone.
- They honor God first, and then they show honor to all humans, acknowledging that human beings are made in the image of God.
- They live by the law of love.
- They accept their human limitations, weaknesses, and failures, and they revel in God's grace and love for them.
- They accept the human limitations, weaknesses, and failures of others without allowing others to use and abuse them.
- They respect the rights and boundaries of others while also respecting their own rights and boundaries.
- They make decisions while trusting God to help them walk through whatever the future holds.
- They let go of toxic relationships and build healthy relationships with people who want to mutually support and build one another up.
- They align themselves with God's view of them by letting go of shame and loving and accepting themselves as good enough because God made them and Christ died for them.

- They accept the responsibility God has given to them to carefully steward their own bodies, minds, and spirits in a way that will glorify God.
- They live out the gospel of Jesus Christ in the messiness of life on earth, applying grace where it is needed.

This is your true identity as a daughter of God. Again, not striving for perfection, but striving to love well with the foundational understanding that you are perfectly loved and accepted in Christ Jesus. In Him, you can fly free!

> *"If God is for us, who can be against us?... Who shall separate us from the love of Christ? Shall tribulation, or distress, or persecution, or famine, or nakedness, or danger, or sword? As it is written, 'For your sake we are being killed all the day long; we are regarded as sheep to be slaughtered.' No, in all these things we are more than conquerors through him who loved us. For I am sure that neither death nor life, nor angels nor rulers, nor things present nor things to come, nor powers, nor height nor depth, nor anything else in all creation, will be able to separate us from the love of God in Christ Jesus our Lord."* (Romans 8:31, 35-39)

FROM HELPLESS TO ADULT

I flew out of my parent's nest at age 18 and embarked on my journey toward adulthood. Like most young adults, I made mistakes, learned stuff, and grew in my adulting skills. It was a memorable time. And then I got married. Because I believed in traditional marriage roles, I worked hard to let go of my identity as *"Natalie: adult woman"* and embrace my new role as *"So-and-so's wife: follower/child/underling."* There was a big problem, though. He wasn't wired to be

a leader, nor did he grow in this area. I remember hearing that if a husband would not take the initiative to lead (the rigid role our religious community wanted him to play), the wife would need to get down on her face, figuratively speaking—as low as she could go—to follow any slight movement he might make in any direction. So I did that, and guess where we went. Nowhere. I sometimes wonder how things would have been different if we had both subscribed to mutuality in marriage. If we had embraced the way God designed us and used our gifts and personalities to their fullest extent—blessing one another with those strengths and blessing the community and church we were part of in the same way. But we didn't.

Instead, I had to become like a little girl/mother in the relationship in order to dutifully play the role assigned to me by my husband and religious community. This meant asking permission for everything. Trying to read my husband's moods or desires in order to manage and meet them. Allowing my husband and church leaders to tell me what God wanted instead of listening to God for myself.

My marriage was dysfunctional from day one. I did reach out for help numerous times throughout the course of that 25-year marriage, but nobody was able to recognize the pathology because their power-over theology got in the way. Toward the end, God taught me a few life-changing things I'd like to pass on to you. We'll talk more about the things you can do to be personally free in chapter ten, but here is an overview.

1. You don't need to be rescued; you need to be empowered. This was huge for me. I had been literally begging people around me to rescue me. Why would I do that? Because I believed they were the adults, and I was the child that needed rescuing! When I first learned this truth, it was like a crack of lightening striking

my brain. Everything was illuminated, and it finally clicked. I didn't
need the permission of all my mommies and daddies (my husband,
my friends, my church leaders) to change my life for the better. I
was an adult woman, and I had a responsibility to make my own
decisions about my safety and emotional and spiritual well being.
Just knowing this empowered me to stop complaining about my
lot in life and begin taking steps in a new direction in spite of the
abusive kickback from everyone around me.

2. **Learn to tolerate the disapproval of people** instead of feeling
like a miserable nothing if someone doesn't like what you do. Again,
this was a paradigm shift in my life. I had never learned this skill,
but it's the key to being an adult! Nobody can make everyone happy.
No matter what we do, there will be someone out there who disap-
proves, and they will probably let you know. This is uncomfortable,
but it really is okay if people are unhappy with what you decide.
You are okay even without their approval. The child inside us wants
everyone to think we are good and right, but that's just not possible.
We need to let go of this child-like pursuit of people-pleasing and
accept the fact that sometimes our decisions will make others angry.
This is another boundaries issue, and it isn't our place to manage the
emotions of others. If they are angry, they must manage their own
discomfort. Maybe they believe they have a right to come into your
home and yard and control what you plant in your flower garden.
When you tell them they don't, they may not like it, but that isn't
your problem. It's theirs.

3. **Take full responsibility for YOU**, and let go of your responsi-
bility for your spouse or the marriage. At the end of the day, the
only person you control is yourself. And you can only do *your* part
to help a marriage grow and thrive. You can't do the parts of both
yourself and your spouse. When you take back power over yourself,

you are taking on the role of a mature adult. Something wonderful happens when you learn that you have full responsibility for yourself along with the power to manage your own life by yourself, on your own. This is basic to adulthood. Remember that a healthy marriage requires two mature adults committed to mutual love and respect. You are only one half of the equation.

4. **Take back your dignity as a daughter of God.** Your voice counts. Your ideas count. Your experience counts. Your skills count. Accept yourself. Respect yourself. Why? Because God does. This inner strength will give you the motivation and power to stand alone against those who want to tear you down and grind you into dust under their boots. You don't have to believe their lies about you. Stand in the dignity that Jesus has robed you with as His redeemed one. Those who are aligned with your Heavenly Father will honor you as a sister. Those who aren't, won't. Their reviling lips say nothing of significance to you. You have the option to listen—or not.

5. **Let go of your desire for things to be different.** I know you had a dream of how you hoped your marriage would be, but you now have a reality, and the sooner you accept that reality, the sooner you'll be able to make adult decisions about that reality. We all have a great capacity for wishful thinking, but wishful thinking is a child-like behavior, and it prevents us from problem solving and creating strategies based on what's actually going on in our lives. Adults make hard decisions based on honest assessments of reality. It will be tempting to listen to the voices of other magical thinkers and dreamers in your life. Christians especially are prone to offering cliches and truisms rather than wise counsel rooted in an honest assessment of harsh realities. But remember that while some may want to help and may have good intentions, they were not given your life, they don't live in your world, and God hasn't given them

direction or wisdom on your behalf. (Be prepared for them to claim otherwise, though!) When we are deeply involved in groups or organizations, we may childishly buy into what those around us say is right or true because it's the path of least resistance, and that's how we stay accepted in the group. While it is good to get wise counsel, not everyone has wise counsel to give. Foolish counsel rests on a foundation of propaganda with a desire to control. One of your opportunities moving forward will be discerning fantasy from reality, and this will often mean standing alone against the flow of shallow, but popular, Christian thought.

5. **Lean on the strengths and endurance you've built up through years of being in a toxic marriage.** Your survival experience in enduring and persevering through chronic emotional abuse has made you stronger than you could ever imagine. This experience will be the power behind your new growth as an adult woman. Adulting is messy, and you will make mistakes along the way. But it's okay to make mistakes! Ignore the temptation to accept and internalize the criticism of others as well as add to their negative voices by criticizing yourself when this happens. Try to resist this temptation by reminding yourself of who you are. You are a human being who has the right to learn and grow and make mistakes along the way. You are a dearly beloved daughter of the King, and He looks on you with the same love when you mess up as when you've got it all together. He is nothing like your abuser or your critics.

6. **Learn to stand alone.** This means detaching from toxic relationships and belief systems. As you set healthy boundaries, you may discover that many of your relationships were rooted in what you could give to the other person rather than being relationships of mutual love and respect. Some of those people will not want to be your friend anymore, and that will hurt; but you need to be willing

to let them go. You won't be alone forever. You'll begin to attract other adults who can offer you mutual love and respect without taking advantage of you or using you. Once you break out of the suffocating bubble of someone else's poisonous lies, your head will clear, and you'll be able to learn and grow as the adult woman God made you to be.

When we embrace our new role as adult women, the balance in our family system and religious community will be disrupted, and the various players will react in different ways in an attempt to bring back the status quo. That's what we'll talk about next.

FOR FURTHER STUDY

» *Fraudulent Authority: Pastors Who Seek to Rule Over Others* by Wade Burleson

» *Daring Greatly* by Brene Brown

Check Point

Dear Heavenly Father,

Give this beloved daughter of yours the power and desire to learn and grow and become all You created her to be. Give her the faith she needs to know and experience a growing sense of being safe and held in You. Take her from a place of powerlessness to a place of finding her power in You and Your truth. Reveal Your plan for her place in this world as Your ambassador of love and hope and freedom. Give her all she needs in Christ Jesus for Your glory.

Amen

House of Cards

WHAT TO EXPECT WHEN YOU SET BOUNDARIES

"Each of us belongs to larger groups or systems that have some investment in our staying exactly the same as we are now. If we begin to change our old patterns of silence or vagueness or ineffective fighting and blaming, we will inevitably meet with a strong resistance or countermove. This "Change back!" reaction will come both from inside our own selves and from significant others around us. We will see how it is those closest to us who often have the greatest investment in our staying the same, despite whatever criticisms and complaints they may openly voice."

—Harriet Lerner, *The Dance of Anger: A Woman's Guide to Changing the Patterns of Intimate Relationships.*

Remember in the last chapter when I gave you some examples of how people can violate your boundaries? And if you defend your boundaries or private space, some people will attack you for doing

that? This chapter serves as a heads up about some of the more specific things that can happen when you begin to take care of yourself and establish those healthy boundaries. For many years, others have been building and carefully maintaining a house made of cards, expecting you and everyone else to participate in keeping it intact. It looks nice on the outside, but it is just an illusion. It's a sick substitution for a home built on the Rock of Jesus Christ. When you establish boundaries, you are removing one of the cards—your own—from this fragile and toxic house, and your action will invite the anger and criticism of everyone around you who is invested in keeping that house of cards standing.

When someone points out a problem, instead of solving the problem, there will always be at least a few people *who attack the one who pointed it out in the first place.* This is because problems are uncomfortable and disrupt the status quo. Many people believe if they ignore the problem, it won't bother them, or maybe it will even go away on its own. If you are the Problem Pointer Outer, that makes YOU the problem, and the easiest way to solve the problem of YOU is to discredit and dismiss your voice. That's why *your way forward in a new direction that actually solves the real problem will not be easy.*

In this chapter we'll be looking at what your emotionally abusive partner may do, what your church may do, and what some of your friends and family members may do when you pull out your card. But we'll wrap it all up by examining some of the benefits to you, regardless of how others respond.

Think of it like a fork in the road, and one path is the same path you've always taken. It's a smooth path with wide open spaces, but it is riddled with unseen mines, and you have to be on your guard at all times. You never know when you'll step on a mine and get

attacked either overtly or covertly by your partner and his support-
ers. The other path is covered with dense foliage. You can hardly see
the actual foot path; in fact, you can only see a few inches in front
of you at a time. To see more, you need to start hacking your way
through the brush, and the going will be tough for a while. The
good thing is that there are no hidden mines on that path—just a
lot of resistance. The other good thing is that once you get past all
the brush, you will find yourself on a brand new journey of discov-
ery, peace, freedom, and inner joy. I've watched dozens and dozens
of women do this, and I have yet to hear any of them tell me they
regretted it. I *have* heard them say that they wish they had chosen
that path earlier in life. I know I do, and that's why I've written this
book—to point this path out to you and give you a chance to make
a different choice for your own life.

I write about this particular fork in the road with a caveat. Remember
when I told you in the last chapter that if you come to a fork in the
road, it doesn't mean one way is the road without God and one way
is the road with God? That still holds true. If you take a road that
also doubles as a mine field, and you have to walk on eggshells for
the rest of your life, Jesus will still and always be there on that road
with you. And if you take the road of resistance, Jesus will still and
always be there with you on that road too. So either way, if you be-
long to Jesus, you will never, ever, EVER be without Him regardless
of the paths you choose in this crazy, messy life on planet earth.
That's the gospel, and if anyone tries to tell you differently, they are
feeding you something other than the gospel. The gospel says you
are always safe and always loved in Jesus Christ. ***Always.***

> *"I give them eternal life, and they will never perish, and no
> one will snatch them out of my hand."* (John 10:28)

247

So back to my point here. This chapter is about that hidden path covered in dense brush—the path where you will need to grab your machete and get your power on because you've got some serious resistance to get through. Let's look at the first wave of resistance you will encounter: the likely reaction of your emotionally abusive spouse to your brand new boundaries.

WHAT THE ABUSER DOES

Emotionally abusive relationships are characterized by a pattern that goes like this:

1. **Life feels normal.** Nobody is rocking the boat. The abuser is being decent, and the victim is being careful.

2. **Life happens.** Maybe someone gets sick. Maybe the kids start acting up. Maybe someone at work bugged him. Maybe you had to correct a mistake he made. In a normal relationship, a couple works it out. They roll with the punches. But in an abusive relationship, the clouds start rolling in. The atmosphere begins to change. The abuser is in one of his dark moods, and the target is holding still, trying to breathe, waiting for the shoe to drop.

3. **There is an abusive incident**. In an emotionally abusive relationship, this can be an argument in which the target's view is degraded and her personhood is attacked. In a covert abusive relationship he might give her the silent treatment. He might passive aggressively withhold information from her and then blame her for not knowing. It's not often a huge incident, like a deep stab wound. It's more of a minor cut. (Always remember that with emotional abuse, the cuts are often small, but

they are numerous. If you could see them on your physical body, you'd be scarred from head to foot with them after a few years. It's important to understand that the cumulative damage of this kind of chronic abuse over the course of several years is just as severe as being beaten with fists on a regular basis. I've talked to victims who have experienced both, and every single one has testified that the worst of the two was the emotional abuse, hands down.) But each cut by itself usually only requires a bandaid. This is why so many people who have not experienced this kind of abuse can ignorantly and flippantly say, "What's the big deal? Emotional abuse is certainly not a reason to end a marriage."

4. **The pain sends the target reeling to her corner**, and she waits for the clouds to pass. She employs one or more of the coping mechanisms listed in chapter five. The incident is swept under the rug because if she brings it up again, she will be cut again. It becomes her top priority just to be able to function in peace and avoid pain.

5. **Life goes back to normal.** Nobody is rocking the boat. The abuser is being decent, and the victim is being careful. In fact, in this part, the abuser may actually be amazing. He may be saying what he knows she wants to hear. He may be especially affectionate. He may be buying her flowers or taking her out to dinner or doing extra work around the house. He knows that being nice now is how to make sure she doesn't fully grasp what's going on in his effort to control her. His nice behavior causes her to feel guilty for thinking he was so mean, and he has successfully covered his tracks and turned her thoughts away from his behavior back to her own guilty feelings and

confusion. This false guilt and confusion is one of the most effective instruments of control in his arsenal.

Something that will help you tremendously is if you begin to document this pattern in your own relationship. Keep a journal in an electronic app like Evernote where you can keep it hidden and password protected. My ex read my physical journals and actually wrote in them, and all of that information was fodder for more covert abuse and personal cuts. So avoid something like that from happening to you by doing this electronically. Write the dates of each step in the pattern so you can begin to see how long it takes for your particular abuser to cycle through it. This exercise will give you a more objective view of your relationship, and that information will clarify what's going on so you can be empowered to make changes in your own life.

Whether you are simply setting a new boundary or filing for a legal separation or divorce, the way your abuser will react is going to be the same. When a woman asserts the truth of who she is and what she believes, she is taking back her rightful control of herself by defining herself rather than allowing her emotionally/spiritually abusive partner to define her. She is setting a healthy boundary that causes her to step outside the abuse pattern described above. For example, when he tells her she cannot spend the money she earns from her new job without asking his permission, and she has to put it all into an account only he controls, she may say, *"I am an adult woman earning money. I will make adult decisions on my own about how I spend that money. I'm happy to share it and discuss our budget together like two adults, but I will not ask permission to spend some of it on something I need for myself, the family, or the household."*

When she does this, there are predictable ways he will respond. The healthier her boundaries are, the angrier and more abusive an abuser will get. (Always remember that emotionally healthy people with good boundaries themselves naturally respect the boundaries of others without getting angry or taking it personally that you're setting the boundary.) Here is an example of how things often unfold.

PREDICTABLE THING ONE: THE EMOTIONAL ABUSER GROWLS AND BARKS

He has a temper tantrum. How dare his wife define her *own self?* That's *his* job as the Head of the Home. The Authority. So he growls and stomps his feet, flinging accusations and Bible verses at her back as she makes her exit. He's not a happy camper, and he will work hard to make sure his target emotionally pays for stepping outside **his** definition of who she is.

The abuse target has some choices here. She can get back into her place in the pattern of abuse, bringing equilibrium back into the equation by placating her partner. This is what often happens, and it's why the pattern works so well for her emotional abuser. He knows the Bible verses will make her feel guilty. He knows his lack of affection will make her feel lonely. He knows his well-selected accusations will make her feel shame. And all these negative feelings will pull her back into the circle like strong magnets, and round and round they will continue to spin. Alternatively, she can **implement an enforceable consequence.**

Here's an example: she tells him if he continues to scold her and/or give her the silent treatment, she will take something she provides away from him. In this case, she opens up her own checking account

and has her paycheck direct deposited into that account. She wanted to work together with her partner, **but he wasn't interested in that**, so now she made the adult decision to take responsibility for her own income. She gets herself off his credit card accounts and opens up her own credit card account and begins to build her own credit rating.

PREDICTABLE THING TWO: THE EMOTIONAL ABUSER FEIGNS AN APOLOGY

This is a confusing stunt for the target, and here's how it goes down: he senses her pulling away and becoming more independent, so he may feign an apology. But while he is supposedly apologizing for what he's done wrong, he also shames her for pulling away and not giving him whatever he believes he is entitled to. He may use texts or maybe an email that contains both apologies and shaming language mixed together. He may verbalize an **accusatory apology** *"I'm sorry you thought I was trying to control you."* But a few minutes later, he may passive aggressively comment on how he never gets to buy a new shirt because he sacrifices so much for the good of the family or how he is now going to be tempted to watch porn because she is selfishly withholding from him.

He will expect forgiveness, but he will not invite examination. He will want to focus the attention on all the things he has learned, his good deeds, how their marriage has grown, how his behavior is normal male behavior and not abusive at all, and how she is also a sinner and needs to own her part in their broken marriage. In other words, he will say he is sorry while defending, justifying, and excusing the very behaviors he is supposedly sorry for.

He will also be unable to give any specific examples of his poor behavior. He will apologize in generalizations while also mutualizing his sin. *"I know I'm a sinner saved by grace, just like you."* *"I know I'm not always the best husband in the world just like you're not the best wife in the world."* *"I know I've hurt you like you've hurt me."* But if she asks him to give her a specific example and explain how that specific example had a profoundly painful effect on her life, he will come up blank. He will make no efforts to listen, understand, and acknowledge how his specific behavior grieved and hurt her. His fake apology simply justifies himself while offering no comfort for his wife.

His abuse will get more covert and less obvious. It will be more passive-aggressive. He's offended and angry, but he wants to make it appear that **she** is the naughty little selfish girl while **he** is the poor victim. He will attempt to take the focus away from his target and the pain he has caused her and onto his own feelings: he is distraught, living in a camper or cheap apartment, kicked out of his own home, lonely, and rejected. He is hoping to appeal to her compassion and empathy. It's always worked before.

Here are a couple of the abuse target's choices at this point: she can go back to the pattern of abuse feeling horribly guilty and sad for her rebellious, selfish, and unloving ways, or she can **hold steady.** She can sit with the uncomfortable feelings of false guilt and shame. She can be curious about *why she feels guilty*. She can talk with her therapist about what it is inside of her that requires someone else's approval. She can practice tolerating her partner's covert disapproval, recognizing that his abuse is about him, not her. She can refuse to accept apologies *that are really just veiled accusations.*

He won't like this. His belief system says he is entitled to power and control over his wife. Who does this woman who belongs to him think she is to question his sincerity? Especially after all he's done for her over the years?

Predictable Thing Three: The Emotional Abuser Jumps Through Hoops

Often at this point, the abuse target reaches out to her church for help. She needs some support. He is making things at home even more uncomfortable as she ramps up the boundaries and subsequent consequences. When she brings in some outside help, this is where the emotional abuser puts on his best-looking mask as he grabs this opportunity to demonstrate just how wonderful he is while quietly throwing her under the bus in the process. This is also when he says he'll go to counseling. He'd never go before, but now that folks are watching, he's up for the performance of his life. He will begin to quietly introduce ideas into everyone's minds. He'll imply she is exaggerating. He'll call specific incidents she brings up simple mistakes and misunderstandings. To everyone, including the abuse target, it appears there is hope. He is willing to get help! Alleluia and praise the Lord, it's a Christmas miracle!

The abuse target has some choices here. She can back off, believing it's just a matter of time before he is a changed man. She can even give a bunch of concessions out of her extreme relief and gratefulness that he is finally getting help. If they do marriage counseling together (please don't do that—marriage counseling is for two committed partners, not for abusive relationships), she can confess all her sins to her husband and counselor in hopes that he will follow

her example and confess all of his, but her vulnerability will be used against her in the very near future if she does this.

Or, she could choose to wait and watch. She could choose not to assume he is going to change just because the outside pressure is on. She knows that real change comes from the inside as a result of the Holy Spirit indwelling a person and convicting that person in a real, deep, authentic way. Change that comes from getting caught and put in the hot seat of consequences isn't real change. She knows that going through hoops is just part of the abuser's game to gain allies and break her down further. He wants revenge and knows how he can get it, which is what he does next.

PREDICTABLE THING FOUR: THE EMOTIONAL ABUSER GETS SNEAKIER

His abuse becomes even **more** covert. Now he is putting on a show, so he becomes Mr. Great Dad, Mr. Giver, Mr. Showing Up, Mr. Bible Reader, Mr. Prayer Warrior, Mr. Guy Smiley in the eyes of everyone around. *Except the target.* Behind closed doors he is still blaming her, shaming her, denying responsibility, mutualizing the marriage problems, insisting on his innocence and goodness, and doing all he can to break her down spiritually and emotionally. He will demand the time he needs to get better and accuse her of not being patient and forgiving. He may guilt trip her by claiming that God is on his side, and she is disobeying God by disagreeing with him.

If she tries to explain these subtle tactics to those on the outside, they look at her like she's crazy. He appears to be doing fabulously to them. What is her problem? Unforgiveness? Bitterness? High expec-

tations? Ungratefulness? Jezebel syndrome? Maybe she has mental health issues? Whatever it is, she is the sinner now. His sneakiness pays off. He successfully pulls the wool over many eyes. He blurs the truth and creates confusion and doubt in everyone's mind because he knows confused people are controllable people. One especially effective tactic he uses is to tell others that he supports his wife and doesn't want anyone to take sides. This way, if she doesn't do the same, she is viewed as vengeful and bitter. The truth that there are two sides—a perpetrator side and a victim side—gets covered up with lazy cliches like "it takes two to tango."

This is by far the worst stage to go through because now you are not only fighting one person's abuse, but you are fighting the collective abuse of your religious community. Have you ever watched a movie where the main character is being duped by someone, and the viewers know it, but the main character can't see it? You know that feeling of frustration you get when you just wish the main character could actually see what's going on behind his/her back? A good movie will use that kind of dynamic to make your skin crawl. When that's happening to you in real life, and there is no way you can convince anyone because he's a skilled deceiver, it makes you feel like you really are going out of your mind. It's insane.

The abuse target has some choices here. She can back down and find her place again in the pattern of abuse, feeling she has no strength to fight not only him, but everyone else as well. Or she can use every last bit of courage and strength in her to stand strong in the truth of the situation. She senses everything slipping away so she makes the decision to go for all or nothing. This empowers her to establish some drastic consequences in a last attempt to demonstrate the seriousness of the issue. It is here that she often chooses to separate. She is now ready to take her last stand, finally accepting the fact that she

cannot control her abusive partner and his supporters, but she can control her own choices and what she will or will not put up with. This usually sets off an explosion.

Predictable Thing Five: The Bully Shows Up

When his target has taken her last stand, the emotional abuser can no longer make her believe he has changed, so he stops even pretending to be nice to her. Instead, he begins to experiment with a smear campaign, gathering as much ammo as possible from her journals, the intimate things she has shared with him over the years, the sins she has confessed in the counseling office, and all of her emotional triggers he has historically used to manipulate her, and he starts to spread stories made up of these different parts. Sort of true, but twisted out of context, these stories are crafted to make her appear to be emotionally unstable, unspiritual, unforgiving, and bitter. He flings sandbox sand and toys every which way in his all-out attempt to wreak havoc on her for daring to take away what he is entitled to—her body and soul. If she decides to file for divorce at this point, he does the next predictable thing.

Predictable Thing Six: The Smear Campaign

This is more than just saying some bad things about her to the folks at church. This is an all-out attempt to actually turn her children, her family, her friends, her counselor, her pastors, her everyone-she-ev-er-knew *against her.* This is a deliberate, orchestrated campaign to

fully discredit her and make even her family and children agree with him about how terrible she is.

If she goes to a conservative Christian church that preaches power-over relationships, she will be church-disciplined for not keeping quiet and submissive under oppression. Instead of loving her, they will launch Bible verse missiles in her direction, hoping to spiritually manipulate her life. Now that she is escaping his controlling clutch, he's got one goal. **Destroy her**. Ruin her financially. Ruin her reputation. Take her children away from her either physically or emotionally. And ruin her health with his fear mongering and stall tactics during the divorce process. In his mind, she deserves total annihilation of her character as punishment for daring to defy him.

All of this sounds horrible, and it is. But this is the crucible in which she will die and be reborn. This is the worst part of the abuse. The climax. The Final Battle. But it is also where the good stuff happens. We will get into all of that in chapter ten.

> *"The thief comes only in order to steal and kill and destroy. I came that they may have and enjoy life, and have it in abundance [to the full, till it overflows]."* (John 10:10)

> *"For nothing is hidden that will not be made manifest, nor is anything secret that will not be known and come to light."* (Luke 8:17)

> *"A false witness will not go unpunished, and he who breathes out lies will perish."* (Proverbs 19:9)

> *"The LORD detests lying lips, but He delights in people who are trustworthy."* (Proverbs 12:22)

WHAT THE CHURCH DOES

"Afterwards, the church I attended excommunicated me and the kids while giving money to my ex-abuser who hadn't worked in 17 years! It's been three years, and they still support him."

"It's like getting run over by a car and along comes an ambulance, but instead of picking you up and putting you inside to see if your heart is still beating, they back up a bit and then drive over you again. Just to make sure you're good and down."

"I lost my community of almost twenty years partly because of the mass emails that were sent out about me being the issue. I wasn't. It was all manipulation, lies, and deflection so his actions wouldn't have a spotlight on them. No one reaches out to me now, and I considered them to be family because I don't have close family. I had to rebuild my life while the church/pastors supported him through their inaction. He still attends, even though his private life is no different than what it was when I was begging for help."

"Our marriage ministry leader, who was an attorney, refused to help me (even with advice) after my husband

abandoned me and our three children because they did NOT BELIEVE IN DIVORCE."

"Three close friends that I trusted abandoned me when I divorced my abuser. To this day these "Christian" sisters refuse to communicate with me face to face about what happened five years ago. My heart still hurts from that abandonment. It was worse than the divorce at the time because I had already grieved and learned to cope with the toxic marriage I was in. But what they did totally blindsided me. Took me about two years to come to a place of not stewing on it over and over daily. It really hurt my soul."

"After discovering my ex-abuser's twenty years of unfaithfulness, coupled with porn addiction on top of refusing to work for seventeen years, the pastor told me if I would buy him a food truck, he would find purpose in life, since my career was overshadowing his manhood, causing the problems in the marriage. I was still walking in confusion at that point and bought the food truck. He never worked it but spent every penny I made on drinking and drugs. The church knew this, and after two years, I filed for divorce. The pastor sent me an email telling me I was not allowed to file for divorce without the church's permission, and I was required to meet with them immediately. I did not feel safe at this church, but I agreed to meet if I could bring an elder from another church whom

I trusted. They told me I wasn't allowed to bring anyone, so I refused the meeting. I was beginning to see how dangerous churches were to women. I requested to be removed from membership, but they refused to answer. They began sending me harassing emails and then sent my ex a letter stating I had been excommunicated and encouraged my ex to use it in court during the divorce. When that didn't work the pastor encouraged my ex to physically harm me and the kids to "teach us a lesson." My ex was arrested and went to jail. The church and pastor continued to harass me. They have made audio tapes calling me every vile word and sent it to my business associates, trying to destroy my livelihood. I can't sit in a service without experiencing severe anxiety attacks, and my mind races with replaying past abuses. I can't really hear what the pastor says, because I'm so scared he is out to harm me. So I stopped attending for now. Church is not a safe place for me."

"The impact of the church's aggressive effort to get me back together with my abuser using intimidation, bribery, and threats was severe. The greatest impact was on my children, who became victims of further criminal assaults. But I was also affected. I was left deeply convinced that no one would ever believe me. I developed severe PTSD and a near-catatonic clinical depression. I was unable to care fully for my home and children, let alone protect my kids and escape. I developed extreme phobias of answering the phone, reading email, and opening mail. I began to have periods of confusion and was unable to

do some fine motor tasks like dialing a phone and writing my name. I developed a fear of leaving my home, of attending church, and of making any eye contact with adult men. I developed extreme insomnia, to the point that I rarely slept more than 3-4 hours/night. I struggled severely with suicidal thoughts, and I have been unable to work. It grieves me that when he was finally taken away (by arresting officers), I was in a much more fragile condition, suffering much more harm than I ever would have known had the elders respected my dignity as a person, my eyewitness reports, my intimate knowledge of the abuser, and my place as the mother of my children. Another impact is that children who MOST need a se-cure attachment to their safe parent so that they can tell her what they know and how they are being treated by the abuser behind her back, are having that very attachment disrupted by some of the people they have been taught to trust most. I have heard from some child victims, '*The church didn't believe my MOM, and she was a grown-up. I was sure that if the CHURCH did not believe her, then for sure nobody would never believe ME, a little kid!*'"

—Quotes from Emotional Abuse Survivors

HOW THE CHURCH RE-ABUSES

As we've talked about in chapter six, a mind-blowing phenomenon often occurs when a woman who belongs to a conservative church decides to take the painful step of separation or divorce from her

abusive partner. Instead of supporting her and loving her, much to her horror they shun and even excommunicate her. Because of their power-over theology, the abuse of women is tolerated, especially if it is emotional and spiritual abuse; but legal protection from abuse (divorce) is not. The devastation in the lives of these women and their children is profound. I myself experienced excommunication from Bethlehem Baptist under the leadership of Jason Meyer in 2017. I had been shunned in different ways by church members for two years prior to my official excommunication. The elders from this church also pursued me to the next church I found refuge at in order to hold several meetings with the elders there to try to convince them not to allow me to attend that church with my children either. I've dealt with a lot of loss in my life over the years, but this particular experience was the most excruciating one of my life. I began having elevated C-PTSD symptoms that required medication and EMDR therapy. The effect it had on my children was also profound, and there are still years of healing and rebuilding to be done in all of our lives.

(You can read more about my personal story here: flyingfreenow. com/bethlehem-baptist-church-is-not-a-safe-church-for-women-in-emotionally-abusive-relationships.)

I am aware that some faith communities treat women with mutual respect and honor. These communities work hard to love and support their people without enabling abusive individuals to harm others. They work together with police officers, social workers, professional therapists, and abuse shelters to protect women and children. This section is not an indictment of them, but of the more common ones where women are attacked when they come forward to get help about their husband's mistreatment. I am currently attending a small, loving church in my neighborhood that teaches

the equality of all humans and promotes safe relationships. I know if my kids or I ever needed help, these people would be in our corner. If you are in a church like this, you are blessed. But many churches are nothing like this, and the ways their power-over theology harms human beings needs to be exposed. Churches that preach the name of Jesus Christ should be a safe refuge for women and children in the same way Jesus is a safe refuge for us. If they aren't, there is something wrong with the gospel they preach.

How a Dysfunctional Church Re-Abuses

When a woman finally gets desperate enough to tell the truth about her home life to the people in her church whom she should be able to turn to, she may be in for a cruel shock. I've talked to many survivors who have told me that even though they were scared, they eventually came to believe that by going forward they would be obeying Matthew 18:15-17:

> "If your brother sins against you, go and tell him his fault, between you and him alone. If he listens to you, you have gained your brother. But if he does not listen, take one or two others along with you, that every charge may be established by the evidence of two or three witnesses. If he refuses to listen to them, tell it to the church. And if he refuses to listen even to the church, let him be to you as a Gentile and a tax collector."

By this time a survivor has gone to her husband countless times over the course of many years, even decades, and he hasn't listened or cared. So the next step is to find a witness or two. The only problem is that **with hidden emotional abuse, there are no witnesses**. She

can hardly put into words the psychological games, dehumanization, and deception she has experienced, and certainly nobody else can see it from the outside. Even her own older children know something is wrong, but they have no category for it. With their limited life experience and strong desire for everything they've ever known to just be normal, they cannot stand for her as a witness, nor does she feel it is right or fair to put them in that position. So she may first reach out to some friends to test the possibilities of support. She will want to see if they can be a "witness" to her extreme pain and confusion. In the next section we'll talk more about what friends and family do when a victim reaches out; but for now, let's just say many of them don't do much of anything helpful.

When I reached out to Christian friends at different times over the course of twenty years, I was told not to gossip, not to slander my husband, to be grateful for what I had, to focus on the positive, to focus on Jesus, to be more submissive, to stop feeling sorry for myself, to lay down my life for my husband, and to read more marriage books about godly wifehood. So I would slink back to my corner and dutifully do all of those things, but of course, nothing changed. Eventually there were a few friends who came over and supported me as I read a letter to my husband listing my concerns and my desire for him to leave our home for a while, get therapy, and make changes. I finally had my Matthew 18 witnesses.

We separated, and I reached out to our church elders for help, planning to continue to follow Matthew 18. But here's where the whole thing broke down for me, and this is where it breaks down for other victims as well. You see, if a woman goes to a church where there is an undercurrent of power-over teaching and preaching, there will be a natural bias against her right from the beginning. These are the very people who believe Eve was the cause of all sin in the world.

Church leaders (who are all male in churches like this) will naturally feel a sense of empathy for the man who has been accused while putting the onus on the woman to prove she was abused. If she's got pictures of bruises and cuts that span a long period of time, she's good to go. If a person from church (preferably male) actually saw her get pushed and sworn at in the church parking lot, she *might* be good to go if she's got documented evidence of the same ongoing behavior in her marriage, but she also might just be encouraged to forgive and forget. If her husband has been verbally abusive to the elders or has disrespected them in any way, she's *very* good to go. If her husband has been placed in jail for molesting people or dealing drugs, she's also good to go. ***But none of those things will be present in the case of covert emotional and spiritual abusers.*** They wouldn't be caught dead disrespecting anyone outside the family. They aren't molesters or drug dealers or wife beaters. They are Sunday school teachers, deacons, pastors, and guys that quietly serve behind the scenes and would give the shirt off their back to anyone in need at church. And now she has to somehow prove this good man that everyone loves is abusive? How is that even possible? She's probably still not even sure herself what emotional abuse actually is and how it's showing up in her relationship.

So the church leaders will look with suspicion on the victim, seeing her as hysterical or maybe even lying. They will listen to the abuser's story and believe and validate his defense. After all, he seems so calm and logical and wounded by her accusations. They'll feel bad for him, pray for him, offer him free counseling to help with some of his "minor issues that really aren't that big of a deal and are only exacerbated by his unsubmissive, angry, bitter wife." They will praise his efforts to apologize and change.

As for the victim, they will turn on her with the same abuses her husband has heaped on her their entire marriage. They will accuse her of not forgiving and allowing him back into her bed. They will accuse her of not trusting God to change her abuser. They will accuse her of hurting the gospel with her lack of love for her husband (because in their theology, love is staying quiet and putting up with abuse). They will accuse her of not being submissive to her husband and to them. They will accuse her of exaggerating her pain and trying to get out of her marriage because she must think the grass is greener on the other side. They will accuse her of being selfish.

"But he is so sorry, and he loves you!" *"You are a sinner, too! Look to yourself!"* *"Emotional abuse isn't abuse, and it's certainly not grounds for divorce."* *"You don't know God."* *"Turn the other cheek!"* *"What did you do wrong to make him hurt you?"* *"Good wives don't have these problems."* *"You've been part of our church for years, and you've never said anything. How are we supposed to believe you now?"* (She didn't come forward because she feared this response! Also, if she were to cast off the charade, she'd need to get out of the marriage, and she knew that wasn't allowed. Churches like this damn a victim no matter what she does.)

So what happens to Matthew 18 now? Not only does the "brother who sins against you" not listen, but **the church doesn't listen either!** Instead, they believe the abuser's lies and turn Matthew 18 against the victim. That's right. They turn the Word of God upside down and inside out to make an atomic bomb that blows up the victim and her family. They take the abuser's testimony, add their own spin to it, and then take it to the church **against the victim**. They publicly share these twisted lies, ripping her reputation to shreds, and sometimes vote to excommunicate the very one who vulnerably came to them looking for help in the first place. This is

not the spirit of Jesus Christ. ***This is pure evil.*** The same evil the Pharisees in Jesus' time perpetrated against Christ Himself.

> *"Now the chief priests and the whole council were seeking false testimony against Jesus that they might put him to death....At last two came forward..."* (Matthew 26:59-69)

They will also quote Deuteronomy 19:15 to back up their hateful response. *"A single witness shall not suffice against a person for any crime or for any wrong in connection with any offense that he has committed. Only on the evidence of two witnesses or of three witnesses shall a charge be established."* This verse speaks to a situation in which someone desires to ***convict and condemn another person in court.*** This is a completely different scenario than when a victim comes forward looking for help in escaping an abusive relationship. But just like the Pharisees did when they used black and white rules to condemn and control and oppress God's people, so the Pharisees of today do not apply the law of love to their application of God's Word. Jesus came to model wisdom in applying the law, and He gave us several examples of how to do this, all of which caused the Pharisees of His day to gnash their teeth and eventually murder Him.

Please be aware that some churches who treat hurting women in this way will actually have protocols in place to help abuse victims, and they may claim they are on the cutting edge of advocating for women and children. I've heard this several times. Some of them will have taken a training course or two, and they may even have a handbook they use and a few folks set aside for this type of ministry. But this does not guarantee they understand or validate emotional abuse, because they usually only consider obvious physical abuse to be abusive. In fact, churches like this can actually know ***just enough to make them dangerous to victims.*** My own former church fell

into this category. They had a response team and their own written handbook along with an online sermon that caused many people to believe they were leading the way in the fight against domestic abuse, and yet they failed my children and me when we needed them most. Their power-over headship theology just wasn't compatible with an authentic battle against abuse of women.

> *"And he said to them, 'Well did Isaiah prophesy of you hypo-crites, as it is written, This people honors me with their lips, but their heart is far from me;'"* (Mark 7:6)

WHAT YOUR FRIENDS AND FAMILY DO

> *"Even my close friend in whom I trusted, who ate my bread, has lifted his heel against me."* (Psalm 41:9)

Recently in a Facebook group, a woman vulnerably shared a scary thing that happened to her children at church, and she rightly felt frightened and angry. The comments from the religious ladies in that group were appalling. It was as if nobody actually heard what she said. Instead of offering encouragement, support, and empathy, they offered her hard hitting lectures on how she needed to forgive and be kind and work hard to make things right with the abusive person who hurt her children. This was supposedly her responsibility as a Christian. Will she share her heart and her pain with those ladies again? Probably not. This experience shamed her and taught her to cover up her fear and pain and hide from others. Sadly, this isn't an isolated incident. This is too often the norm in conservative, funda-mentalist circles. Many survivors have learned that being vulnerable among Christians invites harsh attack.

Why is this? Some Christians are so insecure in their identity in Christ that they have to judge and criticize others in order to feel that they are a good person, worthy of God's approval. There is a constant comparison process going on— a jockeying for power and control. Everyone's got his/her inner critic shouting accusations and condemnation in his/her head, and this putrid mess spills out onto others as well. This is a stench to the unbelieving world around us—not gospel living. John 13:35 says the world will know we are followers of Christ by the love we show one another. No wonder so many people want nothing to do with the Christian faith.

Another reason some Christians will respond to an abuse target's story with an attack is that they may feel personally threatened by hearing of a Christian woman suffering abuse. If it's the victim's fault, that means they are safe from it happening to them. But if they agree that the victim is suffering through no fault of her own, that means it could happen to anyone, including a loved one. This is an uncomfortable and insecure realization most people don't want to acknowledge.

When you open up and share your story and your experiences with your friends and family, you'll get mixed reactions. Some will not believe you, especially if they have known you alongside your husband for several years. Especially if you've done a good job of hiding the abuse in an attempt to "cover a multitude of sins." Some will actually be angry with you for not telling them sooner or even feel betrayed you hid it so well. *How dare you claim to be a friend and then hide what was going on from them?* I know women who have lost friends simply because the friends were upset for this one reason alone. Others will be angry with you for saying things about your husband they don't want to hear. They will call it gossip. Valerie Jacobsen says that *"gossip is telling someone else's story from a bad*

motive, while honesty is telling your own story faithfully, both for the glory of God and for the good of others." I love that. But many of your friends and family members will not see it that way, although those same folks will soon go and actually gossip (in the very real sense of that word) about you.

Some of your friends and family will go to your abuser to get "his side of the story because that's only fair." And of course, he is ready and waiting for them. You will now come across like the one on the offense which places him in the defense role, and this dynamic flips the victim/perp roles upside down. It's the perfect storm. The extreme pain and anxiety this causes in a victim is almost unspeakable. Many victims have told me it's the worst thing they've ever endured—especially when family members take the side of the abuser.

I recently experienced this after the death of my dad. One of my sisters and her husband put together some activities after the funeral to which my family was invited, including my abusive ex-husband. I was not invited, and several people in my immediate and extended family, in an effort to keep the peace, colluded with this sister. It was easier to throw me under the bus than to take a stand against hateful treatment. I've heard countless similar stories from coaching clients and other survivors. This kind of experience is traumatic and can leave you alone reeling in confusion and pain long after it's over.

And the children? I could write an entire book on how children are affected when a woman finally stands up to their father, but we have limited space here. From my work with emotional abuse survivors, I've observed that while younger children tend to do much better under these circumstances, it is quite common for older children to actually side with the abuser. Adult children will often go so far as to disown their own mothers who have historically been the emo-

tionally safe and connected parent for them during their childhood. There are many reasons for this tragic fallout. One reason is that older children spent more time in the same confusing, toxic environment, often buying into the power-over structure of male/female relationships. And why wouldn't they? The mother had to go along with this structure in order to make sense of his selfish entitlement and the expectations he put on her and the kids. She raised them to love their dad, to excuse his bad behavior, and to see his viewpoint and desires as primary. Young adults raised this way can't overcome this kind of brainwashing easily. Because she taught them from birth that daddy was the boss and the only one who really mattered, their immature, brainwashed minds cannot conceive that all of this was a lie. It tears down their entire world.

Another reason young adult kids will reject their mother and embrace the abusive dad is because they've been craving and needing the love and approval of the emotionally disconnected parent their entire lives. When the woman disengages from her abusive husband and sets up healthy boundaries, the abuser retaliates by using their older children to triangulate against his target. And in some cases, these older kids will succumb to this in a subconscious attempt to have that longed-for love and approval from their dad. They don't know it's not real love. It's predicated on their disapproval of their "sinful and rebellious" mother. Many divorced moms have excruciating stories of how this plays out long after the divorce is over.

One of the best treatises I've ever heard on this subject is a lecture done by Craig A. Childress, PsyD at California Southern University on November 21, 2014, called "Treatment of Attachment-Based Parental Alienation." (https://bit.ly/2w0vMDf) Another excellent resource packed with research on this phenomenon is *The Batterer as Parent: Addressing the Impact of Domestic Violence on Family*

Dynamics by Lundy Bancroft, Jay G. Silverman, and Daniel Ritchie. Do not let the title mislead you. The book does not only speak to violence in the traditional sense of physical abuse. It applies to every kind of domestic abuse, including hidden emotional abuse.

A common line victims hear from friends is *"I wouldn't be your friend if I didn't tell you that what you're doing is wrong."* Or *"I love you too much not to tell you how wrong you are."* But is that love? Is that friendship? Do we take opportunities to lecture hurting people when they are down? How many women have I talked to who were single parenting under extreme financial duress due to their husband's withholding of funds during the course of divorce? How many of them were totally abandoned by their churches and families and friends while they struggled to raise their children and put food in their mouths and find a job after being out of the workforce for their entire married lives?

These women didn't need a self-righteous lecture about how wrong they were. They needed the love of Jesus through the body of Christ. They needed healthy, God-saturated people who would be open, vulnerable, safe, and wise. They needed Christ lovers who are seasoned in suffering. They needed good listeners, not good judgers. They needed someone kind and compassionate to sit with them in their pain—not judge them for it. They needed someone who was already safe and secure with God, not needing to be in a one-up position, who could offer them a safe, secure friendship. They needed someone who would not tolerate lying and abuse. Who would not coddle and condone it. They needed someone who would set captives free and extend the help and hope and love of Jesus Christ.

I hope you have a few people in your life who will be faithful to love you well in your efforts to recover and heal.

FOR FURTHER STUDY

» *The Subtle Power of Spiritual Abuse: Recognizing and Escaping Spiritual Manipulation and False Spiritual Authority Within the Church* by David Johnson and Jeff Van Vonderen

» *Fractured Covenants: The Hidden Problem of Marital Abuse in the Church* by Marie O'Toole

» *Safe People: How to Find Relationships that are Good for You and Avoid Those that Aren't* by Henry Cloud and John Townsend

Check Point

Maybe this was a hard chapter to read. When you pull your card out from a house of cards, you face a big crash, and it's painful. Not only does the house fall down around you, but you are blamed for its destruction, and *this is what you've probably spent your entire life avoiding*. But I have some good news for you. When your house of cards falls down, you get the incredible opportunity to build a new house on the solid foundation of Christ's love and acceptance of you. You will discover who you are as a daughter of God, and you will find the inner peace and rest of living authentically in alignment with the truth. You will be able to come out of hiding and learn adult skills of relating to all kinds of people, including dysfunctional ones who refuse to change. You will be empowered to truly come into your own and live the life God created you to live without being under the scrutiny and management of manipulative, controlling people.

I've worked with hundreds of women just like you both in my private coaching practice as well as in my private support and educational community called Flying Free. (Please visit my website: flyingfreenow.com for more information.) These women have experienced exponential growth and healing through educational resources along with the validation and support of other survivors. In the next two chapters, we'll look at the key to your future, *because you've got one!*

Flying Free Sisterhood
An online coaching, education, and support community
for women of faith in destructive relationships.

What if you didn't NEED the approval of others to feel confident that you can make good decisions for you and your kids?

What if you had a group of friends that understood your marriage problems and could offer the support and acceptance you crave? Friends that have your back and will love and respect the choices you're making?

… and what if you had a way of dealing with your old hurts and baggage so you can deprogram from the lies that are keeping you stuck—to start walking with confidence and hope?

Imagine not being afraid of the future because you had the self-awareness, skills, confidence, and freedom to make adult decisions.

(You feel like you could do this if you weren't so alone.)

We'd love to have you join our private, online community of Christian women who are learning and growing through weekly coaching, courses, workshops, live gatherings, and a private forum.

Learn more about this program and apply here:
www.joinflyingfree.com

The Key to Your Future

THE PROCESS OF HEALING

This was the chapter I couldn't wait to write. You see, I don't enjoy talking about abusive men and their entitled, misogynistic worldview. I don't get a kick out of writing about the horrible pain and confusion women go through while living with abusive men who claim to be followers of Christ. I don't feel any joy uncovering church re-abuse and the stench it sends all across this planet and up into heaven. You know what I do love? You know what gets my heart pumping with excitement? The stuff in this chapter. This is my passion—to help women of faith find hope and healing from emotional and spiritual abuse. To help them go from crawling to flying. This is why I started the Flying Free education and support community—so I could work more closely with women, offering them education, validation, and emotional and spiritual support on their journey up and out.

One of the most shared articles on my website is called "How to Go From Crawling to Flying After Living with Emotional and Spiritual Abuse." Several of the women I work with requested that I include this article in my book, so I'd like to share it here:

DENIAL
(THE CATERPILLAR IS HIDDEN INSIDE A TINY EGG.)

You are in denial. You may know there is something horribly wrong, but you don't have a category for what it could be. One day you think your relationship is fine and normal (and you want that so much), and the next day something happens that sends you reeling from the painful reality that your relationship is the most confusing and hurtful thing in your life, and that just can't be normal or fine at all. Let's talk about what happens when the greatness of your pain no longer allows denial to be an option.

WAKING UP
(THE CATERPILLAR IS BORN!)

Waking up is like jumping into an icy cold lake in the spring right after the ice has just thawed. It's shocking. It hurts like crazy. It's a known fact that denial is one of the ways our bodies are able to absorb the initial shock of a traumatic event. In the case of long-term emotional abuse, **denial is a way of life**. Breaking out of it is like a punch in the gut that sort of keeps punching for a while.

I can remember when this happened for me. One morning, after spending a night in a hotel room contemplating suicide, I dragged my eight-month pregnant body to a local bookstore and started doing some research on my computer. I remember the dawning realization that I was in a destructive relationship that was quite literally killing me from the inside out. I wanted to believe I had married a good person. Someone who loved me. Someone who respected me and cared for my feelings. I wanted to believe we had a healthy

family. A happy family. This was all I had ever wanted in life. Now the kingdom I spent nineteen years passionately pouring myself into was crumbling to pieces.

It hit me hard. It felt like something inside me died. I remember telling myself—forcing myself—to look at it honestly. To face it. To not run. I was aware in that moment that I had been running from the full impact of the truth for many years. When this happens to you, you can't go back. In a sense, you are born. Like the tiny new caterpillar emerging from the tiny black dot of an egg, once you're out, you can't get back inside the protective shell of that egg. You have to learn to survive in reality now. Which brings you to the next stage.

Learning
(The caterpillar eats and eats and eats!)

Now you begin to learn everything you can about your experience. Just like a baby caterpillar eats continuously and grows daily, shedding her old skin to accommodate her new growth, so you learn and grow, shedding old belief systems that kept you deceived and trapped.

Compared to ten years ago, the resources available on the subject of emotional abuse have exponentially multiplied as victims are finally exposing and leaving behind abusive relationships. This is good news for you! Not only are there excellent books on this subject, but there are several educational blogs and YouTube videos available.

- *The Emotionally Destructive Marriage* by Leslie Vernick— This was the first book that nailed everything on the head for me. I hired Leslie to coach me for several months while

I learned everything I could about why my marriage was the way it was and how I could change my own dance steps and grow up into adulthood.

- *The Verbally Abusive Relationship* by Patricia Evans—I literally ugly cried my way through this entire book. I had no idea verbal abuse was all the things Evans describes. Highly recommend for identifying this type of covert abuse.

- *Why Does He Do That?* By Lundy Bancroft—This is another must-read, not just for victims, but for those who care about them. It explains the pathology behind abusive behavior and is very practical in the waking up process.

- *Becoming the Narcissist's Nightmare* by Shahida Arabi—This book has a "mean" title, but it's really about becoming yourself instead of being what your abusive partner wants you to be. When you are fully you, that is his nightmare.

- *Safe People* by Henry Cloud and John Townsend—This resource helps you figure out who to get close to and who to avoid.

- *In Sheep's Clothing: Understanding and Dealing with Manipulative People* by George Simon—Learn how to spot and deal with a fraud.

- *The Wizard of Oz and Other Narcissists* by Eleanor Payson—Discover everything you need to know about narcissism and how it relates to your emotionally abusive relationship.

- *The Mind of the Intimate Male Abuser: How He Gets Into Her Head* by Don Hennessy—I consider this to be one of the best books out there for getting insights into how your partner is able to control you from the inside out.

Some helpful blogs include my own, Flying Free, as well Little Red Survivor, Self-Care Haven, and Leslie Vernick's blog. I also highly recommend the YouTube videos by Patrick Doyle. I think I've

listened to almost all of them, and several I've listened to numerous times.

There's also the Flying Free Support Community (https://membership.flyingfreenow.com/sign-up) where you can choose from a list of relevant and empowering courses to work your way through the pain and confusion of emotional and spiritual abuse and find the true peace of God. You'll get to know other women of faith who have endured the very same pain you know too well.

GRIEVING (THE CATERPILLAR GOES INTO A CHRYSALIS AND BEGINS TRANSFORMING.)

As you learn more, you feel a strange release of hidden, inner pressure, and it brings a sense of relief in many ways. You discover you are not crazy after all. However, now that you are beginning to see things for what they really are, it dawns on you that you will need to do something with this new understanding. It means that life cannot go on as it always has.

As painful as the relationship was, it became your normal, and when something feels normal to us, we are reluctant to change things. It feels scary and uncomfortable to think about all the unknowns ahead. You are also realizing the relationship was a farce. Your spouse didn't love you. The relationship wasn't what you dreamed it could be. The hopes you had were never realized. The wall you kept hitting was real, and now you know it's never going anywhere.

You are now convinced that your attempts to make a difference in your relationship never worked, and to think they will work at some

point in the future is not realistic. You were living in a dead marriage where the vows were broken long ago, and now you will go from denial to feeling the full impact of that loss.

You will inevitably need to move through the grief cycle in order to find hope and healing. This process can take two years and longer. Many people will not understand that you are grieving since you haven't lost anyone to death. The process of grief is not linear. It twists and turns through loops that overlap, move forward, and then fall back again. Give yourself the time and compassion you need to get through this part of healing and choose to ignore those who are unsupportive and don't get it. They will only keep you from doing the hard work that lies ahead.

I spent over three years going through the grieving process. The worst part for me was all the anger that surfaced after so many years wasted in vacillating between hope and despair. I was also angry at the people I had reached out to for help who ignored me and actually took his side in blaming and shaming me rather than addressing the serious issues in his life that were destroying our marriage. They applied grace to him though he was unrepentant, and they laid down the law for me when I most desperately needed support and love. I was angry at myself for putting up with it for so many years. I was angry at God for letting me marry him and buy into the religious propaganda that enabled the abuse. I was angry at all the things he continued to do that were hurtful and shaming and deceptive—all with the support of other religious men and women who had no idea what was really going on.

I eventually became depressed. I was having panic attacks and ended up going on medication for anxiety and depression—something I never thought would happen to me. Eventually, I came out on

the other side a whole, intact person who is no longer stuck in the pain of the past but who is looking forward to the future. *It just took time.*

The grieving stage can be compared to the caterpillar when she spins her chrysalis and begins the hidden process of transformation. This is a dark, quiet stage where there seems to be no movement forward from the outside. It takes a long time and feels suffocating. It's cramped, and everything in you is undergoing major changes in how you think, feel, and what you believe. But just because you can't see the transformation taking place doesn't mean it isn't happening. This hard stage is where the most painful, most miraculous stuff is actually taking place. I recommend just immersing yourself in the Psalms and the Gospel of John during this stage and letting yourself do a lot of ugly crying. Writing out your feelings in a private journal can help as well.

Getting Out (The butterfly emerges.)

The caterpillar is no longer a caterpillar. She is now a completely different creature altogether—a beautiful butterfly with the capability of doing things she could never do before. But first, she needs to shed the remnants of her old life in order to be free to move into all her potential.

If you've ever seen a butterfly work to get free, you will know that it isn't always easy. This work is critical, though! While she struggles, blood is pumping into her wings, prepping them for their future flight. This takes time and effort, and others should not interfere with this process, though they may attempt to circumvent things by

trying to control you as well as the process. Though their intentions may be good, only you can break through the chrysalis of broken dreams and lies. You have to do it on your own to be strong enough to fly once you're free. You'll learn about healthy boundaries and apply them here, gently letting others know you are capable of making decisions for yourself now. You're all grown up and can take responsibility for your own life.

This stage would not be possible unless that caterpillar had already done the transforming work in the chrysalis. In the life of the emotional abuse survivor, this stage is the Final Stand. It's where you take all the things you've learned and integrated into your life, and you bring it all to bear on this last effort to break free. Your old life struggles to keep you trapped.

Your spouse will likely fight back, attacking your character and personhood in order to make breaking free through separation or divorce hell on earth. Abusive individuals do not want you to have healthy boundaries, and they will do everything in their power to maintain control. They may launch a smear campaign against you, making it appear to others that you are actually the crazy, abusive one while he is the innocent victim who just wants to keep the marriage together because he loves you so much. Sadly, this usually works in the man's favor. Be strong! Just because people believe lies doesn't make them true. Healthy, respectful people will come to you to find out about your life—not just listen to your abusive spouse and his allies.

Breaking free means saying goodbye to old friends who weren't really friends. Saying goodbye to your reputation. To your church. To your marriage. To your financial stability. To your previous dreams. It hurts. It requires much of you, but remember that in this stage, you

are a new creature. God has given you the power and desire to do it. To fulfill your destiny and the purpose for which He created you. Evil can no longer destroy you through your spouse or your religious community. You belong to God Himself, bought with the blood of His Son, Jesus Christ. Nothing can snatch you from His hand. It's just you and Him now, and that's all that is required for flying free. These are two books I recommend at this stage:

- *Boundaries* by Henry Cloud and John Townsend—This was a game-changing book for me. I wish I had read this book many, many years ago. Boundaries are something I now teach my kids regularly as life unfolds for them. People with healthy boundaries won't fall into abusive relationships because abusers can't stand being around well-boundaried people.
- *Necessary Endings* by Dr. Henry Cloud—I am convinced God had me read this book right before I lost two close friendships as well as my church and my marriage. Because of the truths I learned in this book, I was ready for those endings, and they were indeed necessary. Those endings would have been far more traumatic had I not been prepared.

Rebuild Faith and Friendships (The butterfly's wings dry and stretch out.)

Once you reach this stage, you have passed through an almost unbearable crucible that has likely caused extreme pain for many years. Your life has been shattered in a million pieces, and you need a break. You need to rest and consider. When the butterfly completes

her struggle to get free from the chrysalis, she rests while her wings slowly dry out. She is now free of the lies and brainwashing and can see the truth clearly. She stretches and practices using her wings, strengthening them and getting them ready for a new life of flight.

This stage is a crucial one because this is where you process your entire belief system, and all the pieces land where they need to for now. You organize your thoughts. If your faith in God was shaken, you find out where the fragility lay, and that part of you gets strengthened. Often, your faith will be more real and powerful than it ever was before—much like a broken bone that has healed.

Friendships will change during this stage as well. There will be some friends who walked through the entire ordeal with you, loving and supporting you every ugly step of the way. Others will have left you in your pile of sorrow, never looking back. Cut your losses and be glad for the opportunity to discover which relationships can withstand the test of time and trial.

But the exciting thing about this time is that you will actually begin to form new friendships that are healthier because as your boundaries and courage and confidence return, you will attract other healthy people. I've been amazed at how God has replaced so much of what I've lost. The tearing down was just His way of doing some necessary renovation in my life, and this will happen in your life too as you allow yourself to courageously embrace and walk this entire process.

NEW LIFE BEGINS
(THE BUTTERFLY SPREADS HER WINGS
AND FLIES AWAY!)

This is the part we all want to get to NOW, without the pain of everything that comes before. But do you see how all the stages are necessary in order to finally make it to the flying part? You can't fly otherwise. When you are finally rebuilding your life, your career, and your relationships, having left all the fully processed past behind, *you are flying into your future.* And boy, does it feel exciting! You can think clearly. You can see clearly. You can feel again. You are embarking on a new path, hopefully moving toward the fulfillment of all that God created you for. This life you were given is now being responsibly stewarded, and you are finally free to worship and obey God, not men. Those who are on the same path will be flying right alongside you on the wings of grace.

One of the exciting parts of flying is helping others still crawling on the ground see how they can also fly in freedom. God will use you to help set captives free. Your testimony is powerful. Anything purified with fire or trials is powerful.

So where are you in this process? Are you right at the beginning, just starting to realize there is something more seriously wrong in your marriage than you could have ever dreamed? Or maybe you are toward the end, getting ready to start a new life in Christ. Wherever you are, Jesus Christ is right there with you, even when you can't feel Him. He loves you and will faithfully walk you through.

SELF-CARE

"Self-care is so important. When you take time to replenish your spirit, it allows you to serve others from the overflow. You cannot serve from an empty vessel."

—Eleanor Brown

Recently a friend of mine shared some feedback she had received on a product she created that encouraged women to not only love and serve others but to balance that out with taking care of themselves. The feedback went something like this: "*I don't think American moms need any more encouragement toward selfish behaviors like 'me-time.' We care for ourselves when we are others focused. This is the work to which Jesus has called us.*"

This sounds spiritual, doesn't it? There are three parts to this woman's belief system regarding self-care. First she believes self-care is selfish. Is this true? That depends. If all we are doing in life is going to the spa and eating bon bons in front of Netflix, then maybe we need to do a little tweaking on our life purpose. Maybe this woman runs in some really selfish circles, but I personally don't know anyone who lives like this. The truth is that self-care in and of itself isn't selfish. It is selfish to eat? Is it selfish to sleep? Is it selfish to read a book in a quiet room? To the contrary, it's healthy to do all those things, and without peaceful activities people burn out and lose their power and effectiveness in serving others. We don't want to be a fireworks display that gives everything in a few moments of glory and then dies down completely spent. We want to be more like a slow burning camp fire that we carefully feed in order to bring light and warmth

throughout an extended period of time. We want to spend our ***entire lives*** doing the work God calls us to do. This is a marathon, and we need to pace ourselves and take care of ourselves so we can run it faithfully. So this assertion that self-care is selfish is not accurate. Self-care is necessary to serving others.

Her next statement is that we take care of ourselves by taking care of others. This is the exact opposite of the truth. We cannot be others focused unless we have first taken responsibility for ourselves. We serve out of the overflow of our emotional, spiritual, and physical health. The Bible tells us to love our neighbor as we love ourselves. This assumes we love, accept, and care for ourselves. It assumes our self-regard is rooted in God's regard for us through Christ. It also implies that if we don't love ourselves well, we cannot love our neighbor well. If we can't connect with and accept who God made us to be, how can we accept others the way God made them? I believe the degree to which we truly love and accept ourselves through Christ is the degree to which we truly love and accept others. When someone is critical and judgmental toward others, I believe they struggle with their own shame and lack of self-awareness. It is this self-awareness that gives us the ability to be aware of the inner worlds of others so we can offer them empathy and love in spite of their weakness and failure. So the truth here is that when we care for ourselves, we are better able to authentically connect and care for others.

Her last assertion is that Jesus is calling us to not only take care of ourselves by focusing on taking care of others, but to do so at the expense of not taking care of ourselves. (It sounded spiritual, but it's really a bit of a brain-flip!) Where is Jesus calling us to do this? We cannot lay down our lives if we don't have a life to lay down in the first place. If what she's saying is true, Jesus disobeyed Himself when He got away to spend time with His Heavenly Father and rejuvenate.

And what was he doing the first thirty years of His life? Why wasn't He in ministry? Was he just wasting His life in a carpenter shop? And how do we know when we are other's-focused *enough?* Do you see how this works-based religious belief system sounds really pretty on the outside, but it puts a tremendous burden on people to burn out in order to be viewed as spiritual and obedient?

> *"The scribes and the Pharisees sit on Moses' seat, so do and observe whatever they tell you, but not the works they do. For they preach, but do not practice. They tie up heavy burdens, hard to bear, and lay them on people's shoulders, but they themselves are not willing to move them with their finger. They do all their deeds to be seen by others."* (Matthew 23:2-5)

What if the truth is a little more common sense than that? We've spent time examining the power-over theology that places women in the role of Cinderella, only there is no fairy-godmother to make it all better. Our goal is not to be the best Cinderella we can be. Our goal is to bring honor to Christ in how we steward the lives and gifts He's given to us. There will always be people who want to use us, and meeting their demands will take us away from our true work. If we believe we are subservient to the whims of human beings, we will never learn to apply wisdom to each demand and select the ones that are in alignment with God's calling on our lives. When we say "no" to something, we are saying "yes" to something with a higher priority at that moment in time. Once again, it's absolutely necessary that we take care of our own homes and yards. **This is the essence of self-care.**

So many emotional abuse survivors are burnt out. They don't believe they are worth taking care of. When we take steps to care for our

bodies and minds and spirits, it rewires our faulty brain thinking from the lie that "*I am worth nothing*" to the truth that "*I am precious and valuable to my Heavenly Father and to this world He put me in.*" I've watched many women begin to respect and care for their bodies, their minds, their time, and their resources, and when they do this, they begin to blossom. They give themselves the freedom to find places of peace and rest in their lives—places God Himself has given them because He is a good God who loves them. When they are in this balanced place, they experience far more productivity.

If you've been immersed in an environment that shames you every time you take action to protect and take care of yourself, you will have a hard time with this at first. It might even feel scary. But try it. Here are some simple, practical suggestions to get you started:

1. **Use your imagination.** Create a special place in your mind where the ***real*** you can go when you are being attacked. Mine is a place by a stream. It's quiet except for the sounds of a breeze rustling leaves, the friendly chirp of birds, the hum of insects, and the sound of bubbling water skipping over small rocks. There are some big trees by the side of my stream, and under one is a large rock on which two people can easily sit. Jesus is there, waiting for me. I sit next to Him and lean on His shoulder. It's quiet, and I rest in His presence.

2. **Use your posture.** Get on your knees and put your face to the floor. Pray for a couple of minutes. Give your burden to Him. "*Father, I can't do this. I can't do this. I give it to you. Take it from my shoulders, and do something beautiful with it.*" Then stand in a power pose in front of the mirror and say out loud, "*I am a daughter of God, and in Him I am safe and loved!*"

3. **Use your resources**. Do you have a bath tub large enough to soak in? Soak. Do you have a view from your back yard? Sit out there and rest. Is there a park nearby where you can walk? Go walk it. Do you have finances to purchase a massage here and there? Do it. Try relaxing and strengthening stretching exercises—there are loads of YouTube videos to teach you how.

4. **Use your focusing abilities.** Breathe deeply and slowly. Notice your surroundings. The sounds you hear. The colors you see. The temperature of the air. The way a blanket feels on your skin.

5. **Use your journal.** Jot down two or three lovely things you noticed today. A cardinal on a tree branch. Something adorable your child said. The look of an old man on a bench. There are a million treasures to experience, but because abuse survivors are always on edge, trying to survive, they often miss the beautiful and normal things in life.

6. **Use your mentorship skills.** Speak truthful encouragement out loud to yourself. "*This too will pass.*" "*I will get through this.*" "*I'm doing my best.*" "*I can learn from my mistakes.*" "*This is not my problem.*" "*I am enough just as I am.*"

7. **Use your story-telling skills.** Remember that God writes long stories. Your story isn't finished. What's the plot? What's the plot twist? Who are the main characters, and how will your character change and grow through the telling of the story? Spend some time thinking through your story and even writing it all down. The process of writing will engage your body and brain and help you process your history and bring some resolution and closure.

8. **Use your time.** Take a short vacation. One hour. One day. One week. Whatever you can afford. Watch a movie. Eat popcorn. Go out with a friend. Listen to beautiful music while laying under the stars. Curl up with a glass of wine or some hot chocolate and a good book. Do a jigsaw puzzle. Do whatever relaxes and rejuvenates your body, mind, and spirit.

I was talking today with a woman who had been taking care of everyone else her entire life, and she had no idea how to take care of herself. I encouraged her to make a list of the things she has always done to care for others and then look at the list and pull out some things she can do to take care of herself. Self-care is far from selfish. It is taking care of yourself so you can go from merely surviving life to thriving in life. And when you are thriving, you'll be in a great place to love others well.

SELF-ADVOCACY

I remember the day I realized I had thrown myself under the bus in favor of protecting and helping someone else most of my life. I felt used and abandoned, and I was angry at the wasted years. While ugly crying in the bathroom, I remember looking in the mirror at my snot covered face and saying with gritted teeth "*I will **never, ever, EVER** throw you under the bus again, Natalie. From now on I'm going to be your best human advocate. From now on I am going to love and accept you the way Jesus does. From now on I've got your back. You can count on me.*" It was a life changing moment, and I've never looked back.

This means that now, when others share their negative opinion of me, I regard it as exactly that—one human's personal opinion. And everyone's got one, right? Are they all going to like us and agree with

everything we do? Of course not. But that's okay, because God loves us exactly as we are. We can align our view of ourselves with God's view rather than with the opinions of people. We have to remember that people are fickle. They might like us today because we're giving them what they want, but tomorrow when we say "no" they don't like us anymore. We don't want to live our lives tossed around on the waves of human opinion.

Going through a public shunning and excommunication from my religious community was the worst experience of my life so far, but I wouldn't trade it for the world. You see, before this I had an insatiable desire to be loved and accepted by others. My identity was wrapped up in what they thought of me. But then it was like God said, "*I am going to take the sinful choices of power hungry men and their supporters and use the pain it causes to heal My daughter, Natalie, of her propensity to look for love and approval from humans. What they mean for evil, I will turn into great good in her life and in the lives of my other daughters. She will lose the love of people, but I will show her that My love is enough. I will heal her not just on the surface, but deep down in the depths of her soul.*" And into the fire I went.

It was terrifying and painful, but I experienced the intimate love of Jesus Christ in a special way, much like I had experienced Him as a child going through several years of bullying at school. The more people hated on me, the nearer He became. He taught me during that time to stop groveling before the people I thought were Big and Important. There was only One Big and Important Being I needed to be concerned about, and He was in my corner.

Self-advocacy feels counterintuitive because every time you've acted with self-interest in the past you've been criticized, made to feel guilty, and rejected by those who believe, for whatever reason, it is in

their self-interest to keep you in a power-under, controllable, child-like state. They've programmed you to believe you're a selfish meanie if you advocate for yourself. But that's not true. Self-advocacy is what all normal, healthy adults do. It's simply taking all your empathy, sensitivity, and conscientiousness and applying it ***not only*** to others ***but also*** to yourself. Self-advocacy means having healthy boundaries. When you advocate for yourself, you do several things.

- You respect your own experience and voice.
- You forgive yourself.
- You trust your gut.
- You are open to learning new things.
- You are free to change your mind.
- You choose.
- You are willing to stand alone (knowing you are never alone!).
- You develop your strengths and accept your weaknesses.
- You spend time with healthy, wise people.
- You limit your time with controlling, abusive people.
- You don't try to justify or explain yourself.
- You no longer pursue the approval of others.
- You are good with YOU!

Here are some of the benefits.

- You replace anger and frustration with peace.
- You have clarity about what is yours and what isn't.
- You experience a new sense of power and control over your own space and life.
- You grow in greater self-awareness.
- You grow in greater respect for yourself and others.

- You experience a deeper sense of safety; you are now on your side.
- You experience freedom from feeling responsible for managing everyone else's life.
- You have more time to do what is important to you.
- You become less judgmental of others and their boundaries.
- You expect less from others, and you are able to love and accept them the way they are.
- You go from being an abuse victim to being an abuse survivor to being a woman who is thriving.

Self-advocacy is one of the most important keys to your healing, but in order for you to get to the place where you can advocate for yourself, you need to rewire your brain by replacing lies with the truth.

REPLACING LIES WITH THE TRUTH

Imagine a dirt road through a field full of tall wild grass. How did the road get there? If you drove a car through a field of tall wild grass one time, would that create a road? No. You might not even be able to see where you had driven the next day. What if you drove it over the same ground ten times a day for a week? Now do you have a road? Probably not a road, but you'd definitely be able to see a path starting to form. What if you drove over that same path dozens of times a week for a year? Now you've got yourself a dirt road.

This is what's happening in your brain every single day. Have you ever noticed that you tend to think the same thoughts over and over again like a broken record? Things like *"I'll never be good enough." "I don't have what it takes." "I can't do this." "I don't deserve kindness." "I hate myself, and I hate my life."* The car of your thoughts has driven over the same territory so many times that you now have deeply

embedded roadways in your brain called belief systems. We make all our decisions based on these core beliefs. But what if we could stop driving our car of thoughts over these same roads and decide to make some new roads? Would we be able to make a new road in one week? Probably not, but we might be able to get one off to a good start!

Here's what I encourage my coaching clients and Flying Free members to do: Every month pick one of those pesky thoughts that you keep looping over all the time. Maybe it's *"If there is a God, He certainly doesn't care about me."* You want to stop giving that road attention while at the same time starting a new pathway that says, *"God loves me; I belong to Him, and He's going to get me through this. He is near to my heart, and I can never be outside of His deep love for me."* At first, driving through the tall grass and lumpy ground to that new thought will feel uncomfortable. You'll be sorely tempted to take the path of least resistance—the smooth dirt road of your old thoughts that you're used to driving over every day. But if you are serious about rewiring your brain, and if you are intentional about noticing when the well-worn thought is rearing its nasty little head, and if you are willing to make the effort to speak the truth out loud to yourself every single time, your brain will begin to rewire itself with the truth. It's so simple it doesn't seem possible, but I spent a couple of years rewiring one lie each month, and it changed my life. You see, our core beliefs tell our brains what roads to drive over every day, and those roads dictate the direction we take in life. If we can change the roads, we can change our core beliefs, and that will **change our lives.**

Here are some typical lies that emotional and spiritual abuse survivors have to rewire:



- I'm a Christian woman, so it is my duty to serve, and I don't deserve respect or appreciation.
- If I was a good wife, my husband would be good to me.
- If someone is a church leader, I need to trust that they know what's best.
- I am responsible for the success of my marriage.
- I'm a failure.
- I'm not strong enough.
- I have no courage.
- If I sweep it under the rug, the pain will go away.
- I am responsible.
- I am alone.
- It's all my fault.
- I'm in so much pain because I'm emotionally unstable.
- I am unloved.
- I am vulnerable and exposed.

Back when I was first separated from my now ex-husband, I kept a journal of my progress. For the first few weeks it was full of utter despair, but I also began to rewire many of the things I listed above. Because I am a Christian, I often (but not always) used Scripture to make new pathways in my brain. For example, one month I wanted to rewire the belief that I was alone with nobody to advocate for me. I used Exodus 14:14: *"The Lord will fight for you, and you have only to be silent."* So every time the thought flitted through my head that *"I am alone. I am so alone, and I am so scared,"* I would say out loud *"The Lord will fight for me. I don't have to do anything. I just need to know that He will fight for me."* Back then all I could do was take one baby step at a time. I needed to know Someone was not only rooting for me but also actively involved in my journey. For me, resting in that promise brought hope and peace while I inched along doing what I could while waiting on God to reveal His plan for my future.

Another rewire I worked on in those early days was the lie that I had to make my marriage work on my own—that I was totally responsible. It was a heavy burden I could not carry after twenty-two years of heavy lifting, and the elders at my church were pressuring me to take my abusive husband back and make it work. These are the verses I clung to during that time:

> "...for the LORD your God is he who goes with you to fight for you against your enemies, to give you the victory." (Deuteronomy 20:4)

> "You will not need to fight in this battle. Stand firm, hold your position, and see the salvation of the LORD on your behalf...Do not be afraid and do not be dismayed. Tomorrow go out against them, and the LORD will be with you." (2 Chronicles 20:17)

> "Wait for the LORD; be strong, and let your heart take courage; wait for the LORD!" (Psalm 27:14)

Here is the rewire I wrote in my journal that went along with those verses:

> "I believe I need to let go of this fight for my marriage. I need to stop thinking that if I say something or explain something, my husband and the church leaders will get it. I want to let God fight for me. I want to stand down and wait for God to move. I am ready now to let go of my marriage. I give it to Jesus. I can be fulfilled in Christ alone. I am ready."

I left that church and stopped pursuing help from the leaders there. I would eventually be accused of not submitting to their leadership and living in unrepentant sin, but I had firmly fixed my eyes on Jesus at that point, and there was no turning back. The Pharisees

claimed Jesus was in cahoots with Beelzebub (Matthew 9:34), so I figured I was in good company.

Rewires can also come about because of new ways of looking at old problems. Here are two illustrations that are helpful for rewiring that same lie that says *"you are solely responsible for your marriage, and therefore it's all your fault that your marriage is so painful."*

> "If two people are in a rowboat and each one has an oar, they both have to row to make the boat move forward. If only one person rows the boat, the boat will go around in circles and not get anywhere. Hearing this set of statements, one of our clients said, 'I would just row harder,' to which her therapist responded, 'Then I guess you would go around in circles faster.'" *Healing the Trauma of Domestic Violence* by Dr. Edward Kubany

Or consider this: let's say you and your partner bought a new house, and it needed some repairs. Your partner refused to do anything to see that the repairs were made, so you took matters into your own hands and started looking up YouTube videos in order to begin making some of the repairs yourself. But every time you'd start working on a project, your partner would come behind you and take away your tools and smack the thing that needed repair, doing even greater damage. Are you responsible for the fact that your new house is still in disrepair? Of course not.

Stories like this helped me clearly see that I could only do my part, and I wasn't responsible for the ending of my marriage. You are not responsible for building a marriage when you're tied to a marriage wrecker.

The earliest and greatest lie that has ever been told is that God is not good. Victims of abuse particularly struggle with this lie since it is drilled into their psyches by their abusers and the church itself when they equate abuse with God's will. It's probably going to be the first lie you work to rewire in your life. Here is the truth about God:

> "But you, O Lord, are a compassionate and gracious God, slow to anger, abounding in love and faithfulness." (Psalm 86:15)

> "There is no fear in love. But perfect love drives out fear, because fear has to do with punishment. The one who fears is not made perfect in love. We love because He first loved us." (1 John 4:18-19)

> "So now I am giving you a new commandment: Love each other. Just as I have loved you, you should love each other. Your love for one another will prove to the world that you are my disciples." (John 13:34-35)

> "Give thanks to the Lord, for he is good; his love endures forever." (1 Chronicles 16:34)

> "The Lord your God is with you, he is mighty to save. He will take great delight in you, he will quiet you with his love, he will rejoice over you with singing." (Zephaniah 3:17)

> "But you are a forgiving God, gracious and compassionate, slow to anger and abounding in love..." (Nehemiah 9:17)

> "Let them give thanks to the Lord for his unfailing love and his wonderful deeds for men, for he satisfies the thirsty and fills the hungry with good things." (Psalm 107:8-9)

*"Your love, O Lord, reaches to the heavens, your faithfulness to the skies. Your righteousness is like the mighty mountains, your justice like the great deep." (*Psalm 36:5-6)

"How great is the love the Father has lavished on us, that we should be called children of God!" (1 John 3:1)

We work extensively with uncovering and rewiring core beliefs in my Flying Free education and support group (https://membership. flyingfreenow.com/sign-up).

ANGER AND FORGIVENESS

When a woman wakes up to the reality of her abusive marriage, she may experience deep anger over the wasted years and immense effort she invested in the relationship. By this time she has sacrificed her entire life, her career, her personhood, her voice, her identity, and her health in order to focus all of her attention and energy on making her marriage work. Now she recognizes that she has nothing to show for her tremendous investment. Anger is the emotion we feel when we've been wronged. Her husband has wronged her in countless ways, and she realizes that she can never recover what's been lost.

Anger isn't a bad emotion. It's just an emotion that gives us some important information we need to pay attention to. What we do with our anger can be either positive or negative. Anger may give us the motivation necessary to make some changes in our lives. Maybe we need to learn healthy boundaries and how to stick up for ourselves. How to steward our time and resources. How to say "no" to someone.

If that same anger causes us to lace our husband's coffee with arsenic, that's not good. Or if we turn around and passive-aggressively sabotage something he cares about just to get him back, that's not good either. When we respond in vindictive ways to the pain others cause us, we disrespect ourselves. We show that we are still children who think we have no choices. But the fact is, we are adults who DO have choices. They may not always be comfortable choices, but we do have them. We can choose to act constructively or destructively. When we act destructively, it's often because we believe we are trapped and don't have any better options.

Every person alive will be hurt by others numerous times throughout life. But the worst pain comes when we are hurt by someone we should be able to trust. When your parent or sibling or spouse or child treats you like a thing to be used, that hurts more deeply for two reasons. First, they supposedly know you the most intimately, and if *they* think you're worth nothing, then it's tempting to believe maybe you really aren't very valuable. Maybe you really don't count for anything. If the people you are closest to don't want to hear you or respect your voice, maybe your voice is truly not worth hearing or respecting. Wow, *does that cut deep*. Human beings **absolutely need to be heard and valued in order to survive emotionally**. We need this the way we need food and drink. So when those closest to us withhold these things from us, we will suffer deeply.

Second, people tend to open up and get vulnerable with those closest to them. We hope and trust we can be ourselves and still be loved. When those closest to us don't show love or respect for us, we feel betrayed at the very core of our being. We can no longer trust them, and we shut down to protect ourselves. So just as this hurt from the people closest to us slices more viscerally into our guts, **so the emotion of anger grows proportionately over time into a**

powerful tsunami. When an abuse target begins to wake up to the reality of how she has been actually treated for so many years, all that rage comes crashing down on her, filling her up with pain that spills out on everyone around her for a while.

Guess what! *That's normal.* That means she is alive and kicking. That means she is no longer sick and anemic and unable to move in any direction. The anger imbibes her with new life and energy to **SURVIVE**. When self-righteous people shame her for being exactly the way God created her to be—a normal human with a need for emotional safety just like everyone else—they demonstrate a lack of understanding, love, and compassion. Their re-abuse can cause paralyzing fear and pain that holds her back from recovery.

Here's my point: If you're feeling angry because you've been relegated to the status of a nobody in the eyes of people in your life, and you feel guilty about that, remember that anyone with a pulse would feel the same way if they were put in your shoes. They may not show it in all the same ways you do. They may let it out in covert, passive-aggressive ways. They may stuff it and become depressed. Or they may take it out on everyone around them. But anger over hurt is normal. It's so important for you to understand this, so I'll say it again. It's okay to be mad at the mistreatment you had and at the people who did it to you. *Anger over hurt is normal.*

So what do you do about it? Because I know you don't want to be stuck in anger mode forever, I recommend digging deeper to uncover the hurt that lies below all that anger. Get a good counselor or therapist. Find supportive people who can handle your hurt. Get to know yourself so you can face off with the pain and deal with it in healthy ways. Quit running from it. Accept it. Sit with it. Ask yourself questions about it. Journal about it. Figure out what you

can and can't control, and take back control of your own home and yard. Don't let people shame you into hiding from the truth about your anger. Shame disappears when you expose the things that shame you, not when you keep them covered up.

Recognize that you have choices now, and exercise your adult rights to make choices that will nourish you rather than choices that will enable destructive people to continue using you. Sometimes we think we're being nice when we let people walk all over us. Yet inside we seethe with rage over their indifference and how they use and discard us. We might be acting nice, but what we're doing isn't good. Adults don't look for the approval of their moms and dads the ways kids do. If you're still struggling with feeling like your husband or your church leaders are playing the role of God or parent in your life, consider this: what if you took some steps toward growing up into your own? You'll make a lot of unhealthy, controlling people angry, but you'll respect yourself more. An additional bonus? You'll attract other healthy adult relationships while the power-over controllers in your life will scurry away to find someone else easier to bully.

WHAT ABOUT FORGIVENESS?

Have you ever been told that you were unforgiving? Bitter? Angry? *What does it mean to forgive?* Forgiveness is only appropriate when someone has taken something from you. When you are an abuse target, you've had many things taken from you over the course of many years. Your voice. Your personhood. Your dignity. Your money. Your safety. Your freedom. Your opportunity to be loved. Your career. Your truth. Your past. Your emotions. Your ability to think clearly. Your dreams. And many other opportunities both tangible and intangible.

Forgiveness is letting go of your right *to make things right*. Forgiveness is not letting the other person off the hook but rather letting him off *your* hook. **He's still on God's hook!** He doesn't owe *you* anything anymore. Now he owes God. You forgive his debt to you for taking all those things away, and now he stands before God with his debt.

You can forgive on your part without the other person *ever* acknowledging they took anything at all from you, which is good news, because **abusers will not acknowledge their need to be forgiven**. Remember? In their view, they didn't do anything wrong! The fact is, your abuser owes you, big time. The other fact is, he won't ever admit it. And the last fact is, he will be held accountable one day. **To be a daughter of GOD means letting Him dole out the appropriate justice.**

> *"Beloved, never avenge yourselves, but leave it to the wrath of God, for it is written, 'Vengeance is mine, I will repay, says the Lord.'"* (Romans 12:19)

But you? You don't need to worry your weary heart over making sure that he receives justice for his wrongs toward you. You get to forgive the debt and move forward. Vengeance is a waste. It's a heavy burden in and of itself. **It drains you of the emotional energy better directed toward your healing and moving forward into all the future opportunities you've previously missed out on because of him.** You've got catching up to do! Letting go of the desire to have your vengeance is freeing.

And guess what else. Forgiveness isn't just a one time thing. You don't say "I forgive you" and all the emotions just magically fade away. That's not possible unless you are a robot or a cartoon character. Forgiveness is something God does in you, and it's a process that can take a long time depending on the level of the abuse or wrong

done. Fake forgiveness might make a good story in a Sunday school class, but if it isn't real, it means nothing. Why not be patient with yourself as you go through the process and trust God to see you all the way to the end?

If someone bumps into you at work, you can forgive the person easily. If the person hits you, you will have a harder time forgiving him or her. If the person sabotages your work and gets you fired, it will take a long time to recover and forgive. If he or she seriously injures your child, you may spend a lifetime struggling with forgiveness. You may think you've forgiven one day and then something will trigger you, and all that hurt and rage will rear up and howl at you, threatening your stability. That's what the gospel is for. Jesus died for that. He loves you. He gets it. **Let Him do His work in you over the course of time.** If others don't understand and can't handle the process, that's their problem.

Here's what forgiveness is NOT: "*Hey abuser, you stole from me, and I'm going to be a good girl and let you keep stealing from me over and over and over again until I'm six feet under and you can't get anything out of me anymore. Why? Because I FORGIVE YOU.*"

That's what many Christians will try to tell you it means. "Forgive and forget." Because if you forget that they stole your dignity yesterday, you'll let them do it again today. They love that. They are counting on you to do exactly that because it enables their chronic sin of abuse. Look at it this way: If a person kept loaning money to someone who never paid it back, this person has one of three choices. One, keep willingly loaning the money and expect to continue doing so forever, thereby letting the negligent recipient happily grow in greed and irresponsibility. Or two, keep loaning the money with resentment in his or her heart, hoping for payback one

day. Or three, stop loaning the money, forgive the debt, and tell the chronic money taker to either go get free money somewhere else or go get a job. When it comes to chronic abuse, the last option is the wisest. Forgive the debt owed you, and then stop investing your precious life in an abusive relationship and get yourself to a place of emotional and spiritual safety.

Here is a way to capture the essence of forgiving someone for a lifetime of abuse:

> "*Hey, abuser, you wronged me, injured me, and stole from me over the course of many years, and this is something I can never forget. I have the right and responsibility to remember all that you did to me. You deserve my vengeance. But I'm choosing to give my right to vengeance to God so I can move on with my life. In this sense, I forgive you the debt you owe me, but my forgiving you does not restore our relationship or give you back any rights to me, my mind, my choices, or my body. What you did doesn't just disappear, and you still bear full responsibility for the results of your actions. You will still have to accept the consequences for what you've done. My forgiving you doesn't mean everything goes back to normal, as if it never happened, because that isn't possible.*
>
> *And abuser, any time you are demanding forgiveness or you are critical of me for not forgiving you the way YOU think I should, you are showing me that you don't care about me or our relationship. You are not righting the wrongs you have done. Instead, you are confirming that you are an abuser and that it would only harm me further to forgive you in the sense you are wanting me to. Because of what you did, forgiveness of the 'forget it ever happened and go on as before' variety is*

not possible. I will now get myself a safe distance from you, and I will let God handle giving you the justice you deserve."

FOR FURTHER STUDY

» *The Gifts of Imperfection* by Brene Brown

» *Presence: Bringing Your Boldest Self to Your Biggest Challenges* by Amy Cuddy

» *The Dance of Anger: A Woman's Guide to Changing the Patterns of Intimate Relationships* by Harriet Lerner

What Comes Next?

CLIMBING OUT OF THE PIT

We've come to the end of our time together. If you're still reading this book, you're brave, because it isn't an easy book to read. You may be feeling all kinds of mixed-up emotions like relief, fear, hope, dread, sadness, anger, shock, or shame. You might be feeling all of these simultaneously! Or you may be feeling numb and dead inside. I remember when I began to wake up to the reality of my own abusive marriage. I felt like I was free falling. It was surreal. It was also the beginning of my own journey toward a life of emotional safety and freedom—a painful process that would take six full years to complete.

I wrote an article about this process on flyingfreenow.com called *Ten Steps Out of Relationship Hell*, and it goes like this:

Imagine that your destructive relationship is a hot, burning pit. It's dark down there. You can't breathe down there. It hurts down there. You're stuck down there. It's HELL down there. You might be sitting in those depths thinking you need to be rescued. You've spent years complaining about this painful pit you live in, waiting for someone to come along and pull you out. But my friend, you

will never be rescued. *What you need isn't rescue.* **What you need is POWER.** Because the only way out of hell is up a very hot ladder, and you need to be *empowered* to climb that ladder and get out. You need to be *prepared* with a working knowledge of every single hot rung you will have to endure on your way up and out.

Have you decided to get out, no matter what? Because that's the first step before you can begin the climb. This article is for those of you thinking about making that decision, for those of you who have decided to make the climb, and for those of you who are half-way up and sorely tempted to let go and fall back into the pit. **Part of getting out is understanding and accepting the fact that it's hell to climb out.** Once you're armed with that knowledge, it won't surprise you when you feel the pain of the climb. I also want you to know that *the view at the top is glorious*, once you get there. But I'm getting ahead of myself. Let's talk about the ten *hot-as-hell* ladder rungs you need to climb in order to get out.

First Hot Rung: FEAR

As you anticipate climbing, you will feel a paralyzing fear of all the hot rungs that lie before you. How will you do it? Is it even possible? It's a long way up, and frankly, many will never make it. I think more women are attempting the climb now simply because there are so many women at the top cheering them on. But even just five years ago, all was silent at the top. Not a whole lot of hope that there was anything up there even if you did get out. When your fear of staying becomes greater than your fear of climbing, you will conquer your first hot ladder rung.

SECOND HOT RUNG: TRYING TO GET YOUR ABUSER TO CHANGE

Because then you won't have to climb, right? I mean, if Hell is transformed into Heaven, problem solved! So you try telling him in 4,789,935 different ways how you can't do this anymore and how you love him and hope he'll see how destructive his behaviors are and how you may need to take drastic measures if he doesn't change something soon. Result? **Hell gets a lot hotter.** That rung really stings, and you may be stuck on it longer than necessary. But once you realize hell is hell because it *just is*, you'll be ready to take the next step up.

THIRD HOT RUNG: GRIEF BECAUSE YOUR ABUSER DOESN'T ACTUALLY LOVE YOU

Next comes the red hot ladder rung of the shocking pain of accepting that you are in a relationship with someone who doesn't love you. That's right. An abuser is not capable of authentic love. Once you are out of hell, you'll be able to see that it wasn't personal—he couldn't love anyone. But when you are beginning your climb out, this realization is a tremendous loss and causes you to take a deep dive into the grief process. Grieving is hard, painful work. It takes time, too, which is one of the worst parts of this rung. You can be stuck on it for a long time. You'll be tempted to keep climbing and get this one over with, but if you do that, you'll inevitably fall back down, because you can't move forward until you've done that grief work.

Fourth Hot Rung: You Tell Someone, but They Don't Take You Seriously

The pit you're in is lonely, and the red-hot ladder out of it is even more so. To get this far, you've had to give up the idea that your husband will ever care about your emotions. But you're still a human being wired by God for emotional connection with others, and you long for someone to talk to. You finally muster up the courage to tell someone you think you can trust. A family member. A friend. A church leader. *You don't want to do this.* You're ashamed that you've kept it to yourself for years—decades even. You worry they might not believe you because your abuser is so nice to everyone outside of the family. You feel like a school girl tattling on your spouse instead of an adult woman able to handle her life.

You don't want to shame him either. You've always seen it as your job to protect his ego. If you're a Christian, you see it as your duty to respect and honor him no matter what. Telling someone on the outside about his bully behavior feels disrespectful somehow. You want him to get help and change, but then you remember Ladder Rung Three. You hope they will offer some empathy and sit with you in your grief. But shock of all shocks (only it won't be a shock now, because, well, this book), *they don't.* In fact, they don't even believe you're telling the truth. Never mind that you've had a reputation for telling the truth your entire life. Suddenly, you're a liar.

One of the hottest rungs you'll touch is ***not being believed*** and ***false accusations*** when you were only trying to get help. In fact, this is the place many women drop, begin the climb to tell someone new, and drop again. It's that painful. And when it happens multiple times, you begin to lose your faith in family. In Church. In friendships. In the entire human race.

But hang on, because there is One who believes you. He saw it all happen. Tell Him, and He will help you hang on to take the next hot step. He is the only One you need to make this climb. (And don't forget the ones on top cheering you on!)

FIFTH HOT RUNG: YOU DECIDE TO SEPARATE

Logistically, this feels impossible. There are financial considerations. How do you physically force a controlling spouse out? Will you need to leave? Where will you go? What if you have children? Sometimes it takes a lot of thinking, preparing, and time before you can make your exit. You may need to get a job and separate your finances first. You might need to build up a nest egg and get ready for your big move. This can take years. Maybe you will decide to stay until your kids are out of high school or at some other milestone in their lives.

These decisions are personal and as varied as the people who make them. Everyone will do this differently, but the point is, you'll need to do it eventually. And it's a frightening, overwhelming step that will also rouse the anger of your abuser. This is one of the times, statistically speaking, you'll be in the most physical danger, even if your abuser only attacked you in other ways before.

The other alternative is to skip this rung and go straight to the next one:

SIXTH HOT RUNG: YOU FILE FOR DIVORCE

When you take this step, you are jumping off the proverbial cliff. You've made a life-altering decision, and everyone around you is

going to explode. *All over you. While you are grieving and free falling through space.*

Divorce is expensive. It's time consuming and emotionally draining. Your stress level will sky rocket even higher than it was before. You may have panic attacks. You may go into a depression.

If you have children, it is common (to avoid paying child support) for the abuser to fight for at least 50% custody, even though he may have not been very involved in their lives prior to the divorce. This may precipitate a long, drawn out court battle that will drag your children and a custody evaluator into the equation. It will add to the trauma your children are already experiencing.

The process of divorce is no picnic, and it is made so much worse by the next rung:

SEVENTH HOT RUNG: YOU ARE REJECTED AND KICKED OUT

So during one of the most horrifying, frightening, lonely, sorrowful experiences of your life, you may be kicked out of your church. Disowned by family members, including your own grown children. Shunned by former friends. Reprimanded. Publicly disgraced. Suddenly, you're THAT woman. A marriage-breaker-upper. (When you are clinging white knuckled to this rung, please remember that divorce doesn't destroy marriages—abuse, addictions, and infidelity do.) This can be the loneliest, scariest, most painful rung of all for some women, but it has to be climbed to get to the top.

EIGHTH HOT RUNG: YOUR KIDS SUFFER AND GRIEVE

Your children will suffer the loss of a two-parent family. Some may process it easily with very little intervention. Others will internalize a lot of garbage and suffer relationship consequences into their adult life. You may want to consider counseling by a professional counselor with experience in childhood trauma. Depending on your insurance, this may or may not cost money, but it is well worth it if there is any way possible to access this kind of help. TIP: *"Biblical" counselors are most often not educated, equipped, or experienced in dealing with the fallout of emotional abuse on a family.*

Some of your kids will see things clearly. Others will be confused— easy targets for the ongoing emotional manipulations of your former spouse. He may turn to the kids for his emotional supply once he knows you are no longer providing that for him. Triangulation is a common problem at this point, and the children are the ones who suffer most.

Don't expect help from your church or friends. You've made your bed, and they'll expect you and your children to lie in it. You are literally on your own. Which brings us to the next step:

NINTH HOT RUNG: YOU ARE SINGLE AND ALONE

You've lost everything. Your marriage. Your home. Possibly your financial stability. Your friends. Your church. Your reputation. Possibly some of your children. And now you are a single woman past your prime struggling to make ends meet for yourself and your

kids. No sympathy or help from anyone. It's worse than widowhood. Far worse. Can it get worse than this? Yes, it can.

Tenth Hot Rung: You Have Health Problems

You actually *haven't* lost everything. You've still got your C-PTSD symptoms. Your panic attacks. Your heart palpitations. Your back and neck pain. Your digestion issues. Your migraines. Your frequent illnesses because your immune system is on the fritz from so much stress.

You are a shell of yourself by the time you get to the top.

Except you're not. Because somewhere along the way you found yourself again.

When you climb up over the edge, you look up and see light. The light of freedom. The sound of peace. The color of beauty. The exhaling relief of knowing you made it out in one piece. YOU MADE IT! YOU ARE STRONG! YOU ARE A SURVIVOR!

And now you get to heal.

You find a friend. Then two. You actually like your job. You find a good counselor and try anxiety medication that changes your world. That child who disowned you comes back around. Counseling is a game changer for your kids. A new church opens its doors in your city. You like it. They like you. You discover you've got a knack for painting, and you start selling your art on Red Bubble.

You start reading your Bible again with new eyes. Eyes that see Love instead of Law. Jesus instead of lies and accusations. You reconnect

on Facebook with a boy you knew in grade school who is now a widower, and you fall in love. You experience normal life for the first time in forever. And it feels wonderful.

You join the growing crowd of women at the large hell hole in the ground and start cheering on the next one making the climb.

It was hell. It took a long time. ***But you are finally free.***

VICTORY IN JESUS

I recently asked some of the women I work with to share the ways God has given them victory over the past year. They gave me permission to reprint their responses anonymously here, praying that it would encourage you to put your hope in Jesus rather than abusive people and their supporters. He will never fail you. He will never lie to you. He will never leave you. And He will never stop pursuing you with His powerful love. He promises.

"I never realized how much of my own childhood image of my abusive dad I had projected onto God. Being 'perfect' kept me safe, so I'd built an entire persona for myself around always following the rules. But since I'd never learned a healthy understanding of my abuse (and how much it impacted my views of myself, other people's treatment of me, and God), I stepped out of the frying pan and into the fire when I married a narcissistic abuser in my twenties. It was the perfect setup: he groomed me for abuse, preyed upon my endless forgiveness and kind heart, and slowly twisted my mind into believing I was a mistake-ridden, worthless human. This happened over

time of course, so I spent ten years of marriage wondering if I was crazy, trying to be more submissive, and always praying with a patient heart that he would simply be nice and that God would show me whatever sin I had that was contributing to the problem. But after waking up to the fact that there was so much WRONG in my marriage (and a dramatic turn of events), I decided it was now or never and got out—despite my fears that God would abandon me for not going with 'His plan for marriage' and divorcing. It was the biggest trust fall of my life, but God caught me! Yes, getting out was Hell, but I cannot *believe* how much more deeply and intimately I know my loving, forgiving, kind-hearted Lord now. It's like I had lived my entire life in black and white, and in clinging to God for dear life as I walked through the door marked 'divorce,' I was stepping into a world of technicolor beauty. I can't minimize how tough it was to get out, but now three years on the other side, I have never been as happy in my motherhood, as fulfilled in my personal life, or as amazed at the goodness of God as I am today. If I'd known ten years ago what I know now, that God would CATCH ME, I never would have stayed as long as I did. But I have four precious kids that I get to model grace for and do life with, and the brokenness I went through has made me a stronger woman—not just for myself, but for my family and the women God brings across my path."

"I thought being married to my husband was a lifelong punishment. After my separation, a counselor helped me

understand that God doesn't work that way. God's love has become much more real to me over the last two years of separation and then divorce. It's amazing! He loves me! Always and no matter what. Nothing can separate me from His love (Romans 8:38-39). I am a child of God, and that is precious."

"As I came to grips with reality, finally putting a name to the shame and confusion I'd endured throughout my fourteen year marriage, I was consumed by a relentless fog. But God gave me a thirst for knowing Him like I'd never experienced before. He was there with me in the depths, quenching my parched soul. He showed me that His grace wasn't an abstract concept meant only for those other good Christian women with loving husbands. It was for me too. He provided for me in ways I still can't fully comprehend. He taught me about His nature and how He sees me and knows what I've been through even when I was covered in shame. My faith is no longer a hollow addendum to the shackles of legalism—trying to measure up, trying to keep all the people around me happy with me so I could feel like God loved and accepted me. Now He is my bedrock. Life is filled with both sorrow and joy, but He remains the same, and I am with Him."

"'*You're just overreacting again. Why do you always make such a big deal about everything?'* This was the patronizing response I got from my husband every time I brought up any concern. I was dismissed, my thoughts and questions were minimized, and I felt small and stupid. I filed for divorce after ten years of marriage, and now, for the first time in my life, I feel like a real grown-up woman! I'm free from his voice in my head—that running commentary that constantly criticized and undermined me while sabotaging my joy. After I left, I used to wait for it. There were times I would actually cringe, bracing myself for his verbal attack. Oh, what freedom the silence and finality of my own thoughts have brought me. I have learned to look myself in the mirror without shame."

"I am so grateful to God. I used to think that I had to stay married even though my husband was emotionally abusive. I thought it was the only way God would love me because I believed God brought this man in my life. Now I know that's not true. God loves each of us for who we are. We are His children, and there is nothing we can do to stop God from loving us. Marriage is important, but not more important than people. I now believe I honored God by getting away from my abuser in order to protect myself and my kids. I just needed to take that first step and find out how faithful God would be."

"I've been separated for nine months now. A few months after I left peace washed over me. I had been battered emotionally by my husband, and my emotions are in the process of healing. I had a double whammy when my pastor believed my abuser and blasted me in a public meeting at church in my presence. I have struggled with this because I thought my church would love and support me, but they did the opposite. God led me to a church that is helping me heal. I learned I can trust God on a deeper level. I learned that God wanted this marriage to work too, and He fought for it as much as I did, but my husband had a free will. He made a choice not to change. This truth changed me! God gave me what I needed. He has been guiding my healing step-by-step and setting me free from abuse!"

"I was fifty-nine when I decided to leave my emotionally abusive husband. I am fortunate that I have a career that I can get a job most anywhere, but I left with just a few belongings and my two little dogs and traveled 1700 miles across country to get away from him. I furnished my apartment with garage sale and Salvation Army items. It hasn't always been easy, but Jesus has been by my side. Even though my marriage was without love, I know the true love of Jesus. He loves and adores me. You can be free at any age!"

"During my emotionally abusive marriage, I lost sight of the fact that I am God's child. I thought that if I could be prettier, skinnier, a better wife, give my husband more sex, do what he says and not complain, PRAY HARDER, etc., that my husband would finally love and want me like a husband should want and love his wife. Now that I am free, I rest in knowing I am always loved and always wanted by my Father in Heaven!"

"When my therapist told me I was being emotionally abused, it set me on the course of a life-transforming journey. By educating myself, so many things began to make sense, and so many burdens, worries, false responsibilities, and shame were lifted off me. At the same time a sense of horror washed over me as I began to see my situation more clearly and realized I'd been living a lie all those years. That was the hardest part to accept, and for a time I kept falling back into denial and living the lie. The journey is not over for me yet, but the online support from wonderful women who've been there is just what I need to keep me strong and help me navigate the least painful path through the continued arrows of abuse. I believe I'm on the road to freedom, health, and healing now."

"I remember the night when I locked the door to the bedroom so he wouldn't see or hear me, and I whisper-screamed a prayer to God to please, please have one of us die so I didn't have to live this way anymore. My church taught that dying was the only way out of an abusive marriage unless he committed adultery. But I learned that abuse mattered to God very much! And even though my husband had everyone else fooled, I knew the truth, and so did the Lord. Step by painful step, He led me out and into freedom, love, and peace! I'm divorced almost two years now, growing and healing more each day."

"For so many years in my marriage I strove to create a peaceful environment for my husband and kids. I did absolutely everything I could think of to accomplish this. After I separated from my husband, I realized that while I had been inviting peace into the front door, my husband had been inviting sin and darkness in through the back door. Since I had been taught to defer to him as the head of our home, I sadly assumed he was doing all he could to protect us. It was only after he was out of the home that I realized I was empowered to fight for and protect my home. I no longer needed to wait on him to grow up, mature, or become the spiritual head I so desperately wanted him to be. Through Christ I could do all these things while drawing on His mighty strength and power."

"'God loves you more than he hates divorce.' This has been a comforting reminder as He has led me through the painful journey of discovering long-term patterns of hurtful behavior—abuse—in what I thought was an imperfect but happy marriage of twenty-five years. I grew up hearing 'You don't matter' in words and actions from both of my parents, and I internalized those voices. After discovering my husband's long-term affair with my best friend, I found that I had avoided the overt physical and verbal abuse of my father but had spent most of my married life subjected to the insidious and quiet disdain, contempt, and rejection of my mother. The hurtful patterns have continued during fifteen months of attempted reconciliation and constant prayer for God's will. Recently, a wise friend reminded me that 'Repentance doesn't hide, and we don't have to search for it.' This helped me realize that divorce can be a healthy and even loving choice, and the death of an unhealthy marriage can be the beautiful beginning of a new life in which my girls and I can flourish. I am separated and currently in a waiting period of stillness and listening as I continue to heal. As a child of God, and by His grace, I have taught my girls to hear a different inner voice—that they DO matter and that the love and acceptance of God is ours no matter the outcome."

"One day I had a talk with myself. I thanked the woman I was for what she was able to do in the last season of her life and how she held it together. She wasn't perfect, but gosh. SHE TRIED. I had a picture of her loading the dishwasher for the millionth time while trying to keep her world and marriage together. I thanked her for trying to keep her cool and not scaring her kids with outbursts of anger or terrible decisions. She made wise choices and made sure they felt emotionally safe as much as she possibly could. If there was help or counsel to be sought, she fought for it. She never woke up without hope. Never. She gave herself as much of a voice as allowed, but it never quite seemed to be enough to convince her husband's heart to change. While desperately waiting for her marriage to have a miraculous turn, she ran the family business, she raised three little kids, she spent countless nights in the hospital with her near breathless baby, she sang her lungs out in desperation for every kind of miracle God had to offer, she enjoyed life as much as she possibly could, and she thought she was pretty happy. This life was something she had to do, and she was in it forever. No matter what. But her world was crashing all around her. She was trapped in a mine. Since she never lost hope, now she could see there was a tiny ray of light shining through the rocks somewhere in the distance. That light is my future. I'm no longer trapped in the mine, and the light is getting brighter every day. I have these moments and hours and days of grief, but things are changing. Some days the light is so bright I can hardly

see. My life isn't what it was. It's not at all what I thought it would be when I started having a family ten years ago, but it's gonna be okay. God is here. He's been here and seen every single thing I tried. God has some secrets up His sleeve that He can't wait to show me. The future is finally exciting again. He's collected all my hot tears in a bottle from all those years, and He said it's gonna be okay. I'm more than gonna make it. And He's really liking the new me."

How about going through this book and companion workbook with a small group of women online?

Is It Me? small groups meet weekly on Zoom for 11 weeks. Members read a chapter of *Is It Me?* and complete the corresponding workbook chapter each week and then discuss that chapter with a trained facilitator and the other women in the small group.

Sign up to be informed when the next group opens up here: https://flyingfreenow.ck.page/groups

CONCLUSION

Just like these women, you too can have a future out of the pit—a brighter, happier future where your wounds can heal, and you can discover how wonderful life can be. It makes the painful journey out so very worth it!

I hope this book has helped you make sense of your confusing marriage, opened your eyes to the very real dynamic of verbal, emotional, and spiritual abuse, and provided you with a helpful guide to finding your way out. There's so much more help out there than I could ever fit in the pages of a book, so please look at the additional resource recommendations along with all the other ones listed throughout the book.

Most of all, please know that Jesus loves you just as you are and is with you every step of your journey. It has been my privilege to walk next to you on a small part of that journey, and as we part ways, I pray that one day God will help you spread your wings and fly free!

Love,

ADDITIONAL RESOURCE RECOMMENDATIONS

Deciding if You Should Stay or Go:

- *Should I Stay or Should I Go?* By Lundy Bancroft
- *The Betrayal Bond: Breaking Free of Exploitative Relationships* by Patrick Carnes Ph.D.
- *Can Your Relationship Be Saved? How to Know Whether to Stay or Go* by Michael S. Border Ph.D.

Parenting Children Through Separation/Divorce:

- *Beyond Logic, Consequences, and Control* by Heather T. Forbes, LCSW, and B. Bryan Post - "…covers in detail the effects of trauma on the body-mind and how trauma alters children's behavioral responses."
- *Raising an Emotionally Intelligent Child: The Heart of Parenting* by John Gottman
- *Transforming the Difficult Child: The Nurtured Heart Approach* by Howard Glasser and Jennifer Easley
- *Co-Parenting with a Toxic Ex* by Amy J.L. Baker Ph.D. and Paul R. Fine LCSW
- *Divorce Poison: How to Protect Your Family From Bad-Mouthing and Brainwashing* by Dr. Richard A. Warshak

Help Your Children Understand Healthy Relationships and Boundaries:

- *Growing Up with a Bucket Full of Happiness* by Carol McCloud
- *The King and Queen of Mean* by Lynne Namka

Preparing for Divorce:

- *Divorce: Think Financially, Not Emotionally* by Jeffrey A. Landers CDFA
- *Splitting: Protecting Yourself While Divorcing Someone with Borderline or Narcissistic Personality Disorder* by Bill Eddy LCSW, JD, and Randi Kreger
- *When I Do Becomes I Don't: Practical Steps for Healing During Separation and Divorce* by Laura Petherbridge

Also, in my private Flying Free education and support group (https://joinflyingfree.com), I offer courses like the following:

- Recovering from C-PTSD
- Detach and Detox from Unhealthy Relationships
- Bible Flippers
- Deprogramming from Spiritual Abuse
- Basic Boundaries
- Essential Self-Care
- Dealing with a Dysfunctional Relationship
- Divorce Basics
- Parenting After Abuse
- Various book studies
- And more!

You can find out more about the Flying Free group here:

https://joinflyingfree.com

ACKNOWLEDGEMENTS

There are several people I'd like to thank for the ways they've contributed to this book. First of all, my husband, Tom Hoffman, helped me set aside the hours necessary to write, and he enthusiastically took over parenting duty so I could focus on my mission. Without his consistent, loving support, I would not have been able to start this book, let alone finish it. He is my daily reminder that there are good men out there, and his love and honor toward me heals me a little bit more with every new day.

The women in my support community, Flying Free, also played an incredibly important role in this book. They took time out of their busy lives to answer all my strange questions and share their personal insights. Their voices are powerful, and I hope the reader will hear them and know she is not alone.

My lifelong friend, Stacie Gates, offered her editing skills and, as usual, taught me things I never knew. A newer friend, Margaret Gregorczyk, contributed her nuanced insights into various parts of the book and spent hours giving me her wise feedback. This book is richer because of her. Helena Knowlton contributed her expertise on the subtle tactics of covert abuse. Jimmie Quick inspired me with the idea of including check points throughout the book to gently connect with the reader's heart while guiding them through painfully new territory. Rebecca Farris (The Well Planned Gal) and

Jeni B. (The Biz Maven) were my constant cheerleaders along the way, lending me their valuable professional and personal advice. One of my best friends since high school, Pastor Kristin Skare, gave me her unique perspective as a minister of the gospel. And Rachel Whitten has been my right-hand woman, taking over much of the administration of the Flying Free group so I could be freed up to work on this project.

I also want to acknowledge and thank Rebecca Davis and Valerie Jacobsen for contributing their wisdom to chapter seven. My hope is that chapter seven will demolish a few religious lies about God, enabling His daughters to find their weary way back into His loving arms.

And finally, I thank and praise Jesus for taking what the enemy meant for evil and using it to set captives free. I've literally been on my face again and again in joyous wonder at the wise, powerful, and creative ways He rebuilds and restores His daughters in spite of so much opposition. May we all find our safe hope in casting off shame, living courageously, and resting peacefully in His never-failing love. *Always. Forever.*

Amen.

ABOUT THE AUTHOR

 My name is Natalie Hoffman. I'm a mom of nine, educator, entrepreneur, writer, life coach, daughter of God, and survivor of spiritual and narcissistic abuse.

I know what it means to crawl, and I know what it means to fly. My passion is to help women of faith go from one to the other.

I've walked this path with thousands of women, and I know it well. I'm ready to walk it beside you too.

CONNECT WITH ME ONLINE:

flyingfreenow.com

facebook.com/flyingfreenow

Made in the USA
Monee, IL
12 April 2022

94573903R00203